CW01371249

JEAN-FRANÇOIS MILLET

AND THE

BARBIZON SCHOOL

The Goosemaiden.
(J. F. Millet.)

JEAN-FRANÇOIS MILLET

AND THE

BARBIZON SCHOOL

BY

ARTHUR TOMSON

LONDON

1905

JEAN-FRANÇOIS MILLET

AND THE

BARBIZON SCHOOL

BY

ARTHUR TOMSON

LONDON
GEORGE BELL AND SONS
1905

First published 1903.
Cheaper re-issue 1905.

CHISWICK PRESS: CHARLES WHITTINGHAM AND CO.
TOOKS COURT, CHANCERY LANE, LONDON.

PREFACE

SINCE writing the study of Jean-François Millet included in this book, it has been my good fortune to have verified my own convictions that the sorrows of the peasant-painter's life have been, by certain writers, very much exaggerated. While in conversation with a well-known collector and possessor of many beautiful pictures by Millet, I mentioned that the creator of a certain drawing, at which we were looking, could never have been as unhappy a man as Millet was generally represented to be. The answer that I received was, "No, he was not always unhappy. Many a time have I talked at length with Madame Millet about her husband, and she assured me that at Barbizon Millet was far from unhappy: there he had everything that he wanted."

To the various owners and others by whose kind permission I have been able to reproduce the pictures in my volume, including Sir John Day, Messrs. Obach, the authorities of the Victoria and Albert Museum, M. Durand-Ruel, and Mr. Henry Willett, I offer my best thanks. As what is biographical in these pages is

naturally based on prior records, it is scarcely necessary to refer to all the authorities whose writings have been consulted. A list, however, of some of the principal works from which I have gathered my information is here given, and to those of these authors who are still alive I desire to acknowledge my indebtedness: "La Vie et l'Œuvre de J. F. Millet," A. Sensier; "Souvenirs sur Théodore Rousseau," A. Sensier; "Jean-François Millet," W. E. Henley; "The Painters of Barbizon," John W. Mollet; "Jean-François Millet," Julia Cartwright; "The Barbizon School," D. C. Thomson; "Peintres et Sculpteurs Contemporains," J. Claretie; "Maîtres et Petits Maîtres," P. Burty; "J. F. Millet, Souvenirs de Barbizon," Alexandre Piédagnel.

<div style="text-align: right;">ARTHUR TOMSON.</div>

WAREHAM, DORSET,
September, 1903.

CONTENTS

	PAGE
LIST OF ILLUSTRATIONS	ix
JEAN-FRANÇOIS MILLET	
Introduction	1
I. Early Days	32
II. Life in Paris	44
III. Arrival at Barbizon	61
IV. Millet's greatest Works	80
V. The End of the Story	105
JULES DUPRÉ	123
NARCISSE-VIRGILIO DIAZ	145
THÉODORE ROUSSEAU	177
THE INFLUENCE OF THE ROMANTIC SCHOOL	215

LIST OF ILLUSTRATIONS

JEAN-FRANÇOIS MILLET

		PAGE
THE GOOSE-MAIDEN	Collection of Sir John Day (Frontispiece)	
SHEPHERDESS	Victoria and Albert Museum	18
SPRING FLOWERS	22
DEAD BIRCH-TREE, FONTAINEBLEAU	26
THE SPINNING-WOMAN	34
A PEASANT WOMAN	42
SAINT BARBARA	52
THE SWIMMERS	Collection of Sir John Day	54
THE FLIGHT OF CROWS (Pastel)	62
THE SOWER (From the Pastel)	64
WOOD-SAWYERS	Victoria and Albert Museum	66
A WOMAN AT A WELL	,, ,,	70
THE SHEPHERDESS	72
DRAWINGS ON THE BACK OF AN AUTOGRAPH LETTER . Collection of Henry Willett, Esq.		74
THE GLEANERS Louvre	78
THE ANGELUS	80
DEATH AND THE WOODCUTTER Glyptotèque, Copenhagen	82

LIST OF ILLUSTRATIONS

	PAGE
THE LITTLE GOOSE-GIRL	86
A WOMAN CARDING WOOL	88
SHEPHERDESS	90
THE MOWER	94
THE WATERMILL	96
BIRD-KILLERS: A NIGHT SCENE	98
SPRING Louvre	100
A WOMAN CHURNING (From the Pastel) . . .	102
NOVEMBER	104
THE WASHERWOMEN	108
THE CHURCH OF CHAILLY	118

JULES DUPRÉ

THE POOL	123
SUNSET	128
THE APPROACHING STORM Collection of Sir John Day	130
THE MEADOW	132
A LANDSCAPE	138
A MARINE VIEW	140

NARCISSE-VIRGILIO DIAZ

A YOUNG GIRL PLAYING WITH A DOG	145
TURKISH CHILDREN	154
IN A WOOD . . . Victoria and Albert Museum	156
THE OUTSKIRTS OF THE FOREST ,, ,,	158
THE LOWING HERD . Collection of Sir John Day	160

LIST OF ILLUSTRATIONS

THE BOHEMIANS	162
THE BATHER .	. . Victoria and Albert Museum	166
BAS-BRÉAU	170
CATTLE DRINKING: EVENING Collection of Sir John Day	172

THÉODORE ROUSSEAU

SUNSET	Collection of Sir John Day	177
MOUNTAIN SCENERY	. . ,, ,,	182
A WATERFALL IN THE AUVERGNE	,, ,,	188
A VALLEY	,, ,,	190
STUDY OF A TREE .	. Victoria and Albert Museum	194
LANDSCAPE: SETTING SUN	198
THE FLOOD . .	. Victoria and Albert Museum	200
ENTRANCE TO THE VILLAGE	Collection of Sir John Day	202
CROSSING THE FORD	206
SKETCH	Collection of Sir John Day	212

JEAN-FRANÇOIS MILLET

JEAN-FRANÇOIS MILLET

INTRODUCTION

IT is due very possibly far more to the extraordinary personality of Millet, than to the actual circumstances which attended his career, that his biographers have with few exceptions accentuated, perhaps I may say overaccentuated, the tragical side of the painter's life. His deprivations have been taken note of, and they were not hard to see, but all that came to him by way of compensation for his suffering has received hitherto but very scant recognition.

Far be it from me to insist that Millet's journey through life was an easy one. Hunger he felt, and the need of many other necessities besides food; and worse, it was his lot often to see those who were dependent on him, his wife and his children, with their wants unsatisfied; yet Millet's life cannot have been, as Alfred Sensier would have us believe, one long foreshadowing of the terrors of Purgatory. He suffered certainly, but he had within him far more sources of happiness than belong to the majority of human beings; and was there ever such a life as Millet's, one that from the cradle to the grave was pursued in a course so even, without any deviation, without any retrogressions? Every recorded thought and

action of Millet's; every influence that surrounded him, his joys and his sufferings, that we know of; all appear to have been especially appointed to bring about the full development of his artistic powers.

Millet was born of peasant folk, and from them he had the habit of simple living, and a powerful physique. From them he obtained too his great tenderness towards the people, whom he was destined to delineate so powerfully. By working with his folk upon the farm he had not only the opportunity of incessantly watching the appearance of figures in different sorts of toil, but he obtained as well an actual knowledge of the farm-labourer's crafts. He learnt how to plough, and how to sow; he learnt all about the peculiar nature of all kinds of crops, and every kind of domestic animal; and he became acquainted with the discomfort, with the agony, that arises from continuous bodily exertion; with all that a farm-labourer suffers from exposure to scorching sun, and biting wind, or frost.

Nor did this family of peasants, from which Millet sprang, endow the boy merely with bodily strength, and accustom him to a life that was irksome and full of hardships. "You will go to perdition for having kept him so long," said the first drawing-master to whom Millet's father showed his son's drawings. But indeed Millet *père* had little reason for loading his soul with remorse. Himself the possessor of a delightful musical talent, he had recognized and encouraged, to the best of his opportunity, everything that was artistic in his son's temperament. No time had in fact been lost by Jean-François in the

little farm in the valley by the seashore. It was as if each member of the Millet household had some premonition of the great future of the boy who was growing up in their midst, and each one, like the fairy god-parents, brought some gift or knowledge that was to be of special use to him hereafter. The strong religious belief that was at the bottom of so much of his art, and that influenced his entire career, was due more particularly to the teaching of his grandmother, in whose hands rested not a little of the child's early training. Francis of Assisi was her patron saint, and after this saint the boy was named, and together with the name the boy seems to have been endowed with at least some of the attributes of the great lover of all things created by God. The saint's great love of the sky, and the flowers, and the fields was Millet's; so was his great understanding of the birds and the beasts—of all the little helpless beings that look to man for safety and assistance. Saint Francis's sympathy with all his fellow-creatures was shared also to a great extent by Millet—was it not indeed the very soul of his art?—and that comprehension of pain and suffering; of their necessity in this world; of their place in the development of the soul, the essence of all the teaching of Saint Francis, did not Millet also teach the same gospel? His life was one long propagation of it; hardly one of his later works but has this same teaching for its particular message.

There are those who of course will say if Millet was gifted to some extent with the wide sympathies that were a part of the holy man of Assisi, he, at any rate, had none

of that joyousness of manner which was so characteristic of Saint Francis. If we are to trust implicitly in some of the descriptions of the great painter, certainly he had not; and it was his sterner moods that Millet loved best to have recorded, and of which he himself liked best to write. Of a certain photograph of the artist—a well-known photograph, a portrait that was obviously taken when the artist was very conscious of what was going on—Sensier said to him: "You look like a leader of peasants who is about to be shot." And Sensier further records that his remark on the picture was very well received by Millet. But for all this there is evidence that his attitude of mind was not habitually a grave one; and we have evidence that Millet could not only be genial, but was a lover of laughter; no matter into what abysmal depths his moods occasionally led him. Millet was the father of nine children. Was a man who cared to collect so many young people about him likely to be given over entirely to sorrow? It is scarcely possible. And that he was fond of his children we know. His letters to Sensier tell of his concern about this infant or that, which happened to be passing through some crisis incidental to childhood; and both Mr. Edward Wheelwright and Mr. Wyatt Eaton, his pupils and friends, tell us that every evening he played with his children; an habitually stern man does not play with his children, because they will not play with him.

That Millet was a good playfellow we can have no doubt. No one who understood children as he did could have been otherwise; no one with the gift of drawing

children in so many playful attitudes can have been but a sympathizer with them, and a partaker in their gayer moods. For this love of children, and this understanding of them, he must have owed not a little to his grandmother, to Louise Jumelin, who made his own childhood a precious memory, to the woman who used to awaken him from his sleep with these sweet words—words which must have acted as a charm to him through the whole day, aye, through his whole life-time: "Wake up, my little François, you don't know how long the birds have been singing the glory of God." One who could arouse her little charge with a greeting so gentle had certainly a claim to name him after the saint who, in a somewhat similar manner, began his well-known address to a great company of birds: "My little sisters, the birds, much bounden are ye unto God, your Creator, and alway in every place ought ye to praise Him, for that He hath given you liberty to fly about everywhere, and hath also given you double and triple raiment."

When Jean-François grew beyond the care of his grandmother there were at hand those who were well qualified to further his progress in life. Of his father we have already made mention. To his knowledge of music —he taught the parish choir of Gruchy—this gentle peasant possessed certain vague yearnings towards the graphic arts, which his son makes manifest to us by the remembrance of such remarks as these: "Look at that tree—how large and beautiful! It is beautiful as a flower." And on another occasion, this time an observation that might have come almost from the artist himself: "See

that house half buried by the field is good : it seems to me that it ought to be drawn that way."

But by the side of Jean-François moved a figure that had perhaps as much effect upon his early boyhood as this excellent parent. This was Charles Millet, his great-uncle, and a priest, who divided his time in labouring upon the farm and in attending to his little nephews and nieces, or in giving instruction to the children of the neighbourhood. A picturesque person is this uncle of Millet's, strong in body and strong in mind; sometimes he is presented to us, in Jean-François' letters, as a Herculean person, engaged in building up a wall of stones which four ordinary men could scarcely lift; at another time he is presented to us in cassock and surplice performing mass before some naughty little boys, with Jean-François Millet among their number. But at all times this priest impressed upon his great-nephew the necessity of being industrious, upright and courageous; and from him proceeded the foundation of that education—an education which was developed afterwards by the Abbé Herpent and the Abbé Lebrisseux, two curés of Gruchy—an education that sent Millet more suitably equipped for the task that lay before him than has been possibly any artist whose name has been written large in history.

Happy was Millet in his instructors, happy were his instructors in their pupil. Millet had no yearning after trivial knowledge; while his instructors might have had but one desire, which was to impart to him just the teaching that was most suitable to a boy who was to become a great painter of outdoor subjects. Latin he

learnt, and he was soon able to translate the Bucolics and the Georgics with so much facility that it was possible for him to recognize their true poetry. We are told that Virgil's words, " It is the hour when the great shadows descend upon the plain," first revealed to the boy the beauty of his own surroundings, and first lit that fire which was to be productive of some of the finest renderings of evening scenes that the world is likely ever to possess.

Nor did Millet's education proceed only while he remained in the hands of his far-seeing instructors. At home he read not only the books he had been taught to read, including the Bible and Virgil, but he devoured eagerly all the literature that was in the family library. And what a library it was! To one cognizant with the reading of an English farmer, wealthy or not wealthy, its list of books seems almost incredible. The lives of the saints he found there, and the Confessions of Saint Augustine, St. Francis of Salles, St. Jerome, and the religious philosophers of Port Royal, and Bossuet and Fénelon. As to his Bible and Virgil, he read and re-read them, and always in Latin, and Sensier says that, "I have never seen a more eloquent translator of these two books." Instead of being an illiterate person, indeed, when he went to Paris, Millet—"the Wild Man of the Woods," as he was called by Delaroche's pupils, among whom he found himself—was already a really cultivated man. His education had been far better than if he had been an ordinary member of a bourgeois, or even of a noble family. Its great characteristics were its

thoroughness, its simplicity and refinement, the very characteristics that make his own works lovable.

At all opportunities, when his work permitted him, Jean-François employed his time in reading. At Cherbourg, where Millet first became the pupil of a matured artist, although he never became the pupil of any artist except in name, we find Millet absorbed in divers sorts of literature. "He read everything," said Sensier, "from the Almanach Boiteux of Strasbourg to Paul de Kock, from Homer to Béranger: he also read with delight Shakespeare, Sir Walter Scott, Byron, Cooper, Goethe's 'Faust,' and the German Ballads." He loved the prose of Victor Hugo; we are told its strong rhythm won him completely; and he was deeply impressed by the great writer's descriptions of the sea, which must again and again have found their echo among his own recollection of his seaside home at La Hague. The books of Walter Scott, it is said, he read again a little later in life, and then he found that the novels of the wizard of the north, except "Red Gauntlet," had for him lost all their savour.

When he went to Paris he turned his attention more to the literature of art. After he left Delaroche's studio he frequently visited the library of Ste. Geneviève, where he studied the works of Leonardo da Vinci, Jean Cousin, and Michael Angelo, the artists in fact who could afford him just the information that he required. But we find him of course most drawn towards anything that referred to Michael Angelo; be it book, or manuscript, every record of the master he studied with avidity.

JEAN-FRANÇOIS MILLET

Fortunate indeed was Millet in his birth, and his bringing up. His parents passed on to him no bourgeois instincts to fight against; no vulgar desires to crop up like weeds again and again in the garden of his mind. The outlook on things in general that he inherited was the outlook of a peasant, simple and dignified, and without any suggestion whatever of unworthy ambitions. Upon this strong basis he was able to nurse the plant of his genius with a surety of success, without fear of any foul growths: from the very outset, in fact, Millet seems to have conducted his career with the full confidence of a man who was building his house upon a rock. This certainty of himself was evident in his dealings with his masters, and evident in his dealings with his fellow-students. It led him sometimes into acts of discourtesy; but these acts occurred mostly in the early part of his life, when an understanding of his fellow-creatures was naturally wanting in him. The pride in himself, of which he at no time failed to be deeply conscious, he announced perhaps too publicly in his youth. But one can understand how it was he became then often mastered by a knowledge of his superiority over those who surrounded him. He knew that he came of a stock that had supported itself without any suspicion of false trading, by taking no advantage of a neighbour's weakness, or failure, or by any of the different opportunities that are sought by the followers of any commercial career. His ancestors he knew had won their bread by wrestling with the elements, as Adam and Eve had done, and were beholden to no man for it; and he knew that

he profited by the simple, just lives of those from whose house he had come. He could review all the mental portraits that he possessed of the little party that had domiciled at Gruchy and find no characteristic that he would have wished away, or even preferred to have been blurred. Millet, too, must have been conscious of the superiority of his own education to that of those with whom he was brought in contact. The wearisome studio slang, the tedious jokes of the illiterate students at Delaroche's studio, we are told, were irksome to him. "The Wild Man of the Woods" had read too deeply for his fellow-pupils; what was very humorous to them was without any sparkle to his more cultivated mind.

About his tastes in art we know too that he at no time had any doubts. They were stated distinctly in two drawings that he took with him to Cherbourg, where his father first sought for him a master; and the pictures that he left unfinished, when he died, were conceived on the same lines as those drawings, only they showed a more developed mind, and a more masterly hand. Millet knew that he had within him a force that would in days to come give rise to a Gospel among all lovers of art, and that to the end of his life must be a source of indescribable joy to himself, and there is no wonder that he went about with his head too much in the air; that he, when he first arrived in Paris, made scarcely any friends; that he preferred to wander about picture galleries, to look there at the pictures by ancient masters, with something in them akin to his own thought, and to brood over the satisfaction that was within him.

JEAN-FRANÇOIS MILLET

Deep indeed must have been the satisfaction that Millet always felt within him, and it is for want of an understanding of that inward satisfaction that many have quite unnecessarily, I think, dubbed Millet a martyr. There was no period of his existence at which the artist was not leading his own life. There are those who will point to his return from Cherbourg to the family farm, after the death of Millet *père*, and to the painting of the Boucher *pastiches*, and ask if Millet preferred to do these things. With regard to the return to the farm; undoubtedly the act brought with it a certain compensation. Millet was very fond of the Gruchy home; but that fondness, of course, would hardly have taken him away from the practice of his beloved art. It is possible a far more potent influence kept him at Gruchy during that time. Like his namesake, St. Francis, he was not averse to suffering for any object that appealed to his imagination. That his capacity for suffering was as boundless as that of St. Francis, or his ecstacy during the period of endurance so sublime, I do not pretend, but that Millet loved to crucify himself is evident again and again in the course of his career, but especially at the beginning of it. Half the difficulties that beset Millet after his arrival in Paris were of his own making; and some things that he did are entirely mysterious to one without a key to the painter's soul. That key is to be found, I think, in the artist's ecstatic reverence for suffering; in his perpetual reference to it in his letters; in his continual delineation of it in his own pictures. The intense fascination that the idea of a tormented

being had for him is conveyed in a description that he wrote of a drawing by Michael Angelo: "But when I saw the drawing of Michel-Angelo which represented a fainting man, it was another thing. The expression of the slackened muscles, the flat surfaces, the lines of this figure all relaxed by physical suffering, affected me. I felt as I if was tormented with him."

There was about Millet undoubtedly the making of a martyr, and there is no knowing to what extent this germ might have been developed had not Millet been surrounded by influences which bound him to life and to accomplish the life's work that had been appointed for him. Each one of these influences is a pleasant matter to dwell upon. No sooner had he left the pleasant haven of his home where all had been ordered for his future well-being, with an almost scientific exactitude, no sooner had he thrown himself upon the broad world of Paris, than there came to him an excellent substitute for the tender care which had surrounded him at Gruchy. Men and women certainly he held aloof from, because those that he at first encountered were not to his liking, but art was waiting for him like a fostering mother, and for a while every need of his was satisfied, as he wandered about amazed and delighted in the beautiful worlds that had been opened out to him by art's chosen apostles.

In time, when the desire and power to create came upon him, came also such sympathizers in his efforts as he most needed. Around Millet there appears always to have been a crowd of friends, ministering to him according to their own capabilities, attending to one or other

of his wants; some of them remained about him until death put an end to their office. In Paris we find Diaz using all his eloquence, and he was a vehement talker, on Millet's behalf; while Charles Jacque, Dupré, and Barye, and a host of others brought to him friendship, and what to an artist is more necessary than friendship, a sympathy with, if not a complete understanding of the objects of his art.

Many hardships had Millet to endure in Paris, but never had he to endure these alone. Always we read of men flitting in and out of his studio, bringing to him consolation and comradeship, if they could not bring to him money; bringing to him encouragement and understanding of his art if they could not find for him a fresh buyer. Nor did Millet have to go far through life before he found a woman ready to share his fate—a girl of Cherbourg, a Mlle. Pauline-Virginie Ono married the painter when he was twenty-seven years of age. Certainly this marriage was not entirely a fortunate one, but ill-health rather than discord was the cause of their unhappiness. Madame Millet was a delicate woman at all times, and was utterly unfitted to live the simple life that Millet was often obliged, but at all times, in accordance with his peasant upbringing, preferred to live. Soon after his wife's death, which happened within four years of his marriage, Millet was fortunate enough to find another woman ready to take her place. Of this second Madame Millet we get no very vivid portrait from any biographer of the painter. Sensier tells us how Millet discovered that she "loved him secretly," and he married her. Of

her part in Millet's life as an artist we know little. Edward Wheelwright tells us that she was "a quiet, reserved woman," and that Millet would often pat her on the back and address her as "my old woman." We may gather from this that he regarded her with content, that whatever part he had intended her to fulfil in his life that she had fulfilled. We know that Millet must have been fond of children, and she bore him nine. We know that Millet had a keen interest in all sorts of domesticities—hence the subjects of many of his pictures—and she must have been one of the most domestic of women. It is scarcely likely that one who had had the bringing up of a French peasant would feel aggrieved if his wife did not prove to be for him an intellectual companion. That she did, however, take an important part in his artistic career on one occasion we do know. It was to his wife that Millet appealed when it was revealed to him in what light his painting of the nude was regarded by the general public, and without her consent he might never have become Millet, the painter of the country, Millet, the painter of peasant life. How many artists must have read this story of Madame Millet's fidelity with wonder. How many men must have wished that to them also had been granted such numerous and devoted friends. No! Millet's life was not all a gloomy one. It had its dark passages as well as its sunlit ones. But so have all lives.

Taking the bad with the good there still remains a good deal about Millet's life that must fill many a fairly contented man with envy. Above all, it is impossible to pass over his capacity for suffering and his knowledge

of its worth. "I don't want to stop pain," he wrote to Sensier, "or find a formula which will make me indifferent or a Stoic. Pain is, perhaps, that which makes an artist express himself most distinctly."

With regard to the Boucher *pastiches*, may it not be that a little too much has been made of their levity and the antipathy that the artist must have experienced in their undertaking? Those that I have seen certainly were conceived in an antique spirit—there was a great gulf between them and anything done by Boucher—and could Millet himself have been so shocked by the remarks that he heard before one of his own pictures—on the occasion when he decided to abandon the painting of the nude—if he had ever painted anything with a lewd intention? Millet could never have contemplated the prospect of continually painting "Boucher *pastiches*," as he himself called them; but could he not have undertaken them every bit as much with the desire of forwarding his own artistic advancement, as with the hope of making money? About the time of their production he was groping here and there for methods of expression; and just as certain well-known writers have learnt to write by assuming the style now of one master, now of another, so Millet, before his own style was arrived at, was known to make somewhat similar experiments. The most frivolous part of the Boucher *pastiches* was undoubtedly their titles—which were provided by his faithful friend, Marolle, who also helped Millet to dispose of these pictures—and that Millet himself gained artistically while making these *pastiches* he himself admits; he gained in certainty of touch, and

made a further escape from the leaden hues which he had been too prone to repeat in some of his earlier work.

During the whole of the time of his stay in Paris, Millet must have been seeking for his *métier*, and to have been searching for a method of uttering his thoughts in paint. For the most part he chose during that time just the sort of subjects that were most suitable to his studies; the sort of motives that bound him down by none of the tiresome chains of necessary realism.

The knowledge that he had obtained all that, for him, was obtainable from those studies, quite as much as the idle words of the loiterers before the picture in the shop window, might have made him realize that the time had come to search farther afield for motives which he could treat with a fresh individuality. It is futile to think that Millet could have concerned himself in making this new venture only by the chance utterances of two or three men in the street, when he himself was perfectly capable of gauging the sentiment that these pictures, spoken of so lightly, were able to inspire in the minds of any true lover of art, which he must have known was just the sentiment that had inspired him while producing the pictures. While searching about then for fresh fields for artistic adventures it occurred to him to make use of what was almost his birthright—a complete understanding of all that pertained to peasant life; all that he had an inborn sympathy with; all that he knew by hard experience and constant observation.

The renunciation of the painting of the nude had its commercial disadvantages, which must have added not

a little zest to the idea of his proposed return to country life, and we can understand that when Millet referred in his speech to his wife to the suffering that his search for new subjects must bring to him, there was in his heart a glow which to some people may seem fantastic, but which for all that had nothing about it that was not entirely noble.

At Barbizon we find Millet in raptures over his environment; over his peasant's cottage—he was inclined to be angry with a certain journalist who, many years afterwards, called it a "villa"—and with his barn-like studio. Sensier writes "such a studio!" and dwells coldly upon the limitations of the artist's little house. But many of us have discovered retreats, dear enough to our hearts, which have been described by our friends in terms quite as cold as those applied by Sensier to Millet's little studio and home at Barbizon; but such friends had little real converse with our inner selves, and had measured our joys by what pleased them, not by what pleased us; our sufferings, by what troubled them, and not by what was likely to trouble us; and one often wonders whether Sensier, although he must have said to Millet many things that were comforting about his art, ever came within a measurable distance of comprehending the various parts that went to make up Millet the man.

To Jean-François Millet much of his life at Barbizon must have been almost ideal. It would be futile of course to pass over the rejections at the Salon, the hard intervals while he battled with creditors, the times when he was a victim to sickness. It would be futile also to pass over

the daily raptures that must have been his as he saw enacted before him nature's daily poem—the coming and going of the daylight, the waxing and waning of the moon, the play of starlight in the heavens—as he saw the life that was going on about him; the life in the fields, the life in the forest; as he watched the movements of the woodmen, of the farm-labourers, of the shepherds and the harvesters, and the men digging in the fields; when he recognized what all these sights meant to him not only as subjects of so many pictures, the painting of which he, in all his life, might never even hope to entirely accomplish, but also as food for the very sort of contemplation that his soul was most in need of. These sights he was familiar with from his childhood; but before he had watched from afar off, although he himself had taken part in much of the field-labourer's toil; his stay, however, in Paris had enriched his mind, and he returned to the country, to Barbizon, to find that nature was now ready to provide him with a new sort of intimacy, that she was ready to converse with him, to take him to her arms as a friend.

This solemn converse with nature must have made for Millet an inner life that nothing ever really interfered with, not even debts, or prosperity, the vagaries of juries, or the weight of sickness. Nothing, even according to Sensier, ever appears to have interfered with the course of his production—of paintings, drawings, pastels, each one indicative of some beautiful vision that had haunted him, of some aspect of nature that he had hitherto not sufficiently recorded, of some incident in the lives of the

SHEPHERDESS

[*Victoria and Albert Museum (Constantine Ionides Collection)*]

beings who lived on such intimate relations with nature, and whose temperament he knew so well, whose sufferings and deprivations he wished his more enlightened fellow-creatures to understand. Nothing interfered with this continued stream of masterpieces, of which each one might almost be considered as a fragment from Millet's dream-life, until Death notified to Millet that he could lay aside his brush and pencil without fear or regret, and with head upraised enter the Valhalla of the Great.

Now and again Millet admits us into this dream-life, not by pictures, but through another medium that he could employ almost as vividly as he could handle paint—by words. To Sensier he writes: "Do you hear the witches' sabbath over there at the end of Bas-Bréau—the cries of strangling children, and the laugh of the convicts? Yet it is nothing but the song of night-birds, and the last cry of the crows. Everything frightens when night, 'the unknown,' succeeds light. All legends have a source of truth, and if I had a forest to paint I would not want to remind people of emeralds, topazes, a box of jewels; but of its greennesses and its darkness which have such a power on the heart of man. See the breaking of those great rocks, thrown here by the strength of the elements, a prehistoric deluge! It must have been fearful, grinding in its jaws a generation of men, when the great waters were upon the face of the earth, and alone the Spirit of God survived the disaster. The Bible paints it in these words: 'Et Spiritus Dei superabat super aquas.' Poussin alone, perhaps, understood this 'end of the world.'"

Has any writer brought to bear upon a description of a forest scene at eventide an imagination more lucid? Here again he writes graphically of the night: "Oh, how I wish I could make those who see my work feel the splendours and terrors of the night! One ought to be able to make people hear the songs, the silences, and murmurings of the air. They should feel the Infinite. Is there not something terrible in thinking of these lights which rise and disappear, century after century, without varying? They light both the joys and sorrows of men, and when our world goes to pieces the beneficent sun will watch without pity the universal desolation." A note so solemn is struck in both these extracts that some readers may well ask if such a writer could at any time be joyful? Indeed he could. Although one aspect of nature called more particularly to Millet for description and pictorial treatment, although he felt the necessity of picturing one side of life more than others, and whatever there was that was divine about the peasant was revealed to him more particularly when the labourer was at his hardest toil, yet Millet's mind was, like most delicately tuned minds, like a beautifully strung Aeolian harp, which, because it responded to the music of one breath of wind, must of necessity also respond to a breath that came from another direction. It was denied to him to be boisterous, but boisterous natures are in accord with nothing that is beautiful; yet in many of Millet's pictures a gentle gaiety, a gentle satisfaction with things, is distinctly evident. What a pretty delight with the tenderer side of life one sees in some of his pictures of mothers and child-

JEAN-FRANÇOIS MILLET

ren. How gay and childish and unconscious are his children, how full of solicitude and pride are his mothers; and than "The First Steps," the picture of a kneeling man with his arms outstretched, waiting for a tottering infant whom a young mother is about to launch on its perilous career, there is in all art no sweeter rendering of a domestic scene; its quiet joyousness gives one very much the same experience as a group of spring flowers.

That gentle satisfaction with life could dominate the painter we know by many a picture. More particularly are we told of it by many of his studies of shepherdesses, those of them that are bathed in golden sunshine, that present to us always a slim girl, intensely virginal in aspect, sometimes knitting, sometimes wrapt in thought, but always surrounded, she and her sheep, whether they are by the roadside, in the harvest-fields, or by the borders of a forest, by an atmosphere of brooding peace. In his rendering of trees, in his drawing of the stems and their leaves, and the irregularities of their bark, we see this same satisfaction with things, this same capacity for surrendering himself absolutely to the less heroic aspects of nature. Millet himself wrote: "Some slander me by saying that I do not sufficiently appreciate the charms of the country. I find there much more than charms—I find countless splendours. With my critic I see and admire the little flowers of the field of which Christ said, *I say unto you that even Solomon, in all his glory, was not arrayed like one of these.* I see beauty in the haloes of the dandelions, but also the sun which spreads out beyond the world its glory of clouds." And,

indeed, Millet did not only see, but expressed these things, and expressed them with a knowledge of their form and sentiment, which is quite remarkable. Who, knowing the painter's celebrated picture of a shepherdess and her sheep in a harvest field, has not noted the artist's playfully earnest insistence of the dandelion heads that are dotted over the foreground; all so accurately modelled, so justly illuminated, so sympathetically described? Another example will be discovered in the beautiful pastel " Spring Flowers." Here are daffodils set in clumps at the foot of some birch stems; they are drawn broadly enough, too much so, perhaps, for those who are accustomed to more commonplace drawings of flowers. But I know that when daffodils are not in bloom, and I want to see a presentment of daffodils—for daffodils bring always pleasant thoughts—it is to a reproduction of this pastel that I would go rather than to any picture of these flowers that I have ever seen, because if the picture does not show one all the form it shows one the spirit of the daffodil.

Those who would paint Millet's life as one long martyrdom, can surely have tasted none of the pleasures that were Millet's in plenty. They can have tasted none of the pleasures of an absolute self-surrender in the presence of nature, and of the revelations that follow such a surrender. They can know nothing of the secret pleasures of nursing such revelations in the mind until they take some form suitable for pictorial treatment; they know nothing of the pride that belongs to the recipient of some new conception—of some new message that appears to

By permission of M. Durand-Ruel]

have come almost from the heavens. They know nothing of the excitement of composition, and the joys and fears that follow the further development of the picture—those joys, those glimmering promises of a successful realization of the dream; those fears! those fears, that no true artist would ever feel happy if he were entirely without.

Millet in town calls constantly for one's sympathy, which Millet in the country does but very seldom. In town, his career as an artist was a troubled one, he was searching and often finding splendid metal mixed among the ore, but what was to be his real life's work had not been revealed to him. In the country it had, and he could hardly look out of the windows of his house at Barbizon without receiving some fresh clear call to work; he could not go out for a walk without finding motives for pictures, and all of them touched with a spirit that was his to capture; but only his to capture—and that was the blessed part of it all—after a hard and prolonged struggle.

Of Millet's more material life in the country we get pleasant glimpses. Like many artists who have been called by their work from the town, he spent some of his day, not in maintaining his family with the brush and the pencil, but with the spade, and the rake, and the hoe. We are told that he worked in his garden until midday. An artist once said to me: "The most satisfactory part of my day's work is that which I spend in my garden." My friend's conceptions were very much in front of his realizations, and I understood well what he meant. Millet's accomplishments can never have fallen very far short of what he intended to do, so that although in his

case the time spent in his garden, which M. Piédagnel tells us was such a delightful disorder of trees and flowers and vegetables—how pleasantly the vision of Millet's garden floats before the brain—was not the most satisfactory part of his day's work; yet we are certain that those hours, occupied in half-unconscious rumination over artistic problems, while his hands and the more conscious part of his brain were engaged in work, that was in itself not unsuggestive, must have been to the painter of incalculable value. The picture of Millet with a hoe in his hand attending to his cabbages, or busy with the necessities of his hens in the chicken-yard, accompanied all the while by, perhaps, half a dozen young Millets, fits ill into the gallery of portraits of the martyred Millet; for such outdoor occupations, if they do not bring inspiration to everybody, very seldom fail to bring with them contentment. An atmosphere of contentment envelops too a picture by M. Burty of the Millet family sitting at dinner. Here again we find Millet living the life absolutely of a peasant, but who can say that he hankered after any other sort of existence? As a peasant he had been brought up; while living the life of a peasant he felt himself more in touch with the sentiment of his pictures, and if he was drawn into any other form of life, he felt himself by no means at his ease. This is what he tells Sensier of a dinner in Paris with Corot and some other friends: "I must confess that I was more embarrassed than delighted with this kind of dinner, and more than once watched those who were served before me out of the corners of my eyes to see what they did with their food."

JEAN-FRANÇOIS MILLET

M. Burty's description of the Millet family at dinner presents to us the great painter very much more at his ease: "Millet," writes M. Burty, "with his deep chest and grave head presiding at the long table which had no cloth, and around which half a dozen children passed up their earthen plates to the smoking tureen. Madame Millet would be trying to put a child to sleep on her lap. There would be great pauses of silence, in which no sound was heard but the purring of cats curled up before the stove."

Yet another extract, this time from a letter to Sensier, presents Millet to us not so much as a painter who loved trees, but as a gardener again, and a gardener who loved trees. "Verdier has brought some thorns for you, some hornbeams, beeches, seedlings, beam-trees; also some elms all twisted of the right kind. We will plant them when you come." These trees were evidently destined to join a plantation belonging to Sensier that stood at the end of Millet's orchard. "They all," Millet proceeds, "have shining trunks and look like healthy fellows. Laurel? I am not so modest as to dislike laurel. Bring all you wish; but if the choice depends on you, let one, at least, be the kind that becomes a tree. I always think of one I knew all my life in the garden at home which will always be to me the type of laurel. The trunk was as thick as a man's body, the leaves rather dull than shiny, and their colour a beautiful dark green; the kind of laurel of which to make wreaths for Apollo."

From these extracts we know that Millet lived his own life at Barbizon. In every particular it was a consistent

life. Compare what we know of it with the lives of many an artist—men who of necessity have lived where not one of their better emotions has had any play, where no living person, with any comprehension of their mental possessions, has been within sight or sound; men, who from the beginning almost until the very end of their days, have done all but the work that they in their souls have yearned to do. Theirs has been real martyrdom. But Millet's! He did the work that he loved; he was never for any interval stopped from doing it by any necessity; he lived where his particular sort of art had every inspiration that it required; and the inspirations to Millet's art —nature's ever-changing display of drama or of beauty— to the man who understood them, what could have brought a more perpetual diversion? Millet was never pushed into any false position by his own acts, or by compulsion: he had to live in no social position that was foreign to him. He was born a peasant, and he lived, in a way, the life of a peasant; and he had the responsibilities of a peasant. He had a wife who cried neither for silk dresses nor fine hats; but who was content and perfectly happy in the position that he gave her. He had children innumerable; and what was patriarchal in his heart had all the food that it craved for. These children seem to have been content to live as peasant children; they besought Millet neither for money for their amusement, nor to receive any other sort of education than was received by the rest of the Barbizon children. Of friends Millet always had a number; a fact that may lessen one's pity for Millet, but in no way lessens one's respect for him. There

By permission of M. Durand-Ruel]

DEAD BIRCH-TREE, FONTAINEBLEAU

is no greater testimony to the sweetness of Millet's temperament than the manner in which he attracted all sorts of men. Of Millet's friendships alone a book almost might be written. Sensier has written one of his own friendship with Millet. But how one would like to know more of his intercourse with Rousseau and Diaz, with Barye and Jacque, and a host of others who have left behind them records of their individuality.

Not only had Millet friends among his countrymen, some of them watching over him with the solicitude almost of a nurse watching over a child, but not long after he had become well established at Barbizon there came to the village a number of Americans, artists, in order to become better acquainted with Millet, and better acquainted with his work. These men not only studied Millet and his pictures, but they bought Millet's pictures. They brought consolation to Millet, and encouragement, and one or two of them brought friendship. They preached the gospel of Millet with an energy that is characteristic of their race; and as the result of their early divination of his genius, and their fine championship, some of the best pictures by Millet are not to be found in France, or in Europe at all, but in America. Appreciated as Millet's art now is all over the world, it is undoubtedly in America and in England that the most enthusiastic admirers of the peasant-painter's art are still to be found. And for an explanation of this I do not think there is any reason to seek very far. Both English and Americans are lovers of outdoor life and outdoor effects. They have studied nature, and nature has rewarded them by making them

conscious of at least some of her poetry. Hence a great deal of the work of the 1830 school brought to them not half the mystery that it conveyed to other people. The 1830 landscapists were inspired by nature, and the people of England and America recognized the truth of their paintings with little difficulty. Between the people who labour in the fields and those who obtain their bread in other ways, or who inherit wealth, there is not in this country that great gulf which exists in France; at any rate English people are for the most part perfectly cognizant with the lives of the people of the fields: they know all about their home lives; they know, too, many facts connected with the peasant's occupations. So the pictures by Millet, which to the French public seemed fraught with mystery or a political significance, to the English people appeared to be but true and intensely realistic renderings of subjects which they loved, partly because they were so absolutely familiar with them.

Of all Millet's friendships not one has given rise to so much discussion as his connection with M. Alfred Sensier. "It would be well," writes Mr. Frederick Keppel in his admirable note on the Millet etchings, which was included in the "Studio," Winter Number of 1903, "it would be well if an historical circumstance connected with Millet could be set right. After the Master's death in 1875 his friend and biographer, Alfred Sensier, sold at public auction his collection of Millet's works at immense profit on the prices which he had paid for them. Hence arose the story that he had unmercifully exploited Millet, taking advantage of the artist's necessi-

JEAN-FRANÇOIS MILLET

ties." Whether Sensier unmercifully exploited Millet or did not is a problem that cannot, I should think, be ever solved since it appears that Mr. Keppel has already been to the very fountain head for information, and come away not entirely satisfied. But what he is able to tell us definitely is very reassuring. If Sensier's assistance was not so entirely disinterested as we would like to think, Millet believed in him wholly. M. Charles Millet, the Paris architect, frankly states that his father always gratefully recognized the sympathy and the aid of Alfred Sensier; and his elder sister, Madame Saignier, who was a grown-up woman before her father's death, declares Millet taught his children to love and esteem Alfred Sensier "next after le bon Dieu." That he rendered great assistance to Millet there can be no doubt, however amply he was afterwards repaid for that assistance. He at all events relieved Millet of the necessity of hawking his pictures about from shop to shop; a necessity that to a man of Millet's temperament would have been intolerable; one that would have interfered enormously with his life in the country, and with the amount of uninterrupted absorption that he found necessary for the full development of his various works. Without Sensier's help, Millet undoubtedly would not have been able to have painted as much, and without him he would undoubtedly have been more often in uncomfortable circumstances. Yet, to the reader of Sensier's book on the Master, the biographer is often somewhat of a puzzle. One wonders whether he was entirely sincere in his accentuation of the gloom of the painter's life, or whether

he dwelt on it merely from a want of comprehension of the artist and his necessities. For to Millet, a man who lived the life that he liked best, who painted just what he liked best; who was surrounded by country which was never-ending joy to him, and friends who were ready to make any sacrifice for him; whose wife was never wanting in fidelity and sympathy; who loved children and had nine of them; who loved admiration and received it to the very full before his death—we can grant but grudgingly the martyr's crown. Millet himself was fascinated by the idea of suffering; one can scarcely read any of his letters to Sensier without feeling that; he knew that it was noble to suffer, and he did suffer; but, notwithstanding, the good things of this world crept into his life, whether he would have them or not, just as they creep somehow or other into the lives of everyone of us.

That Millet had hard times we are all aware; but so has every innovator; so has every artist who determines to paint not for the public, but according to his own artistic beliefs. That he was so constantly in financial difficulties as M. Sensier would have us believe we are sometimes inclined to question. We know that at times Millet received large sums of money, and that his manner of living was of the simplest. In one part of his book Sensier is insisting on the painter's penuriousness, and yet at the same time he tells us that the painter has a plan for buying a house. He publishes a letter from Millet, written soon after Delacroix's death, and at the time of the sale of Delacroix's paintings and drawings,

in which Millet says: "Could I like Lazarus pick up a few of the crumbs under the table of your banquet at the Delacroix sale." Of these crumbs it appears that Millet picked up fifty—fifty sketches by Delacroix were purchased by him. In another part of Sensier's book we read of an amusing rivalry that existed between Millet and Rousseau in the matter of collecting curios and pictures from Japan. No! Millet lived not a long life, but a full life, and every experience that he hankered after came to him. He suffered, but nearly everybody who is at all venturesome does suffer. And we know that Millet, like St. Francis, often went forth to meet his suffering.

In some poem of his, Matthew Arnold wrote:

"Resolve to be thyself: and know that he
Who finds himself loses his misery."

Millet found himself at the beginning of his life, and we may be sure that his misery was seldom quite what the world understands as misery.

CHAPTER I

EARLY DAYS

JEAN-FRANÇOIS MILLET was born at Gruchy, a little hamlet situated in a valley opening on to the seashore near the Cape de la Hague, the western boundary of the harbour of Cherbourg. Gruchy belongs to the parish of Gréville, and is from Cherbourg distant about ten miles.

The country around Gruchy may perhaps be likened to the more wooded parts of Cornwall. It includes downs and moorland, and valleys where there is good pasturage for cows, and shelter, too, for apple orchards and other tree plantations. The coast near Gruchy has a sinister reputation; and very grim it looks with its foam-fringed rocks of black granite stretching far out into the sea; and all the trees, the oaks and the elms, that grow in the uplands are twisted into fantastic forms, so that at no time can the dwellers or visitors at Gruchy be unmindful of what winds and tempests are frequent visitors to the spot.

The Millets occupied a small house of rough stone, from which could be seen the seashore and the fields belonging to the family farm. From these fields bread could have at no time been won easily, yet the picture that has been handed down to us of the early life of Millet is very free from any sordid details.

The elder members of this family consisted of Jean-Louis-Nicolas Millet, the painter's father, a man of sweet disposition and of some accomplishments; Aimée-Henriette-Adélaide Henry, the mother of Jean-François; and Louise Jumelin, his father's mother, who, while her daughter-in-law was working in the fields, attended to the cares of the house, and to the bringing up of the younger children.

Besides these three elders, of whom Jean-François ever preserved the most affectionate remembrance, there was yet another very notable member of the family circle. This was the Abbé Charles Millet, a priest of the diocese of Avranche, and Jean-François' great uncle. Having refused allegiance to the Constitution during the Reign of Terror, this person came to his brother's house for shelter, and in Jean-François' younger days he was still with the family at Gruchy, still an occupant of the little room over the great stone well, although the need for his hiding was long past. Jean-Louis Millet learnt to read from him, and so did Jean-François and his little brothers and sisters. During his latter years the Abbé appears also to have acted as parish priest, and as a labourer on his nephew's farm. He seldom cast aside his priestly garments, but was always ready to tuck his *soutane* into his belt and lay his hands to the plough, or to assist in any work that was proceeding for the welfare of the family.

In all Millet's remembrances of his early childhood this picturesque figure played an important part; for over Jean-François, as well as over the other members

of the household, the Abbé Charles appears to have watched with uncommon love and solicitude.

But more influential than the Abbé Charles; more influential, indeed, as a guardian of the child Jean-François than the boy's father and mother, was his grandmother, Louise Jumelin. "Her family, of the old race of the country," according to Sensier, "had strong heads and warm hearts." Her part in Jean-François' ancestry, and bringing up, was shown in his strong religious belief, without which many of his pictures would never have been produced for lack of inspiration, and in his courage, which was manifested by his unfailing belief in his own principles, and by his ultimate triumph over every obstacle that beset his way to victory. The few letters of the Widow Jumelin which have been handed down to us are strangely interesting. We see in them the same courageous attitude which characterized Jean-François, and not a little of that clarity and picturesqueness of utterance which lead one to believe that, had Millet been so minded, he could well have secured for himself as a writer a position almost as important as that to which he attained as a painter.

Madame Millet, the mother of Jean-François, belonged to a family whose social position was slightly superior to her husband's. It seems not improbable indeed that she was of noble ancestry. Millet always carried with him recollections of his mother's description of her home —a house spacious and built of large blocks of granite, with a courtyard shaded by large trees. This woman, although she seems to have been lacking in some of the

By permission of M. Durand-Ruel]

THE SPINNING-WOMAN

finer qualities of her husband and his mother, was by no means behind them in piety and kindness of heart. She bore Jean-Louis no less than nine children, and also shared with the family all the labours of the field; so as a wife certainly she was beyond reproach. Nor did she fail as a mother, for by her children she was loved. One of them records that in spite of her hard life she never lost a certain elegance of person and manner, and that she preserved, too, a great taste for bright colours—for brightly coloured clothes and for gaily-tinted earthenware.

Jean-Louis, the father of the great painter, was a just man, and a man whose influence over his neighbours was always for the good. His musical talent was sufficient to enable him to conduct the village choir; and this he did so ably that for miles around the singing of his choristers was famous. Millet preserved some chants which had been written down by his father. These had the appearance of the work of some fourteenth-century scribe.

Among these good people Millet grew up happily and wholesomely. He tells us of a few boyish escapades, but of nothing to lead one to believe that the life in the little farmhouse at Gruchy was anything but harmonious and pleasant, although it must have been toilsome enough. His guardians taught him the love of man, as well as the love of God. Jean-Louis kept Sundays after the manner of a patriarch, offering to his friends and relations on that day, after mass, all the hospitality that was at his command; and it is recorded that beggars went to his house at any time "as if to a home."

Some engravings in the family Bible first awakened Jean-François' interest in the pictorial arts. Soon he did not content himself by merely looking at the pictures, but he began to imitate them. Then the objects outside the house attracted his attention, and while his father slept, during the midday rest, or when he was left alone in the house, Millet drew everything that he saw—the trees, the farm buildings, the cliffs, and the sea that was beyond the cliffs, and the animals that were about the farm.

But while he was making these first exercises in the art by which afterwards he so distinguished himself, Jean-François entertained no idea that there stretched before him a future which differed in any way from his present lot. In his mind he harboured no dream of becoming a great artist. His father had ploughed the land, and sowed, and afterwards reaped his harvest; and so had his grandfather, and all his forefathers before him, and Jean-François Millet was prepared to do even as they had done. But while the boy had been sketching, Jean-Louis had not always been asleep, and unaware of how his son was occupying himself. At last this was made known to Jean-François.

One day, when he was about eighteen years of age, while returning home from mass, he saw walking along the road an old man whose figure was bent and whose gait was weary. Millet noted the foreshortening of the twisted human form and its movements, and there dawned upon him for the first time some of the more fascinating possibilities of the art, which for so long had

interested him. On his arrival home he took a piece of charcoal and drew the old man from memory. When his parents returned from church, Jean-François showed this picture to them, and, according to Sensier, "his first portrait made them laugh." The picture was like the old man that it had been drawn from, and, as even highly cultivated people will do who are suddenly confronted with a striking likeness of somebody whom they know intimately, Millet's parents laughed.

But Jean-Louis at any rate was not surprised by this exhibition of his son's skill, and soon showed to what extent this predilection of the boy's had been under his consideration. A family council followed their mirth over the drawing, and soon afterwards the elder Millet addressed Jean-François.

"My poor François," he said, "I see you are troubled by the idea. I should gladly have sent you to have the trade of painting taught you, which they say is so fine, but you are the eldest boy, and I could not spare you; now that your brothers are older, I do not wish to prevent you from learning that which you are so anxious to know. We will soon go to Cherbourg and find out whether you have talent enough to earn your living by this business."

To Cherbourg they went, the father and the son, but not until three years later: and not before the younger Millet had prepared two drawings to take with him. These drawings seem to have been remarkable in several ways—remarkable as foreshadowings of the kind of art in which Millet was to make himself famous, and re-

markable because of their style and sentiment, and kinship with the work of the old masters, and being as they were but the work of a young peasant whose only familiarity with pictures had been derived from the study of a few engravings in an ancient family Bible. One of these pictures represented a man offering bread to another man on the threshold of a house. It is a night scene and the sky is besprinkled with stars. To this drawing Millet attached the motto, a well-known passage from St. Luke —by Millet it was written in Latin—"Though he will not rise and give him, because he is a friend, yet because of his importunity he will rise and give him as many as he needeth."

The second picture was more idyllic and as prophetic of the happier days of Millet's life as the other was of the times of darkness that awaited him. In this picture are set forth two shepherds, the one piping the other listening—the listening shepherd placed among a group of apple trees, while in a more open space are his sheep feeding.

These two drawings were taken by the Millets to M. Bon Dumoucel, who was more commonly known as Mouchel, an eccentric young man, according to all accounts, with a great love of animals—and having the power of conversing with some of them, even with pigs —but of no very great capacity as an artist. He had, however, an admiration for the old masters, and recognized immediately the extraordinary merit of the drawings brought to him by the two peasants. So emphatic indeed was he in his praise of Jean-François' pictures,

that the elder Millet, without any hesitation, placed his son under Mouchel's guidance.

The tuition that the younger Millet received from Mouchel did not amount to very much. It is possible that from the very first he recognized that he had nothing to teach his pupil.

"Draw what you like," he said to Jean-François, "choose anything of mine that you care to copy, follow your fancy, and certainly go to the museum."

And so Jean-François Millet began his artistic education; he being at the time of his first visit to Mouchel a little over twenty years of age.

At Cherbourg he employed himself copying engravings and drawing from casts. He also took Mouchel's advice and worked in the museum; there he copied, among other pictures, a "Magdalen" by Van der Weyden, an "Entombment" by Van Mol, and a portion of Philippe de Champagne's "Assumption." He also found time to take part in a competition inaugurated by the Town Council and secured a prize, and this success, and his constant visits to the museum, won him some favour in the eyes of the notabilities of Cherbourg.

But in November, 1835, after Millet had been away from home for about a year, his studies were brought suddenly to an end, and he was compelled to hurry back to Gruchy. The news reached him that his father was lying ill of brain-fever. Jean-Louis Millet, although he was unconscious at the time of his son's return home, recovered consciousness sufficiently to talk to François, and deplore that his life was to be taken from him

before he could witness his son's success as an artist. Some insight is given to us of the tastes and temperament of the great painter's father by a remark made by him shortly before his death. "Ah, François!" he exclaimed, "I had hoped that we might have one day seen Rome together."

After his father's death there seemed to François but one course open to him—to abandon his artistic studies altogether and remain at home, and take upon himself the conduct of the family farm.

This he accordingly did; but notwithstanding all his endeavours, he was not altogether successful with his farming, for his mind was occupied with other matters. But while he was thus striving to do his duty, there came to his grandmother and mother the intelligence that the influential people of Cherbourg, having noted the absence of the young peasant from their museum, were concerning themselves on his behalf. There is also no doubt that these two good women had both very much at heart the wishes of the dead Jean-Louis. Together they made up their minds that at all cost the young man must return to Cherbourg and the study of art. It was Louise Jumelin, the master spirit of the two women, who addressed him.

"My François," she said, "we must bow to the will of God. Your father, my Jean-Louis, said you should become a painter. Obey him, and go back to Cherbourg."

Langlois, who became Millet's master on his return to the town, was a more influential person than Mouchel;

yet he seems to have followed Mouchel's example and to have interfered very little with his pupil's studies. He too, as did also Delaroche very possibly, noted the immense artistic powers of the youth, who had come to him for advice, and may have feared to direct them.

Langlois had been a pupil of Gros, and when Millet first went to him he gave the young peasant some drawings by Gros to copy. Millet also continued his studies in the museum, where he made a large drawing, six feet wide and eight feet high, of an "Adoration of the Magi"; he also painted some portraits and made many original compositions, and he helped Langlois with his altar-pieces, painting hands and draperies for him; there are at Cherbourg, in the church of the Trinity, two large pictures, in the painting of which Millet is said to have rendered Langlois considerable assistance.

But Langlois was an observing man, and a conscientious one as well. He saw that Millet's progress was so rapid that he required more assistance than he could ever obtain in Cherbourg; and as the people of the town were interested in his pupil, he determined to appeal to them on Millet's behalf for pecuniary assistance. In a letter, very ably and discreetly worded, he addressed the Town Council of Cherbourg. He put before the councillors Millet's want of monetary resources. He wrote with emphasis of his astonishing talent, and with certainty of his great future, and of his necessity for a wider sphere "than our town, and better schools and better models than we can give him." He referred to Millet's high moral character, and he asked of the council a sum

of at least five or six hundred francs to enable Millet to begin his studies in Paris. The reply that Langlois received to this excellent letter was not altogether unworthy of the appeal. After some discussion the Council General of the Department agreed to allow Millet six hundred francs yearly; while the Town Council of Cherbourg promised to add to this sum another four hundred francs; but unfortunately Millet never received this grant at all regularly, and in time the payment of it ceased altogether.

The young artist left Cherbourg full of hope; but before starting for Paris he went to Gruchy to bid farewell to his family. By them he found that his bright anticipations were not shared to the full. Paris was to his mother and grandmother a sink of iniquity; yet they were persuaded that for his future welfare it was needful for him to go to the big city, and with prayers and with tears they prepared for his departure. But they did not only pray for him and weep over him. From their slender store of savings they brought forth whatever they could spare, and perhaps more than they could afford to part with, and Louise Jumelin sent him forth with these words: "Remember the virtues of your ancestors. Remember that at the font I promised for you that you should renounce the devil and all his works. I would rather see you dead, dear son, than a renegade, and faithless to the commands of God."

That Millet himself felt this severance from his family and was keenly alive to the helpless situation in which he left his mother and grandmother we learn from his

JEAN-FRANÇOIS MILLET

By permission of M. Durand-Ruel]

A PEASANT WOMAN

own words: "I always had my mother and grandmother on my mind," he said to Sensier, "and their need of my arm and my youth. It has always been almost like remorse to think of them, weak and ill at home, when I might have been a prop to their old age; but their hearts were so motherly that they would not have allowed me to leave my profession to help them. Besides," he would add, "youth has not the sensitiveness of manhood, and a demon pushed me towards Paris. I wanted to see all, know all that a painter can learn. My masters at Cherbourg had not spoiled me during my apprenticeship. Paris seemed to me the great centre of knowledge, and a museum of everything fine and great."

CHAPTER II

LIFE IN PARIS

AS Millet neared Paris his courage began to fail him. He was depressed by the country he passed through—the straight roads, the long line of trees, "the pasture-lands so rich and so filled with animals, that they seemed more like scenes in a theatre than reality." And Paris itself, when he arrived there at night, served only to increase his gloom. He found it black, smoky and muddy, and immersed in fog; and the narrow streets and the many vehicles that crowded the streets, made him experience the feelings almost of suffocation. He looked into a printseller's shop for some comfort, but he found none there; he saw only pictures wanting in art and decency, and Paris seemed to him lugubrious and insipid. He spent the night in a small hotel, dreaming of his mother and his grandmother, and when he awoke the next morning there was neither air enough nor light enough for the country lad in the room in which he found himself. Millet says that in time he recovered his calm and his will; yet in his heart there still lingered the complaint of Job: "Let the day perish in which I was born, and the night in which it was said, there is a man child conceived."

Truly, Millet appears to have quickly recognized that between him and the life of Paris, the ideals and the

JEAN-FRANÇOIS MILLET

philosophy of Paris, there existed a great gulf. This division was made known to him before ever he reached Paris; when he set foot in the city he knew its full extent, he felt that it was unalterable, as indeed it remained. Although nearly forty years afterwards Paris became reconciled to Millet, yet Millet never became reconciled to Paris.

Certainly, when he first arrived in the city, both by temperament and bringing up he was ill-qualified to make his way among men and women of the great world. He was undoubtedly very sensitive, and his manners were of the country, and he knew that, which made him shy and a little suspicious perhaps of the people with whom he was brought in contact; and he very probably thrust aside many offers of assistance because he could not understand the spirit in which the helping hand was held out to him.

His friends in Cherbourg had given him many letters of introduction, and of these he began to make use. His first concern was to find a more permanent lodging. One of his letters took him to M. D——, a maker of fans. M. D—— offered him a home, but under conditions that Millet found "menacing to his liberty," so the offer was refused. Finally he agreed to lodge with M. L——, who promised that Millet should live in his house without any interference whatever; but a time came when Millet must have wished that he had taken the more rigidly minded fan-maker as his host.

Through another letter he obtained an introduction to M. Georges, an expert in the Royal Museum. The

young artist showed M. Georges a drawing, possibly the large drawing that he made of "The Adoration of the Magi" before he left Cherbourg. The Professor looked at the picture with wonder and admiration. "It is very good," he said. "You must stay with me; it will be of great use to you. I can let you see the museums, introduce you to celebrated artists, and get you into the school of the Beaux-Arts, where you can compete, and where you will be sure soon to get the prize at the rate you are going."

Millet left M. Georges intending to return to him; but the more he thought about the schools, of the discipline that he would have to submit to there, of the competitions that were even less to his taste, the more it became evident to him that his education must be sought for somewhere else. Fearing that he could not make his objections to such a course of study intelligible to M. Georges, he never returned to this very kind Professor, and the drawing which Millet had left with his new acquaintance was sent back to the artist some time afterwards.

Millet now wandered about Paris with very undetermined plans for the future. He endeavoured to find the Louvre, but even that gallery became to him like a promised land, which he was only permitted to enter after many futile searches, for he felt so much a stranger among the Parisian folk that he was afraid of asking of them his way. At last he found his Palace of Delight, and once there he felt no longer alone. "The Louvre," he said, "bewitched me." For a month he found sufficient occupation in studying the old masters, and in the

end he found that Michael Angelo supplied most of his artistic needs. Rembrandt was to him somewhat of a puzzle; at first, anyhow, he found his illuminations too affected, it was not until later in life that he realized to what great ends the Dutch master ordered his superb effects of light and shade. At no time did Velasquez appeal greatly to him, he liked his painting but did not like his compositions. Murillo's portraits he admired, and the two big pictures by Ribera, the "Centaurs" and "Saint Bartholomew"; and once he spent the whole day before the "Concert Champêtre" of Giorgione. Of this picture he tried to make a copy, the only copy he ever made of any picture by an old master, or even—with one exception, which was a replica of a shepherdess made for Mr. Wheelwright—by himself. The sketch of the "Concert Champêtre," however, that he accomplished, brought him some consolation, for while making it "Giorgione," he said, "opened out a new country to him." But it was a country of which Millet also was an inheritor. The spiritual world as well as the material world in which Giorgione placed his personages is often occupied also by the people in Millet's pictures, and in a way was occupied also by Millet himself.

Rubens he liked for his strong, manly painting, and for his extraordinarily robust compositions; but, undoubtedly, the masters that told him what he really wanted to know were Michael Angelo and Nicholas Poussin. He loved Poussin's antique world; he loved the directness of his conceptions. With his colours he found no fault; even a little later, when he was in the thrall of

Correggio's elaborate and radiant tones, Poussin still continued to charm him; as the possessor of a fine style he found no equal to Poussin, unless it were Michael Angelo; but he was able to place himself on more intimate terms with the work of Poussin, while the work of the great Italian master—the master of style and emotion—affected him more as the work of a demi-god.

"Next to Michael Angelo," Millet writes, "I have always loved the early masters best, and have kept my first admiration for those subjects as simple as childhood, for those unconscious expressions, for those beings who say nothing, but feel themselves overburdened with life, who suffer patiently without cry or complaint, who endure the laws of humanity, and without even a thought of asking what it all means. These men never tried to set up a revolutionary art as they do in our days."

In this short sentence of Millet's we learn a great deal of the man; of what he tried himself to do in art, of what he tried also to do in his life.

While Millet was dreaming and working at the Louvre he was also gaining his first knowledge of woman-kind—of woman-kind as it had not been presented to him at Gruchy. The story is somewhat wrapt up in mystery, but some explanation is given to us by Sensier, who writes, "that, like Joseph, he [Millet] met at the very outset of life a Potiphar's wife." The "Potiphar's wife" in Millet's case was the wife of his host, M. L——, and, like Joseph, Millet left suddenly the house of his sojourn, leaving behind him his luggage and what little money he had.

When this excitement had gone by, and the more intense excitement of his first introduction to the Louvre, Millet began to look about him seriously for a master.

Paul Delaroche was the fashionable painter of the day, and he had also a large atelier full of pupils; to Delaroche's studio Millet went. Why, we wonder, did he not go to Eugène Delacroix, whose work he admired then as he always admired it: as he admired no other modern painting, except the work of his friend Théodore Rousseau. At Delaroche's studio he found himself in accord neither with the master nor the students. The students ridiculed him because of his country manners and appearance, and the unacademic manner of his art, while they bored him because of their meaningless talk and dreary jokes. Delaroche himself regarded him at first with distrust: he found Millet's art too revolutionary; yet he at all times seems to have been alive to his pupil's talent, and it was not at Delaroche's desire that Millet left his studio. Like Mouchel and Langlois, Delaroche avoided the responsibility of directing Millet's studies.

"Do just what you like," he said, "big things, figures, studies—I like to see your work."

But alas! Millet soon found a flaw in the proffered goodwill of Delaroche when he made known to his master his intention of competing for the Prix de Rome. Delaroche had at that time another pupil, whom he desired to support in this competition; he promised Millet, however, his assistance in the following year. This promise did not accord with Millet's sense of fairness, and he left Delaroche's studio never to return again.

While Millet was a pupil of Delaroche he made at the studio many acquaintances, including Couture, Hébert, Yvon, Feyren, but none of these men appears to have taken any considerable part in his after life. One only of his fellow-students was on at all intimate terms with him; and when Millet bade farewell to Delaroche his friend did the same thing, and the two young artists settled together in a little studio at the corner of the Rue d'Enfer.

Very unlike Millet was this comrade of his, named Marolle. Marolle was no peasant, or the son of a peasant, but a Parisian to the backbone; his father was a varnish-maker, possessed of ample means. To Marolle, Virgil and Dante and Shakespeare—Millet's favourite authors—were but names: he loved the poetry of De Musset, and the sentiments of De Musset coloured most of his life and thoughts. If he had no sympathy with Millet's literary taste certainly Millet had no liking for Marolle's. The art of De Musset and of the Romantic schools of literature he criticised with severity and some justice. All its affectation and tinsel displeased him. "Musset," he said, "gives you a fever, and that is about all he knows how to do. A charming mind, capricious, and profoundly poisoned, all he can do is to disenchant, corrupt, or discourage."

Yet in spite of many differences these two young men, Millet and Marolle, were fast friends. To Millet, Marolle was a kind of link between him and the great world. When he went to the library of Ste. Geneviève, as he constantly did to study the works of Dürer, Leonardo da Vinci, Poussin and Michael Angelo, Marolle went

usually with him, so that the young peasant's shyness might not prevent him from obtaining whatever information he required. All sorts of worldly knowledge came to Millet through the medium of Marolle. Marolle it was who set before Millet the material advantages of painting, not pictures of people reaping, and making hay, as he at first proposed to do, but imitations of Watteau and Boucher. Marolle it was who found the titles for these pictures when they were painted—titles that were intended to close the eyes of dealers to that severity of style which Millet was at all times unable to conceal. Marolle it was who took these pictures round to dealers and other buyers, and obtained for them whatever money he could. Marolle's portrait was one of the two portraits—the first two pictures—that Millet sent to the Salon in 1840; and we read with some sorrow that Marolle's portrait was the one that was not accepted, for Marolle must have been at any rate a very well-meaning friend.

In the summer of 1840, Millet returned to Normandy, and tried to obtain a living in Cherbourg in order that he might have his family nearer to him. About this time he made two portraits of his grandmother, which, it is not surprising to hear, were remarkable for their austerity. He also painted some subject pictures; for these he obtained no sales. We next find him painting signboards for thirty francs; and painting the portrait of a deceased mayor of the town; an undertaking which in the end did more to separate him from the goodwill of the notables of Cherbourg than the painting of signboards. Poor

Millet! No portrait was ever painted under circumstances more disadvantageous to the artist. He had never seen this mayor, a M. Javain, who died well on in years; nor were the townspeople able to provide him with any reliable likeness of the deceased; only a miniature which had been painted from him when he was very young and which was generally considered to be a very bad portrait.

So that Millet might have the advice of the Town Councillors, and the public generally, he was commanded to paint the picture in the Town Hall. Millet therefore suffered from a multitude of advisers; but it is not unlikely the people of Cherbourg might have endured a bad picture of their dead mayor if the artist had not used as a model for M. Javain's hands a man who had spent three months in prison. The people of Cherbourg finally received this picture as a gift, for they refused to give Millet the three hundred francs that had been promised to him by way of payment for the portrait.

Evil times for Millet naturally came after this unfortunate undertaking; and there followed a further course of the painting of signboards. Langlois, his former master, refused to have anything more to do with one who occupied himself so humbly. But Millet was not dismayed; in time he painted more portraits, principally of the younger people of the town, and some pictures of local interest; he did also for a friend, a Dr. Asselin, a "Saint Barbara Carried up to Heaven," of which picture a reproduction is given in these pages.

In November, 1841, occurred the first marriage of Jean-

JEAN-FRANÇOIS MILLET

By permission of M. Durand-Ruel]

SAINT BARBARA

François Millet. His bride was a Mdlle. Virginia Ono, a young dressmaker, who is described by François' brother, Pierre Millet, as a charming little woman, gentle and affectionate, but very delicate. A further testimony to the charm of the first Madame Millet is in the possession of Mr. Staat Forbes, who owns the only known portrait of her, a gracefully fashioned pastel from the hand of Jean-François himself. Happiness, however, does not seem to have followed this marriage; Millet did not find his wife's relations congenial, and Madame Millet suffered constantly from ill-health. Early in 1842 Millet returned with his wife to Paris and from then until Madame Millet's death, in 1844, the artist passed through a period of darkness that was almost continuous.

The pictures that he sent to the Salon in 1842—a portrait and a picture—were both refused. In 1843 he did not try to exhibit anything, but in 1844 he sent two pastels, and both of them were accepted by the Jury. Of these pastels—one a Normandy peasant girl carrying a pitcher, called by Marolle "The Milkmaid"; the other a group of children playing at horseback on the floor—the latter attracted some attention. When Diaz saw it, he exclaimed: "At last, here is a new man who has the knowledge which I should like to have, and movement, colour and expression too—here is a painter."

In 1844 Millet was thirty years of age. Since 1841, in the art of painting he had developed considerably; he had abandoned the dark shadows that were among the traditions of Delaroche's studio, and had profited by his knowledge of Michael Angelo's work, and perhaps

more by his study of Correggio's splendid and always living interpretation of flesh. Painting now meant happiness to him, for he was full of the love of life, and the nude studies which at this period of his existence came from his brush in quick succession were not the result of a prurient fancy, but merely wholesome expressions from a young man, himself abounding in vitality, who found in the painting of naked, radiant, moving bodies just that which was most profitable to his mental and physical needs. It was in 1844, just before his first wife's death, that he painted "Love the Conqueror," a picture which has been exhibited in London once or twice, and which belongs to the beautiful collection of Mr. J. Staat Forbes. In this painting, which represents a half-nude girl being drawn by amoretti through a dark wood, may be seen a very precise summary of what Millet was capable of doing at this period of his life. Here is a master's breadth of handling; colouring which is sensuous enough and full of reality but full too of poetry and refinement. Here, too, we find a subject—a common enough subject among French artists—treated by a man who is a thinker and a dreamer. The girl is but a peasant girl, not inelegant in form, but made beautiful by the sentiment that is possessing her. And the amoretti! Each one of those vigorous and alluring little bodies, painted with such verve, painted with such infinite knowledge, belongs without doubt to the cohort of messengers from the goddess of Love.

After the death of his wife Millet returned to Gruchy and found consolation by painting and working among

THE SWIMMERS

[*Collection of Sir John Day*

the fields at his old home. When a little later he proceeded to Cherbourg, where the news of the success of his pastels in the Salon had gone before him, he received, perhaps to his surprise, a hearty welcome. And when he began to paint there he found that his study of Correggio and of other masters of colour had profited him in more ways than one—for a while he was almost popular, even at Cherbourg.

One of the most successful portraits that he painted in the town was the daughter of an old friend, a M. Feuardent, a clerk of the library of Cherbourg, who had provided Millet with books and advice while he was yet a pupil of Langlois'. This picture of the little Feuardent, a charmingly playful conception, is full of character, of child character. We are shown the back of the child with the front of her reflected in a gold-bordered looking-glass, against which she is leaning. The reflection gives us a face very bright and very quaint, and naturally, perhaps, not without the suspicion of a grimace.

So successful was Millet at Cherbourg that the prefect of the town, forgetting the unfortunate portrait of Mayor Juvain, offered him the post of Professor of Drawing at the Municipal College; but Millet, who was not so likely to have forgotten about Mayor Juvain's picture, refused the offer. He valued his independence too much to again place himself at the mercy of the municipal authorities; and moreover, in spite of all that he had suffered there, he had made up his mind to return to Paris.

Before leaving Normandy again he contracted his second marriage. This time he wedded Catherine Lemaire,

a girl of barely eighteen, a peasant who had been attracted by his romantic appearance and his dreams for the future, in which she, peasant though she was, from the very first seems to have had some understanding. To this woman all lovers of art, and especially all lovers of Millet's art, owe a debt of gratitude; for without her sympathy, without the maintenance of her strong spirit at one period of his life, so many of Millet's projects might have remained for ever in the land of dreams.

On their way to Paris, Millet and his wife stayed for a while at Havre, which they reached in November, 1845. Here the artist painted a number of portraits including a nearly life-sized one of M. Vanner. Sensier says that "all these portraits have a brilliant side, but they were too hastily executed." Some of the subject-pictures that he did at Havre, which it is surprising to know found favour in the eyes of the Havre sea-captains, have been exhibited comparatively lately, and in them there is no sign of haste; only the rapid brushwork of a man whose mind is charged with ideas, and who is just beginning to realize the mastery he has attained in the use of his medium. To this series belong "An Offering to Pan," "A Sacrifice to Priapus," "Daphnis and Chloe,"—the sea-captains of 1845 must have had very different tastes from the sea-captains of to-day—and "The Flute-lesson." In "The Offering to Pan" a girl crowns with leaves a tall statue of the god. She is half naked, and entirely a creature of the woods. A little way from her and on lower ground, their shadowed figures silhouetted against the sunlit leaves, stand two nymphs, both regarding the

strong, sensual figure ef the god with adoration. It is a picture replete with tho antique and remote sentiment of forest depths. When Delaroche's pupils called Millet "the Wild Man of the Woods," theirs was not altogether an ill-considered jest, for no man on whom modern civilization had ever firmly laid its hand could have painted a picture with just the poetry in it of "The Offering to Pan." At Havre Millet held an exhibition of his pictures which, considering the popularity that his work attained, brought him but a trifling sum. He started for Paris with nine hundred francs in his pocket.

In 1845 Millet rented three rooms, one of which he fitted up as a studio, in the Rue Rochechouart. Here he found himself surrounded by a number of friends. Toussaint, the sculptor, lived in the same house, and near him lived Charles Jacque, who was then employed mostly with etching, and Diaz, and Campredon.

The first picture that he painted in his new environment was a "Temptation of Saint Anthony," but no good fortune attended this venture. Although Couture found it "wonderful," the Jury of the Salon rejected the work; and on the same canvas, over Saint Anthony, Millet painted his "Oedipus being taken from a Tree." While he was engaged on this work he did a number of small works, which passed into the hands of M. Durand Ruel and M. Deforge, the well-known dealers. At this time there was little to choose between Millet's pastels and his paintings; for these exquisite studies from the nude that he executed in oil, these studies of women, nymphs and fauns, children sleeping, playing and dancing, all rich in

fancy, pure in suggestion, came from his brush with every bit the same facility, were full of the same nervous force and had just the same charm as anything that he ever did in pastels. It was only later when Millet had lived for a while at Barbizon, when the meaning of his subjects had become to him of greater importance than the painting of them, that Millet's brushwork grew a little ponderous and his colour a little heavy as well.

The "Oedipus taken from a Tree," a powerful piece of painting and a strangely complicated design, was exhibited in the Salon of 1847. Thoré and Gautier wrote well of it, and among artists it was noticed as a fine demonstration of Millet's excellent capacity for painting the nude. It had little in common with modern renderings of the classical subject, albeit it was by no means without the flavour of old Greek poetry.

In the spring of 1848 Millet had his first serious illness—a rheumatic fever which brought him to death's door. Happily some neighbours of his, Séchan and Diéterle, scene-painters of some notoriety, were able to supply him with a few necessaries, for the Millet family were at that time without any resources. Millet recovered in time to finish two pictures for the Salon of 1848 and secured his first real success with his "Winnower," which was bought by the Government for five hundred francs. M. Ledru Rollin also gave him a commission for twelve hundred francs. But these successes do not appear to have supplied the requirements of the Millets for very long, for in June, at the time of the insurrection, we find them so reduced to poverty that the artist is compelled

to paint a midwife's sign for which he received the sum of thirty francs. It was indeed an ill time for selling pictures, and all that Millet did about that time remained upon his hands. In more ways than one Millet suffered from the revolution of 1848; he was compelled to carry a gun in defence of the Assembly, and he saw the worst of the fighting about the Rue Rochechouart. The sight of blood, shed because of a difference of opinion for which he had no sympathy, sickened him, and already half-unconsciously his thoughts were turning towards a change of life —a life lived far away from the turmoil and useless dissensions, artistic as well as political, of a city. He drew a series of pastels of scenes that he had witnessed in the outskirts from impressions that he had received during evening walks taken with Sensier: their titles, "Horses Drinking," "The Fountain of Montmartre," "Sleeping Labourers," sufficiently suggest their subjects; but these pictures did not bring to his mind the relief that it needed, and taking his "Hagar and Ishmael," a picture for which he had received a commission from the State, he boldly painted out his design, and began in its place a fresh subject, which was afterwards called "Haymakers resting in the Shadow of a Haystack." A chance conversation that he heard before a shop window had also to do with this sudden destruction of the "Hagar and Ishmael." By two men quite unknown to Millet, who were discoursing about one of his pictures, he heard himself described as "Millet who paints nothing but nude women." "If you choose I will never do any more of this sort of painting," he said afterwards to his wife. To this Madame

Millet answered: "I am ready. Do what you wish." And from that time Millet only painted pictures according to his heart's desire—according to the desire of the Millet to whom appeals from the country were coming now with an ever more and more insistent voice.

But it was not until a year after this event; not until he had finished his picture of the "Resting Haymakers," and had received the price for it; not until Millet had searched all about the environs of Paris for the models that he required, that the artist and his family finally turned their backs on Paris. And then possibly it was the cholera which was raging in Paris rather than the requirements of his art which brought about the exodus. But whatever the cause may have been, whether they were fleeing from a sickness, or seeking a change of scene or the models that they needed, or purposed only a short holiday, Millet, who had a little money, and Jacque, who had been ill and had none, started off to find a little village that Jacque had heard of, the name of which he believed ended in "zon" and which was situated on the edge of the forest of Fontainebleau.

This famous journey took place in June, 1849.

CHAPTER III

ARRIVAL AT BARBIZON

NOT without some ceremony did Millet and his friend and their families enter Barbizon. Instinctively the entire party appeared to be aware of the greatness of the occasion. The first part of their journey from Paris brought them to Fontainebleau. Here they remained until Madame Millet's frugal mind became alarmed. The village with a name ending in "zon" of which Jacque had heard was suggested as an advantageous change from expensive Fontainebleau, and they set out again in search of it. At Chailly they left their coach, and performed the rest of their journey on foot. Millet entered the village carrying his two little girls, and his wife followed him with the baby boy in her arms.

"Here come some strolling players," they heard one old woman say. So at least their arrival was not without some appreciative spectators.

At Père Ganne's inn Barye, Corot, Diaz, Rousseau, and François had already made many a long stay. They had *pension* with Ganne, but hired studios from the peasants. At this inn Millet and his party found the accommodation that they sought for, and at a moderate price. They were welcomed by the host himself and by Diaz and Rousseau. Millet and Diaz were already on fairly intimate terms; while Millet's great friendship

with Rousseau, who was a reserved man, had yet to be made.

It did not take Millet very long to discover that at Barbizon he could find all that he required. Barbizon was sufficiently near to Paris; in Barbizon he could find all the companionship that he needed; living was cheap in Barbizon and house rents also; the forest of Fontainebleau awoke instantaneously many echoes in his heart; while the Barbizon plain seemed to him nothing less than a vast theatre of great inspirations.

Millet and Jacque rented houses that were next to each other. They were primitive enough little houses; but to Millet, to whom country air and country surroundings were essentials, his new little home must have been, after his long stay in Paris, after his recent experiences there and the mighty disgust that had grown up within him of city life, like a corner of Paradise.

It was a little three-roomed house set in a courtyard; the gable end of the house, not the front of it, was parallel with the street. In one corner of the yard was a barn which Millet used as a studio; beyond the courtyard —away from the street—was a garden, and beyond the garden an orchard.

Millet now cast on one side the more conventional dress that he had been obliged to wear in Paris. He put on sabots instead of boots; instead of an ordinary coat and waistcoat he wore a weather-beaten red sailor's jacket, and he covered his head with an old and battered straw hat. Again he took up the gardening implements that he knew so well how to handle, and dug, and raked,

By permission of M. Durand-Ruel]

THE FLIGHT OF CROWS
PASTEL.

8

and hoed, and planted in his little piece of ground. Every morning he laboured in his garden, or in his fowl-yard, until nearly midday, and then, after his meal, he went to his studio, which Sensier found so dark and dismal, but which the artist himself liked so well; there he worked until sunset, or until the light in his little room failed him, when he would often go forth into the woods, or on to the plain to study the clouds, and watch the mysterious shadows of the oncoming night. "I have no pleasure," wrote Millet, "equal to that of lying on the ferns and looking at the clouds." Of the forest he said: "If you were to see how beautiful the forest is. I run there sometimes at the end of the day, when my day's work is over, and I come back every time crushed! The calmness and grandeur are appalling, so much so that I find myself feeling really frightened."

In the evening he employed himself sometimes in recording any particularly vivid impressions that he had received during his walk, or in developing some other idea that had come to him during the day. Very often he gave himself up entirely to amusing his children. He would read to them or tell them stories; he would draw for them, illustrating some fairy story with which he had made them familiar. In Mr. Wyatt Eaton's delightful reminiscences of the great painter he gives us by way of illustrations some of these drawings made by Millet for his "toads" as he called them. There is an ogre's head —an ogre that ate little children; a frightening visage with a mouth set with teeth that could have torn to pieces an ox; there is a whole set of pictures illustrating the

story of Red Riding Hood, and another series setting forth the fate of a man who was unkind to a horse. The Red Riding Hood pictures especially are admirable in design, and are certainly not wanting in dramatic force; in no way did Millet ameliorate the fate of the errant child.

To rid himself of some of the numberless impressions that beset him among his new surroundings, Millet made a little series of drawings in which he represented a great deal of the life that was going on around him; he drew the woodcutters at their occupation, the charcoal-burners at theirs; and mysterious figures of shepherds, those lonely sphinxes of the plain, and women cowherds knitting all the while that their cows searched for herbage by the roadside; he drew poachers and quarrymen, men ploughing and harrowing; he drew also young women carrying children, and old women carrying monstrous faggots upon their backs. He made also studies of the trees in the forest and of the vast stretches of open land beyond the forest. These things he did as it were to unburden his mind, and then he turned his attention to a more important subject, which he sketched upon his studio walls, a "Ruth and Boaz." This picture, however, was not completed until 1852, when it was shown under the title of "Les Moissonneurs"; at no time was the picture anything else but a truthful impression of some scene that he had witnessed on the plain of Barbizon.

In 1850 Millet exhibited the first of his great peasant pictures, possibly the greatest of them all—his "Sower." The idea of this picture had been with him a long time

THE SOWER

FROM THE PASTEL

before ever he came to Barbizon; and when he painted his first "Sower," it was not a peasant of Barbizon that he produced, but a Gruchy labourer—a man in a red shirt with his legs encased in straw and wearing a hat which had been beaten out of shape by the unwearying winds that blew from the Cape of La Hogue. Later he drew many times in pastel the sower of Barbizon plain: of one of these pictures we give a reproduction. In all of the Barbizonian sowers the costume is less fantastic than that of the Gruchy "Sower," and they have a larger and more level background, which includes the old tower of Chailly. In the Gruchy pictures, the man seen with a harrow in the distance is driving oxen, while the harrower in the Barbizonian pictures has a pair of horses. The great picture, the Gruchy "Sower," is almost too well known to be described; the man's majestic stride, the wonderfully rhythmic movement of the whole figure, the sense of ceremonial conveyed in the proud and almost defiant swing of the right arm, the expression of a certain time of day and of a certain season of which the picture is so eloquent, the decorative setting of the figure within the canvas—all these qualities have made the picture famous in whatever corner of the globe a photograph or engraving of the masterpiece has been sent; and there are no civilized people now that do not know the splendid "Sower" of Jean-François Millet.

Millet painted the great Gruchy "Sower" twice. The first picture was executed with so much haste that the artist did not leave sufficient space upon the canvas for the man's feet. In the second essay, Millet traced the

figure from the first painting on to the new canvas, placing it this time within the limits of his picture in a manner with which no critic can find fault.

The exhibition of "The Sower" in the Salon created no small stir. Théophile Gautier thought highly of it and wrote: "There is something great and of the grand style in this figure, with its violent gesture, its proud raggedness, which seems to be painted with the very earth that the sower is planting." Other critics decided that Millet must have revolutionary tendencies and condemned his picture. "The Sower," they said, "cursed the rich. Did he not throw his grain upwards towards the sky?" But Millet had no socialistic doctrines to propound. He preached only the gospel of work and the gospel of nature. His sower threw his grain upwards towards the sky because neither at Gruchy nor at Barbizon had Millet seen a man sow in any other way.

Soon after the completion of "The Sower" Millet painted another picture, which has become well known in London—it was exhibited in the Guildhall about four years ago—entitled "Going to Work;" a picture which is as much like an idyll as any realistic study of labour-life that Millet ever painted. In it two young people, a young man and a young woman, are seen on their way to the fields; both of them are too young to carry the traces of hard toil, or to be concerned with any other matter than a healthy pleasure in each other's company. Like "The Sower" this picture has admirable decorative qualities: it is also one of Millet's best essays in the use of blue.

WOOD-SAWYERS

[*Victoria and Albert Museum (Constantine Ionides Collection)*]

In 1851, there came to Millet from Gruchy where he had not been for some years, mainly for the want of money, the news of the death of his grandmother, Louise Jumelin. Millet was for a while inconsolable. For days he sat without speaking. Nor was his sorrow lightened by the tidings that he received from his mother; she, too, was failing rapidly. "My poor child," she wrote, "if you could only come before the winter! I have such a great desire to see you one single time more." But her desire, poor woman, was never to be fulfilled. As Louise Jumelin died, she also was to die, without seeing her beloved one. For two years she waited after the death of the grandmother, for Millet's monetary difficulties did not decrease, while his responsibilities increased—sons and daughters were born to him in rapid succession. When Millet next visited Gruchy, it was in order to assist his brothers in the division of the little family estate.

But while Widow Millet had been waiting, waiting for her son's return, the artist had not been labouring in vain. He had painted his "Man Spreading Manure" which was one of his first attempts to realize the poignant poetry of a winter landscape. And he had begun his wonderfully interesting series of studies of life within the cottages—of the woman's part in the drama of toil which he had taken upon himself to illustrate. About "Les Couseuses," a picture of young women sewing, an interesting story is told. An attempt had been made to obtain for Millet an order from the State, but M. Romieu, the then Director of the Fine Arts, who knew nothing about pictures, searched far and wide for news of Millet's moral

character. Much that he heard was satisfactory, but at last, he came upon certain artists who liked neither Millet nor his work, and who, therefore, combined to instruct the Director mainly in Millet's eccentricities and his rejection of all Academic traditions. By this M. Romieu was frightened, as it was intended he should be; but Sensier, who had the conduct of the affair on Millet's behalf, was not so easily beaten. He hung "Les Couseuses" in the Director's office and waited for circumstances to assist him. Good fortune did come in the person of M. Paul Delaroche, who, entering the room one morning, caught sight of Millet's little painting and, being delighted with it, asked for the artist's name. "Millet!" he exclaimed in response to the reply he received. "Why, he was my own pupil. I am not at all surprised; he was full of imagination and had a vigorous method of his own."

After this Millet received the order that he required readily enough, and six hundred francs as a first instalment of the price to be paid for the picture.

In 1853 he was given a second-class medal for his "Le Repas des Moissonneurs," which was but another name for the "Ruth and Boaz," the picture which he began soon after his arrival at Barbizon. The composition had remained almost unchanged. Two figures occupy the foreground, a young man and woman; the man is addressing the girl, who is carrying a few ears of corn; in the background, under the shade of a stack, are some reapers resting; all the figures were of course in the costume of the Barbizon peasants. Millet had laboured for some time on this picture, and as a natural outcome

of spending so much time on one canvas he was not satisfied with it.

But during this period of sadness, during this time of want in his own house, and sickness and death in the house of his mother, the greatest of all the inspirations that presented themselves to him was the direct outcome of the trouble that he had mostly at heart. "L'Attente," or "Tobit," as it is also called, was suggested to him by his mother's last letter and the two years that followed the writing of it; those two dreary years of unsatisfied longing. Madame Millet's letter is full of pathos, but no writer or painter has surpassed the quiet drama of Millet's picture.

"L'Attente" sets before us the outside of a cottage half encircled by dark trees, and standing a little apart from the high road. The whole picture is full of the glamour of evening atmosphere, the glories of the sun that has set have not yet left the sky, but all about the house and its surroundings hangs already a veil of gray air. From the cottage are coming forth two aged people. The foremost is a woman who, with a gait that denotes weariness and hope deferred until hope is nearly dead, steals along a pathway towards the glimmering high road. Behind her, descending the cottage steps, comes the man, and his is by far the most moving figure of the two. He is coming, not to watch, for he is blind, but to welcome, should the long-lost one come forth from the golden sky. Was ever the awful pathos of blindness expressed quite so fully as it is in the fumbling, groping, hesitating figure? The eyes that are directed towards

the sky but do not see; the hand that moves slowly over the surface of the rough stone doorway; the nervous search for the ground with the long staff, and the timid, timid feet, one still upon the step and the other prepared to follow the way that the staff shall indicate: by these and other details had Millet expressed the tragedy of the helpless man; so graphically has he done it, that he who looks upon the picture cannot but feel for a moment or two that he too is beset by the terrors of blindness.

This picture was not finished until many years after it was begun. It was exhibited in 1860, and then it was abused even by Millet's two former admirers, Saint Victor and Théophile Gautier, but Millet himself always knew that it was a good picture.

In 1854 there came to Millet's studio at the instigation of Rousseau, whose friendship for Millet was ever disinterested and unfailing, a M. Latrone, who bought some pictures and ordered others; for him Millet painted a "Woman feeding Chickens," one of the most statuesque of his many studies of female peasants. M. Latrone kept Millet employed for six months, and at the end of that time, in June, 1854, the painter found himself in possession of two thousand francs. With this sum Millet and all his family started off to La Hogue—the painter no doubt a little sore at heart that this good fortune had not come to him a little earlier.

He went to Gréville for one month, but he stayed four; to such an extent did he find himself bound to the place of his birth by old associations; so much did he find there to draw and to paint.

JEAN-FRANÇOIS MILLET

(Victoria and Albert Museum (Constantine Ionides Collection)
A WOMAN AT A WELL

JEAN-FRANÇOIS MILLET

Of his brothers and sisters two only still remained at Gruchy; one sister—his elder sister Emilie, the friend of his childhood, who had married a farmer named Lefèvre—and his brother Auguste, who still lived in the old home; with him Millet and his family stayed.

From his brother Pierre, at that time a student of sculpture at Cherbourg, but a frequent visitor to Gruchy, we learn that Millet's visit to the land of his fathers was a very happy and profitable one. He worked in the harvest fields; with his wife he went to every place in the neighbourhood that was associated in any way with the Millet family; and, besides this, he painted fourteen pictures, made twenty drawings, and filled two sketch-books full of studies. Everything of interest to him about the farm he drew—the house and the gardens, the barns and the sheds and stables, the old apple trees in the orchard, and the great laurel tree which grew near the house, and which had always haunted his boyish imagination. He drew the cliffs and the rocks, and the animals feeding upon the cliffs. One hears of no struggles during this time at Gruchy; no struggles with poverty nor with the exigencies of picture-making. The two thousand francs had brought him freedom from material cares; and art for a while was but his handmaid, enabling him to preserve records of many things that he loved. Of these sketches and studies he made later ample use in the composition of his pictures.

Before he left Gruchy he met again—inside the church of Eculleville—his old friend, pastor and teacher, the Abbé Jean Lebrisseux.

"Your Bible, François, have you forgotten that?" asked the curé of him after they had embraced. "The Psalms you were so fond of—do you ever read them now?"

"They are my breviary," replied Millet. "From them I find all that I paint."

"Such words one seldom hears nowadays," said the priest. "And Virgil, you used to love him."

"I love him still," said Millet.

"It is well," said the Abbé. "Where I sowed the blades have sprung up; and you, my son, will surely reap the harvest."

During Millet's stay at Gruchy considerable alterations had been made in his Barbizon house. His former studio had been turned into a sitting-room, and the hen-house converted into a sort of kitchen; while to the barn, which stood on the street side of the little courtyard, was added a floor, a ceiling, a large window, and it was used always afterwards by Millet as his studio. This building still exists, but it resembles in few respects the room in which Millet made so many of his masterpieces; where he entertained at different times during his life so many eminent men. Millet's studio is described by Mr. Wyatt Eaton, who visited it soon after 1871, as "plain and gray. A green curtain hung at right angles to the window, behind this Millet retired to look at his pictures, so that he might have the curtain between himself and the light. The walls were of plaster darkened by time; heavy rafters crossed the ceiling; a few plaster casts hung about the walls—reliefs from the Trajan Column;

By permission of M. Durand-Ruel]

heads by Donatello and Lucca Della Robbia, the arm of Michael Angelo's "Slave," and some small Gothic figures carved in wood, of which Millet was very fond. All the study accessories or decorations were so unobtrusive that I did not see any of them on my first visit. No pictures were in sight. A large frame hanging over the already mentioned mirror, which I afterwards found to contain a rather highly coloured seventeenth-century master, was covered with a quiet drapery, but the end and right-hand side walls were closely stacked with canvases and with frames for temporary use containing canvases, all standing on the floor, their faces turned to the wall."

The mirror referred to by Mr. Wyatt Eaton was at the far end of the room, beyond the easel, and was used, Mr. Eaton tells us, by the painter to study folds from his own dress. Millet, it seems, had an extraordinary dislike for asking peasants to pose for him: the few male models that he used were usually obtained for him by his wife, so that one can well understand the necessity for the mirror. For his female models he used his children and very often his wife. Madame Millet told Mr. Wyatt Eaton that she often wore the roughest of peasants' dresses about the house and garden for weeks, and that Millet often compelled her to wear the same shirt "for an uncomfortably long time" in order that the garment might "become as it were a part of the body, expressing," as he said, "even more than the nude, the larger and more simple forms of nature."

One of the first pictures that Millet painted in this new studio was "The Grafter," a work which represented

the artist in the Universal Exhibition of 1855. Its motive was suggested to Millet by his favourite poet, Virgil; it is, however, a rendering of modern peasant life. A labourer, his day's toil over, is busying himself in his garden; with considerable care he is placing a new young shoot into the stem of an ancient apple tree, while by his side stands his young wife holding their child—the child who is to profit by the growth of the young apple shoot. The costumes and the *mise-en-scène* certainly are modern, but for all that the poetry of the picture is the poetry of Virgil. Notwithstanding all its truth of movement—the man's look of absorption and the justness of his action are remarkable—the figure of the grafter is invested with a grace that is purely classical, and classic, too, are the woman and child; despite her rough gait she appeals to one as some antique statue might that had been charmed into life, and yet, for all that, we are made to feel that she is a woman of the people enduring in every particular a peasant's lot. When this picture was exhibited it received a deal of approbation. Théophile Gautier wrote about it at length. "How strange is art!" he said. "These two quiet figures on a gray ground, performing an ordinary work, occupy your mind and make you dream, while the ingenious thoughts carefully rendered leave you as cold as ice. It is because M. Millet understands the hidden poetry of the fields; he loves the peasants whom he paints, and in their resigned faces expresses sympathy with them: sowing, reaping, grafting, are to him holy occupations having their own beauty and nobility."

JEAN-FRANÇOIS MILLET

[Collection of Henry Willett, Esq.

DRAWINGS BY MILLET ON THE BACK OF AN
AUTOGRAPH LETTER

But despite many new admirers that this picture won for the artist, for a while no one came forth who was willing to buy it, and Millet was in need of money. At length the purchaser appeared; albeit a mysterious person enough he was to begin with. Rousseau found him, and described him as an American, who did not wish his name to be known. He was, however, willing to pay the purchase money, and for a while the secret art collector remained unknown. But at last the truth was discovered. The American vanished into thin air. The buyer was no stranger at all. He who had acquired this picture, who had acquired it at no beggarly price under the guise of friendship, but had paid the catalogue price for it—four thousand francs—was the painter's own familiar, needy, but very generous friend, Théodore Rousseau. It is pleasant to read of this transaction in Sensier's book, in which the writer has set down so much that is sordid, and so very much more than he ever intended to make known to us.

After the sale of this picture Millet appears to have spent a very peaceful half year. We read of his entertaining Rousseau, Diaz, Barye, Campredon and a host of other friends at Barbizon, and delighting them all with his gaiety and wit. But in 1856 we find Millet again in financial difficulties. Again we find him addressing Sensier in his search for money. And Sensier—! But Sensier is an enigma which it is not altogether the purpose of this book to solve.

In 1856, which was from beginning to end a bad financial year with Millet, he made, in spite of all his

difficulties, fresh explorations into the kingdom which he had taken over for himself. This time the shepherd attracted his attention. But who has seen anything of the shepherd's life in France and has not been fascinated by it? Who has not wondered at the man's almost inhuman patience? At his almost inhuman capacity for bearing solitude? In their long cloaks of sheepskin, or of rough cloth, these men appeal to the spectator as do priests and monks, and those who in some way are set a little apart from ordinary human intercourse. Who has not felt a slight thrill, as if he had been brought suddenly in contact with some being not entirely of this world, at first sight of one of these mysterious beings, leading his flock, perhaps, along a white tree-lined road in the early morning; the sheep and the man reminding one somewhat of the Pied Piper of Hamelin and his troop, mainly because of the strange communion that exists obviously between the human beings and the beasts. As impressive, too, is the shepherd when we discover him after harvest is over in the middle of some deserted field, standing possibly not amidst one flock but surrounded by the flocks belonging to a whole village, and he, the only human being to be seen on a landscape, flat, and with a limitless horizon. Impressive, too, is the shepherd when he appears within our vision at evening time, emerging from a group of tall trees to which the setting sun has given the colour of molten metal; his dark silhouette outlined with gold, and his sheep encircled as it were by living flames. But more impressive than at any other time does the shepherd appear to us at night; then not

even the light of his lantern, if he carries one, gives him any real humanity; then indeed does he look a creature of altogether another world and one that it would take a deal of courage to address for the first time.

Of the shepherd pictures that Millet painted in 1856, the most suggestive is undoubtedly his night scene, " Le Berger au Parc." Here is the romance of a vast plain lit only by the moonlight. Here is the romance of a half moon lying low, almost upon the horizon. In the foreground is the fold, made of light hurdles, and into this fold through a small opening made by the shepherd— we see his head and shoulders silhouetted against the moonlit sky—pour the sheep with steady flow. How admirable is the movement of the beasts in this picture; how just the importance given to each sheep, with what skill are they relieved one against the other. It was Millet's ambition in many of his pictures to suggest sounds as well as sights. In " The Angelus " it was the sound of bells that he wished to make evident; in the " Parc aux Moutons " pictures, for there was a series of them, he would compel the spectator to hear the bark of the dog. But one hears more than the bark of the dog; one hears the shouts of the shepherd; one hears the pattering footsteps of the sheep—the patter, patter, like the sound of heavy rain on a summer evening—and above all one feels the silence of the night.

These pictures of shepherds caused Millet to study landscape more intimately than before, and revealed to him the enormous value of landscape in accentuating the sentiment of such subjects as he loved to paint; and we

find Millet from this time in all his more important pictures very much reducing the proportion of his figures to the size of his canvases, and paying more attention to the forms of his landscape, and far more attention to the lighting of it, and also to the illumination of his figures. In 1857 he produced one of his masterpieces, and one in which the figures and landscape are in perfect accord. I refer to "The Gleaners."

The idea of this picture had long been in Millet's mind. Mr. Staat Forbes has no less than six preliminary studies for this picture, showing how the final composition was gradually arrived at. In some of these sketches the figures move with even more subtlety than the peasants in the finished picture. But in the finished work is undoubtedly the composition that Millet was searching for, and if the figures in it have not all the extraordinary vitality of his first sketches, they have yet about them enough of life to make this picture famous even among the great pictures of the world. In how many ways "The Gleaners" appeals to the imagination! It gives us all the heat of an August day; all the sentiment of an open plain on which the harvest is drawing to a close, the golden colour of the landscape seems to signify the fruitful ending of months and months of ceaseless toil. And the figures of the three gleaners they, too, have their tale as they appear on the fields after the farmer has taken all that he requires. With such avidity are two of them searching the ground for what remains that they might be gathering not ears of corn but single grain; poverty-stricken enough they all three

look for even such a quest. But go so far from the picture that the women no longer compel you to a contemplation of their sordid lot, and the picture has still a message; this time of beauty. Those three gaunt women might be figures from the Parthenon frieze; not only is each silhouette perfectly fluent and beautiful in line, but about the entire group there is a rhythm and a unity which reminds one of nothing in modern art; only of some masterpiece in ancient Greek sculpture. But as this picture appeals to us it did not appeal to the critics of the Salon of 1857. The artists found the work admirable, but not the critics; they saw in this picture "a plea against the misery of the people": some declared that "these three poor women were savage beasts threatening the social order." But poor Millet had no doctrine to teach. He was but recording his impressions: that toil was the common lot of all mankind—a lot that he would have in no wise altered. He painted the people working in the fields because he had been brought up as a field labourer; had he served an apprenticeship in a factory, it is not unlikely that he would have painted factory life with equal realism and pathos.

CHAPTER IV

MILLET'S GREATEST WORKS

AFTER the painting and exhibiting of "The Gleaners," Millet again entered upon a period of poverty. Yet while trouble was besetting him, while he was even dreaming of suicide, according to Sensier, he produced the most popular, the most placid of all his great pictures, "The Angelus." By the side of "The Sower," "The Gleaners," and many another lofty composition of the great peasant painter, "The Angelus" compares but unfavourably. Although, however, it is no great exhibition of his control of line, no particularly fine outcome of a learned research for great and noble forms, there is about the figures and the landscape a poetic realism that has appealed and always will appeal to those whose artistic senses are developed, and to those whose artistic senses are not developed. The man who can look unmoved upon a silhouette without blemish, who can regard modelling worthy of Michael Angelo without even a thrill, will yet be able to understand a great deal of what Millet had in his mind when he began to paint "The Angelus." To him will be evident enough the expression of rapt devotion that envelops the two figures as completely as ever the evening air does. He will understand, too, the atmosphere that permeates the flat, far-stretching landscape, with its little church tower in the distance

By permission of M. Chauchard, Paris]

THE ANGELUS

surrounded by a group of trees. And the name of the picture, "The Angelus," does it not suggest the sound of bells—the sound of bells heard in the dim half-twilight? Is not the name of the picture sufficient to bestow upon it an interest that will command attention, irrespective of artistic handling and conception, even if Sensier had never recorded the words spoken between Millet and himself—"Millet said to me: 'What do you think of it?' 'It is the Angelus,' I cried.

"'It is, indeed. You can hear the bells. I am contented; you understood it. It is all I ask.'"

With "The Angelus" Millet sent to the Salon of 1859 a picture of surpassing grimness and strength, "Death and the Wood-cutter." While dealing with the calm poetry of "The Angelus" some means of exercising his darker thoughts were not unlikely necessary to him, and the field discovered for their display was this weird and powerful canvas. We print a reproduction of the picture: the terrified and collapsed woodman! the imperious Death! Could any figures be more expressive? But while "The Angelus" was accepted for the Salon, and was moreover bought rather later by M. Van Praet, the Belgian Minister, and received other marks of favour, the "Death and the Wood-cutter" met, anyhow at first, with but little success. The Jury of the Salon refused it, and about the picture there soon arose an animated discussion. It was engraved in the "Gazette des Beaux-Arts" by Edmond Hédouin, and Paul Mantz wrote in the same journal in defence of the work. But for a while neither it nor "The Angelus" found a purchaser, although

Arthur Stevens, the well-known dealer, concerned himself in the selling of the pictures; and Millet again found poverty knocking at his door. When the grim visitor was at last sent away he was dismissed for a long while, and the manner of his dismissal must have been rather a surprise even to Millet.

During the painting of these celebrated pictures Millet had done other work, and one or two other matters of importance had happened in his life. In 1858 he received through M. Trélat, the Pope's engineer, an order to paint an "Immaculate Conception" for the Pope's private railway carriage. Something of mystery envelops the whole of this affair. That Millet ever received the commission has given much cause for wonder, since a Pope's views on art can be scarcely expected to be very liberal. Millet executed the work naturally in a way characteristic of him. He painted a young peasant girl looking upwards, her child clasped to her bosom; at her feet is a dead serpent. But what happened afterwards to the picture no one can tell. Millet was paid for his painting, it was sent away to its supposed destination, but from that time it passed into obscurity. If it ever did find its way into the Pope's hands there is little doubt that the Pope did not find the picture to his liking.

Millet also about this time completed his picture of a "Woman leading a Cow," in fulfilment of his commission from the State. It was exhibited in the Salon in 1859, and was presented afterwards by the Emperor to the Museum of the town of Bourg-en-Bresse. In the painting of this picture, and indeed in the other work

DEATH AND THE WOODCUTTER

Trydes photo] *[Glyptotique, Copenhagen*

that he had on hand at the same time, Millet was interrupted again and again by headaches. Of all the afflictions that beset Millet these headaches alone, which seem to have visited him at frequent intervals during his life, after his first visit to Paris, appear to have interfered materially with his work. While Sensier was receiving the most piteous cries for money from the painter, Millet was often engaged in developing quite the noblest of his many beautiful paintings; but these headaches were a trouble of another sort, they rendered him quite helpless. According to his brother Pierre, Millet might have done twice as much work if it had not been for this affliction. The doctors and their medicines—he was persistent at one time in consulting fresh doctors—brought him no relief, and in the end the only remedy that profited him at all was a remedy his advisers had warned him against—black coffee. Millet attributed this illness to his time of misery in Paris, and not a little possibly to the tyranny of the art that he followed. To Pierre he said: "If I had never left home and country life I should not have had to endure these terrible headaches."

But if Millet had to endure headaches and many mental woes, there were those about him on whom life weighed equally, if not more, heavily. There was his friend Rousseau, his good, generous friend, Rousseau, who always watched over Millet like an elder brother, Rousseau! the rejection of whose pictures for many years won for him the name of "Le Grand Refusé," Rousseau, who even at home had little peace, whose house was often turned into a hell by the presence of a

madwoman. And there was Decamps! Decamps, the victim of many strange idiosyncrasies, who came to Millet's studio first of all in 1859, but who, neither then nor afterwards, would ever enter Millet's house; who reached Millet's studio by back ways, leaving his horse outside the village so that no one might know of his coming. Millet's summing up of Decamps is full of insight, and characteristic of Millet, the thinker. He found Decamps "a very original and a very clear mind in his judgments of the masters and contemporary art, but a restless man, doubtful of himself, who, under the rough exterior of a cavalry officer, hid a profound weakness, straying into theories about painting and the search for means rather than an end. Execution was his god." Millet said: "I never heard him say one heart-felt word. He had cruel bon-mots, a crushing sarcasm, a very just criticism even about his own pictures. He suffered like a man who is always searching, and losing his way. On the whole, he had a superior mind in a suffering soul."

Millet, anyhow, never lost his way, and never suffered from any doubt of himself. He never suffered for want of faith in his fellow-creatures or for want of kindliness of heart. He never suffered for want of friends, as Decamps did, nor did unrest reign in his house as it did in Rousseau's. From M. Piédagnel, who stayed with the Millets, from M. Burty, from Mr. Wheelwright, from Mr. Wyatt Eaton, two of the little group of Americans who lived at Barbizon for a while for the love of being near Millet, we obtain glimpses of the artist's home-life—of the comradeship that existed

between Millet and his wife, of the confidence and love that existed between Millet and his children. M. Burty sketches for us the patriarch Millet seated at the head of his table at dinner-time, his children arranged around him waiting to be fed like the little birds in a nest. Mr. Eaton shows us Millet, his day's work over, drawing, reading, playing to amuse himself and his family; at that time of the day more of a child than a man, and therefore an apt amuser of his children. M. Piédagnel gives us a vision, or visions rather, that are wholly picturesque: Millet seated in his studio, working with the door open, so that he may see well into his garden. In the garden are children playing, and a mother working under the shade of syringa and lilac bushes; the little children and the mother modulating their voices so that papa, who is at work, may not be disturbed. Or again, in the summer evening, Millet and his family taking a walk in the forest; all laughing, singing or telling each other frightening stories, as they approach the more eerie parts of the wood. Surely these tales of Millet's life with his family—and they are reliable, for they come from men who could have had no interest in giving false evidence as witness to Millet's happiness—are certainly not wanting in idyllic touches.

On March 14th, 1860, Millet signed the celebrated contract between Messrs. Stevens and Blanc and himself. Mr. Stevens was the brother of Mr. Alfred Stevens, the artist, and M. Blanc was Mr. Alfred Stevens's father-in-law. The arrangement was brought about at the instigation of Sensier, and by it Millet's biographer is

said to have financially profited. By this deed Millet was to receive on the twenty-fifth of each month, for the space of three years, the sum of one thousand francs from Messrs. Blanc and Stevens; while they on their part were to have from the painter all that he painted and drew during that period of years. For each work that the dealers received a certain sum was to be placed to Millet's credit—for the drawings, four pounds; for the pictures, a sum not exceeding one hundred and twenty pounds— and at the end of the three years the accounts of the two parties to this agreement were to be duly balanced, any disagreement between the parties was to be settled by two arbiters; by Mr. Alfred Stevens and M. Théodore Rousseau.

At the offset, of course, this appeared to be an arrangement in every way beneficial to Millet; but, unfortunately, as the dealers were men of business, and the artist very much of an artist, matters between them did not continue to run altogether smoothly: the dealers charged Millet with sending them unsaleable work; the dealers quarrelled between themselves; Millet's one thousand francs did not arrive on the twenty-fifth of each month with absolute regularity, and in the end, when the day of reckoning came, it was found that Millet owed Stevens two hundred and thirty pounds, a sum which he had eventually to pay off in pictures. But during 1860, at any rate, Millet lived in peace, and during this year and 1861 he completed "Tobit" or "Waiting"; he painted another "Sheepfold by Moonlight"; the well-known picture, now in the Lille Museum, of a woman feeding her children by the thres-

By permission of M. Durand-Ruel]

THE LITTLE GOOSE GIRL

hold of her cottage, called rightly "La Becquée," for indeed the group brings to one's mind vividly the spectacle of a bird feeding her young; "La Gardeuse d'Oies," one of his series of little gooseherd pictures, a study of rippling water, bustling birds, and at a little distance among some trees one small childish figure; "La Grande Tondeuse," which was exhibited in the Salon of 1861 and is now in the possession of Mr. Quincy Shaw of Boston.

Of these pictures the one that advanced Millet most of all in the eyes of critics and of artists, was the last one "La Tondeuse," a life-size painting of a woman shearing a sheep, while a man, standing half in shadow at the back of the picture, keeps the animal in its requisite place. Thoré wrote of this picture: "This simple 'Tondeuse' of M. Millet recalls the most admirable work of antiquity —the statues of Greece, and the paintings of Giorgione." And indeed it is impossible to look at the composition of "La Tondeuse" without thinking of "the work of antiquity," even if one desired to. And yet this woman, this female shearer, with the figure of a Juno, with all her massiveness, and dignity, and grace of outline, is a living person, a peasant, attending to her occupation with perfect ease and skill. A stately poetry proceeds from the light and shade of the picture and from its splendid selection of forms, but none the less is the picture almost scientific in its realism. The downward movement of the sheep's head, the woman's intent look, her right hand holding the scissors resting gently upon the animal, while with her left she pulls back the already severed fleece; the amount of force given by the man to his part of the

operation; all these facts will give pleasure and satisfaction to anyone to whom sheep-shearing is a familiar spectacle.

In 1862 Millet painted his "Wool-carders," of which we give a reproduction; a "Shepherdess," "The Birth of the Calf," "Winter," and "The Man leaning on a Hoe." Of these pictures, two, anyhow, roused Millet's critics to anger, and one at least must have added to the discord existing between the artist and Messrs. Stevens and Blanc. It is not unlikely that while painting "The Man leaning on a Hoe," which was exhibited in 1863, Millet was inspired by a spirit of defiance. Before Millet had uttered his creed, the gospel of work, with at all events some slight embroidery; with some additional appeal to the senses through the medium of fluent and graceful outline; or by setting his figures in an environment and atmosphere that were themselves replete with a softening and beautiful sentiment, but about "The Man leaning on a Hoe," there is no compromise. About everything in the picture is an appalling severity. The very earth the man stands on—how admirably it is drawn—is tortuous and sinister in form, and as aggressive-looking almost as the man who leans above it on his hoe, resting for a while, panting, but by no means overcome in his stupendous task. M. Pelloquet alone wrote well of this picture, and Millet sent a letter to M. Pelloquet, which was printed in the "Moniteur de Calvados," setting forth the intentions of his work—a letter beautifully worded, and full of characteristic wisdom. In the end the storm abated, as such storms do, without much gain to

JEAN-FRANÇOIS MILLET

By permission of M. Durand-Ruel

A WOMAN CARDING WOOL

땅으로

JEAN-FRANÇOIS MILLET

any party, and Millet, a little overcome by the fatuity of his part in the contest, retired to his studio to begin work afresh. He returned not to the painting of pictures, but to the making of drawings in pastel and chalk. At this time he appears to have realized that painting must be always for him a slow and laborious process, and feeling instinctively perhaps that his life would not be a long one, not long enough for him to paint all the subjects that remained in his mind, he proceeded to develop a method more spontaneous than any brushwork. And so he began that great issue of drawings that were to reach the hearts of many who remained untouched or were repelled by his painted pictures. In Millet's drawings, certainly in his later ones, the technique is irreproachable; has seldom, if ever, been surpassed. With black chalk, or charcoal, he placed himself on terms of perfect intimacy with nature. Whatever he desired to set down he accomplished—an outline, a shadow, a light, a movement, any sort of expression—in a manner sensitive, beautiful, always alluring, and with a fidelity that was marvellous. In his later drawings he often added a little pastel or hard chalks, using them not so much to give colour to the monochrome, as to heighten the suggestion of colour that was already included in the black and white. In the fuller use of pastel, in the use of it as a medium by itself Millet was from almost the beginning of his career, while he was still in Paris, a perfect master.

Millet began this freshly inspired output by making some biblical compositions for the purpose of reproduction. But two only were completed—a "Flight into

Egypt," and a "Christ rising from the Tomb," the latter is given as an illustration in M. Sensier's book, and is slightly grotesque and eminently forcible. Some illustrations of Theocritus followed the biblical drawings. A young friend named Chassaing sent him the works of Burns and Theocritus. Of Burns, Millet wrote to his friend: "I must tell you that Burns pleases me greatly; he has thoroughly his own flavour, he smacks of the soil." Of the Theocritus book he said: "It has a naïve charm peculiarly attractive, which is not to be found in the same degree in Virgil." In the same letter he refers again to Theocritus, a reference that is worth quoting, for it explains so much of the charm in Millet's own art: "The reading of Theocritus proves to me that one is never so Greek as in painting naïvely one's own impressions, no matter when they were received."

When he had digested both books the impression left by Theocritus began to form pictures in Millet's brain; and before long Millet formulated a plan for entirely illustrating the Sicilian poet and much correspondence passed between M. Chassaing and the artist upon this subject. One or two illustrations were made but the scheme was eventually abandoned. The impressions, however, did not so easily pass away from the artist's mind, and when, in 1864, a little later, he received an order through M. Feydeau his friend, and an architect, to decorate a dining-room in the Boulevard Haussmann, his designs were much influenced by the reading of the book that M. Chassaing had sent him.

The reason that was most assertive in causing Millet

JEAN-FRANÇOIS MILLET

By permission of M. Durand-Ruel]

SHEPHERDESS

JEAN-FRANÇOIS MILLET

to put his Theocritan illustrations on one side was the necessity of preparing some pictures for the Salon of 1864. Moreover he had in the course of his wanderings on the plain of Barbizon encountered a new and charming model—a shepherdess. So enthralled was Millet by this girl that he spoke to no one about her; to him she was typical of strength and purity, a Joan of Arc, one who in the solitude of the plain heard strange voices. Much of this mystic air that in Millet's mind enveloped the girl he has realized in his picture of her. Of his many shepherdesses this one that he exhibited in 1864 has the most charm. The serenity expressed in the girl's figure is expressed throughout the canvas. It is in the sky with the pale luminous clouds. Throughout the landscape it is there, in all those long stretches of garnered harvest fields; the nibbling, meandering sheep are serene also, and even the dandelion heads with their haloes of gold glow too with a content that is perfect. This picture passed into the hands of M. Tesse, and afterwards was bought by Mr. John Wilson, who gave it to M. Van Praet in exchange for "The Angelus."

With "The Shepherdess" Millet sent to the Salon "The New-born Calf," which received every bit as much ridicule as "The Shepherdess" received admiration. Here again Millet suffered from the lack of observation of his critics. For those who are unfamiliar with this composition it may be noted that the calf is being borne home on a litter carried by two men. "Millet's peasants," exclaimed the critics, "carry the calf as if it were the bull Apis, or the Blessed Sacrament itself." To this

accusation Millet replied: "The expression of two men carrying something on a litter depends upon the weight which hangs from their arms. So, if the weight were the same, whether they had the Ark of the Covenant, or a calf, a lump of gold, or a stone, the same expression would be the result." So great was the popularity of "The Shepherdess" that Millet was offered fifteen hundred francs for it from the Director of the Beaux-Arts. The picture had, however, already passed from Millet's possession into that of M. Tesse, who had given him two thousand francs for it; but the artist further obtained a medal for the painting while it was in the Salon.

In 1865 Millet completed his four panels for M. Thomas, the owner of the house in the Boulevard Haussmann; not without some difficulty. He was harassed, while painting them, by want of room in his small studio at Barbizon; he had for want of information to paint these great designs in ordinary oil colours instead of in a more suitable medium; he had a great difficulty with the perspective of his ceiling, and he was suffering repeatedly from an affliction of the eyes which took the form of a swollen eyeball. Yet in the end he brought this work to a successful issue, and in September the four panels and the ceiling were fastened up in their destined places.

These panels represented Spring, Summer, Autumn, and Winter. We reproduce the Spring, a subject which might well have been suggested by Theocritus, and the Winter, which is an illustration of a poem by Anacreon. Autumn was represented by a Bacchanalian group, and

Summer by a figure of Ceres walking through a field where the harvesters are at work. The ceiling represented a blue sky diapered over by light clouds, and further ornamented by figures of children, and owls, and bats, all engaged in play. The border of the ceiling set forth the good things of the table, haunches of venison and fowls ready for the cook, fruit and flowers. When these pictures were taken down from their places and sold at the Hotel Drouot, M. Paul Mantz found them very disappointing; but Mr. Wyatt Eaton on the other hand, who was well qualified by temperament and training to discover the good in any work of Millet's, found them indicative of Millet's great strength and versatility; but at the Hotel Drouot they must undoubtedly have been shown under disadvantageous circumstances. The panels that we reproduce show, anyhow, the vigour and poetry of two of the designs.

In 1865, Millet made the acquaintance of M. Gavet, an architect, who a little previous to the introduction had bought a picture of the artist's. M. Gavet proved a good patron and an excellent friend; he loved art, and entirely understood Millet. To him we are indebted for the encouragement which enabled Millet to produce many of his masterpieces in chalk and pastel. He began by ordering twenty drawings, when Millet died he was in possession of ninety-five. This collection, which eventually sold for the sum of four hundred and thirty thousand francs, was exhibited after Millet's death for the benefit of his widow.

The exhibition of the pictures by Millet that he

possessed had been contemplated by M. Gavet while the artist was still alive. When Millet's enemies saw them, the architect prophesied, they would hold their peace; and, indeed, in 1875 when the drawings were shown, Millet's critics not only ceased their fault-finding, but took part, one and all, in a chorus of admiration.

Millet's drawings have justly been called "an epic of the fields." From them we learn a great deal about the artist and almost all that there is to learn about the poetry of peasant life and the ever-changing spectacle of the fields. We learn from them how sympathetic Millet was with every effort that was simple, just, and good; from his drawings of women and children we learn what infinite tenderness there was in his nature. There is hardly a form of rustic toil that Millet has not presented to us, with all its dignity, with all its picturesqueness, in one or other of his drawings. There is hardly any phase of nature that he has not realized in the series —the caprices of spring, the fulness of summer, the brooding melancholy of autumn, and the grim tragedy of winter. "One is never so Greek," Millet said, "as when painting naïvely one's own impression." Of all his work these drawings are the most direct expression of his own feelings and sympathies, while making them he was hampered by no difficulties of technique, his ideas and impressions proceeded from his chalk or pastels always with perfect fluency, certainty and beauty, and these are of all Millet's vast accomplishment the most Greek.

1866 was in some respects a shadowed year for Millet. While painting a picture for the Salon—a street scene

By permission of M. Durand-Ruel]

THE MOWER

at Gréville—he was called to Gruchy to receive the last words of his sister Emilie—the elder sister, who had been a little mother to him when he was a child, and who had always afterwards held her place in the artist's affections. After the funeral Millet hurried back to Barbizon, but notwithstanding all his efforts to recover time, and his equanimity, his picture was exhibited unfinished, or at all events unvarnished, and M. Edmond About wrote indignantly of the artist: "M. Millet sends us alternately masterpieces and daubs."

Domestic troubles still pursued him during the summer. His wife, who since the birth of their ninth and last child had been unwell, became so ill that in the autumn she with Millet went to Vichy. The visit benefited both the artist and his wife, although Millet undertook the journey unwillingly enough. The neighbourhood of Vichy provided him with fresh spectacles, fresh inspirations for drawings and pictures. He saw there a more varied landscape than he had been accustomed to, and shepherdesses, not dressed as those of Barbizon, but more primitively, with far more character, who while they watched their flocks employed themselves in spinning with the distaff. He saw the peasants' carts, and the haymakers' waggons drawn by cows and oxen, and men and women whose heads agreed with the type familiar in Gothic art. He made innumerable sketches in chalk and in water-colour, the latter being a medium he seldom made use of, but which he handled now with a dexterity that is amazing. I know of one small drawing of a shepherdess plying the distaff, belonging to

THE BARBIZON SCHOOL

Mr. Forbes, that for sheer cleverness surpasses any wash drawing I have ever seen. In July he made a short expedition with M. Chassaing into Auvergne. Of the multitude of impressions that he received during this journey he wrote afterwards to Sensier:

"My head is full of all we saw in Auvergne. Everything dances together in my brain, calcined ground, sharp rocks, splits, barrenness and greeneries, the glory of God dwelling upon the heights, and other heights veiled in darkness. I hope all these things will finally arrange themselves and go each one into his pigeon-hole."

To the International Exhibition of 1867 Millet sent with some trepidation eight pictures: "The Gleaners," "Death and the Wood-cutter," "The Angelus," "The Shepherdess," "The Shepherd," "The Sheepfold," "The Potato Planters," and "The Potato Harvest."

Contrary to his expectations his pictures were received with acclamation. The tide had already set in his favour. Théophile Silvestre wrote about Millet's contributions as one who had discovered the artist. But Millet found in the critic's article very little that revealed any true perceptions. He was less pleased, indeed, by Silvestre's too-long-delayed admiration than by the first-class medal that he received, which was not entirely Silvestre's fault, for Silvestre asked Millet himself to revise the descriptions he had written of his pictures. But the greatest triumph of all, for Millet, was undoubtedly the triumph of his friend Rousseau. Rousseau, "Le Grand Refusé," had become Rousseau, the President of the Jury, and Rousseau, the recipient of the Grand

By permission of M. Durand-Ruel]

THE WARREN INN

Medal of Honour. To Théodore Rousseau, however glad he may have been to receive them, these honours came at the eleventh hour.

In June Millet went again to Vichy, where he made more sketches, obtained more impressions. When he returned in August he found Rousseau, who had been ill periodically for some time, ill now beyond repair. But Rousseau lingered for a while yet—for his malady was softening of the brain, about which there is no hurry; he lingered long enough to receive the news from M. Puvis de Chavannes and Alfred Stevens that he had been made an Officer of the Legion of Honour; and long enough to prove to the full the unfailing devotion of his friend Millet.

To M. Chassaing Millet wrote on the 28th of December, 1867: "My poor friend, Théodore Rousseau, has just died at Barbizon, in the house where we once went to see him together. Poor Rousseau! His work killed him; and to think, my dear Chassaing, what an innumerable number of miserable men and fools are in excellent health." Later he wrote to Sensier: "The death of Rousseau haunts me still. I am so overcome with sadness and weariness that I can hardly work. But I must by some means or other try to conquer this feeling. Eight days have already passed since he was buried. Poor Rousseau! How does he feel in his cold bed?"

Soon we find Millet engaged in erecting some rocks and trees brought from the forest of Fontainebleau over Rousseau's grave. Of one tree in particular he wrote to Sensier: "I have had a fine young oak brought there

with rocks from the forest which is likely to flourish and spread its boughs out well."

So Millet did what he could for his dead friend, small though those offices must have seemed to him. But do what he could, he was not to recover from the loss of Rousseau. His infirmities increased; his times of working and writing became less. Soon the young oak with the spreading boughs was destined to shadow not only Théodore Rousseau, but Jean-François Millet.

In 1868 Millet, although he did not exhibit in the Salon, was made a Chevalier of the Legion of Honour. The reward came unexpectedly to Millet; but more unexpected was the burst of applause that followed the mention of Millet's name by Maréchal Vaillant, Minister of the Fine Arts, who had the distribution of the honours. The bestowal of the red ribbon upon the peasant painter was popular among men of all shades of opinion; by many, in fact, it was considered that the recognition of his genius had been far too long delayed. But although Millet himself may have had some pride in his success, it in no way disturbed his equanimity. He was busy with his work, he was hurrying as men hurry who have something to accomplish within an appointed time.

Since Rousseau's death Millet had discovered a new client, M. Frédéric Hartmann; and in the autumn of 1868 he visited M. Hartmann at Münster. From Münster he went to Bâle, and afterwards to Lucerne, and Berne, and Zurich. But what he thought of these places is not known, nor did he give his impressions of the pictures by Holbein in the Bâle Museum; but we do know

BIRD-KILLERS

By permission of M. Durand Ruel.

JEAN-FRANÇOIS MILLET

the state of mind in which this journey altogether was performed by Millet. "I want to get back to Barbizon," he wrote. "My homesickness continues."

No journey was enjoyable to Millet that had not work as its main object. "My programme," he said "is work."

When Millet returned to his work circumstances combined to destroy his serenity. Lemerre was about to publish a collection of sonnets and etchings; to this Millet was asked to contribute an etching. Misunderstandings arose. Millet made an etching—a medium that he employed with varied fortune—of an Auvergne shepherdess with her goats; meanwhile M. Mérat, who had been asked to write the sonnet that should accompany the Millet picture, selected his subject from a drawing owned by M. Gavet, the beautiful design of two peasant girls watching a flight of wild geese. Yet further trouble arose when matters had been arranged between the poet and the painter. The publisher desired to print 350 copies only of the etchings, and afterwards to destroy the plates. To this arrangement all the other contributors, Corot, Jacquemart, Ribot, Seymour Haden, and Daubigny agreed. But Millet found the destruction of a work of art, no matter whether it was an etched plate or not—one that had been used or not used—a barbarism. At last he consented to M. Lemerre's scheme, but with no good will.

In February, 1869, Rousseau's wife died; and although her life must have been as much of a puzzle to herself as to her friends, Millet took her death very much to heart. It stirred up latent memories within his mind, and,

moreover, Madame Rousseau in her sane moments had been very kind to him. "God knows," he wrote, "I only remember now the good she has done me! I pray for the peace of her poor soul."

Millet had always been an ardent admirer of Japanese art. Indeed, he and Rousseau were at one time almost obsessed by it, Rousseau perhaps more so than Millet. It brought about the only disagreement between the two friends that has been recorded—a rival collectors' quarrel it was, and naturally, under the circumstances, insisted on more seriously by Rousseau than by Millet; Millet, in fact, wrote about the matter humorously to Sensier, and Sensier settled the difference in the only possible way, by arranging that Rousseau should have whatever Japanese pictures discovered by the friends that he had set his heart upon.

After Rousseau's death we find Millet writing about the art of Japan. This time it is no friends' misunderstanding that is concerning him; his letter instead contains some interesting comments on a portfolio of prints sent to him by Sensier to relieve his melancholy.

"I agree with you," he wrote, "in thinking the album which you have sent me very rich and splendid in the arrangement of colours, but that is about all that pleases me. I do not see that fidelity to nature and humanity which as a rule lies at the root of all Japanese art. It is a rare and curious object rather than anything else; and I should prefer to spend my money in buying more natural Japanese drawings (if you should happen to see any), or some fifteenth-century woodcuts."

Neurdein photo] [*Louvre*

SPRING

JEAN-FRANÇOIS MILLET

In 1869 Millet sent his " Knitting Lesson " to the Salon; a picture of a woman teaching a child, a very serious rendering of the subject, but very tender withal. For the Salon of 1870 he prepared " The Woman Churning " and a landscape called " November." Meanwhile Millet's life was uneventful, but peaceful. His financial difficulties were over. Two of his daughters had married, but were constant visitors at Barbizon. His eldest son had obtained some position as a painter, and all his children had arrived at an age to bring happiness into his life, and not a little of the serenity that he enjoyed was due to them. He obtained good prices for his pictures, and one or two dealers were ready to free him from any uncertainty about the sale of his works, but Millet, remembering his evil experiences with Messrs. Stevens and Blanc, refused to sign any further contracts, not even with M. Gavet, for whom he had such a sincere affection. When Millet's earlier pictures came into the market they were always resold for prices greater than he himself would have ever dared to ask. Millet had become famous. His genius was recognized; and before his death, not when he himself was past enjoying the fruits of his struggle. During 1869 and 1870 Millet worked on the "Spring," a picture now in the Louvre, but designed for M. Hartmann, the subject of which he obtained from the little field at the end of his premises. Our reproduction of this picture shows its vivid, manly treatment, and also some of its peculiarly spring-like sentiment. The artist also continued to pour forth his series of drawings for M. Gavet. The arrival of one or

two grandchildren into the family drew his attention particularly to studies of babies and of maternal love. Some of his exquisite, simple, almost Madonna-like renderings of women and children belong to this period.

Of the two pictures that he painted for the Salon of 1870 the best known is "La Baratteuse." This subject he rendered not only in oils but in pastel as well. One pastel is in the Luxembourg, and Mr. Forbes has another version. The reproduction of "La Baratteuse" from the Louvre pastel, which we give, presents the leading characteristics of the picture—the strong statuesque figure of the woman; the refined realism of her action; the poetic illumination of the room; and the glimpse through the doorway—that glimpse which adds so much to the sentiment of the picture, with all that it tells of the life outside the dark interior; of sunlight playing on roof and straw-yard; of life within the distant milking-sheds; and of the movements of the restless, ever-seeking barn-door fowls. The cat lingering around "La Baratteuse" will certainly fascinate all cat lovers. Millet understood cats. He found solace in their purring; and in their sinuous forms a great deal that appealed to his own extraordinary sense of line.

The "November" we also include among our pictures. It will be seen that out of very slight material Millet made a great picture, a great poem. The tale of the fields is his theme—of the earth from which the harvest has been removed, and which now lies broken up, waiting for another sowing. For a brief moment man has ceased his struggle with nature; in the fore-

JEAN-FRANÇOIS MILLET

A WOMAN CHURNING
PASTEL

M to U

ground lies a harrow; above the earth hangs, like a cloud of bees in the air, a flock of ever-watchful birds. Here, as in all such pictures, the play of light and shade is admirably contrived. The eye is carried by easy stages from the foreground right over the hill; right into the luminous sky where there is an infinity of space. And as in all such pictures of Millet's, the forms of the ground and the perspective of them, are given as they could only be given by an artist who had made of such matters a life-long study.

Millet had now returned to his earlier style of painting. His brushwork had become more fluent; his colouring as it was when Correggio was among his masters. Two reasons may be given for his escape from exhausted handling and from leaden and monotonous tones. Millet had gained a greater mastery over his art, and could express all that was in his mind without ever a struggle, without any undue labour. Secondly, he had been doing a great deal of work in pastel; and pastel, as everybody knows who has used it, forces the artist to lay aside sombre tints and express himself in colour, whether he will or not. There can be no better remedy for a painter who has lost his control over colour, than a period of exercises with pastel.

In March, 1870, Millet found himself among the eighteen jurors for the Salon exhibition, the fourth selected. He went to Paris, performed his duties, with no great enthusiasm, one can imagine; for he could have seen among the pictures brought before him but very few that could have in any way aroused even his interest;

and then returned again to Barbizon to grapple with the difficulties of his celebrated "Pig-killers." The "Pig-killers" is an almost repulsive realization of a scene in the courtyard of a farmhouse. Shut in by trees and buildings, this place seems a fitting background for what Millet called "a drama." The actors are four peasants and a hog; there is a contest between them: the beast is opposing with all his weight, with all his strength, his conduct to the slaughtering-block. In this as in all his other works Millet was absolutely consistent, and between his animals and his human beings there is scarcely any difference of expression. Though one may admire the dramatic force of the picture, to say that it is repulsive is scarcely an exaggeration.

By permission of M. Durand-Ruel].

NOVEMBER

CHAPTER V

THE END OF THE STORY

BEFORE "The Pig-killers" was completed war had broken out between France and Germany, and the Germans had already begun their march into France. Millet stayed at Barbizon until the issue of the campaign was placed beyond any doubt, and then he and his family packed up their principal belongings and fled, out of the way of the ubiquitous Uhlans, to Cherbourg. Here, while the Germans completed their triumphal progress, he lived in the house of his old friend, and the father of his son-in-law, M. Feuardent. As soon as Millet had accustomed himself to his fresh surroundings, and to living in a town that was subject to the rumours and panics of war-time—he was arrested once for drawing in the streets—he began to work within the house upon two pictures which were afterwards sent to London to M. Durand Ruel, who had left Paris, carrying with him some important paintings, at quite the beginning of the war.

Millet's canvases both represented scenes on the Gruchy coast. The immensity, and cruelty, and loneliness of the landscape, so well known to him, he realized as he had never realized them before. The sentiment with which he invested these pictures was just the sentiment that would characterize the work of any great painter of poetic temperament, who was trying to work under cir-

cumstances strange, untoward and harrowing; for his country's woes weighed upon Millet heavily. When peace was declared the artist would have returned to Barbizon, but Paris had not yet settled its own internal differences, and he left Cherbourg only for Gréville, where he and his family stayed at the principal inn. At Gréville Millet threw off the shadow which recent events had cast upon him; we know from Madame Polidor, the landlady of the inn, that he and his great family of children were very happy there; we know that he revelled again in atmosphere clear and bright. While he was at Gréville he painted from the inn window that brilliant little study of the village church, which is now in the Louvre.

On the 7th of November, 1871, he returned again to Barbizon, but not before he had entertained Sensier at Gréville, and had made him acquainted with all the scenes of his youth. He showed Sensier his parents' grave, and the house where his parents and grandparents had lived, and the fields that they had tilled, and while showing him these things he spoke often with tears in his eyes; the farm had altogether passed from the Millet family, and it went to his heart that the house and lands had fallen into the hands of strangers; that where he had been free to wander at his will he could only walk now as long as the strangers permitted him. Together with Sensier he visited Eculleville, the Priory of Vauville, and Hameau Cousin, places that he painted afterwards on his return to Barbizon. He not only showed Sensier these scenes but, unknowing, saw many of them himself for the last time. Although he promised Madame Polidor—the inn-keeper's wife of

Gréville, who had entertained Millet and his vast company of children with so much goodwill, with such pleasure to herself, "We should have liked to have kept them always," she remarked afterwards—that he would be there again within a year, the return visit was not to be. When Millet reached Barbizon in November, 1871, he was to remain there; occasional visits to Paris, of course, were before him, but nothing more, until his final journey to that land of which no man knows.

Millet returned to his old home, to a life of some comfort and of prosperity; illness only came between him and a life of perfect ease. He had mastered his art; he had mastered the critics; he had mastered the public. "Durand Ruel," he wrote to Sensier, "has asked me to send him as many pictures as possible, canvases of all sizes." We even hear of an assistant from Durand Ruel's coming to Barbizon to assist Millet in unpacking his Gréville pictures. Millet himself, with his simple mind, must have indeed marvelled over the change in his circumstances; must have looked back with wonder at the time when the very pictures which were now being sold and re-sold at ever higher prices were worth but little more than the very canvases they were painted on.

Several very advantageous offers were again placed before him by dealers who wished to obtain a monopoly of the sale of his pictures, but Millet refused to listen to their blandishments. He had not forgotten his affair with Messrs. Stevens and Blanc; he had also a number of commissions unfulfilled—from M. Hartmann, for instance; all the landscapes he had begun for him were

still undeveloped, even the "Spring," although several seasons had passed since it was first placed on the canvas, was far from finished. Nor could Millet at any time have been a person well suited to form a contract with a dealer, who is bound to look upon a picture more or less as merchandise, who must sell his wares when the opportunity for doing so offers itself, and cannot often afford to wait during that long process of incubation to which an artist of imagination is often obliged to submit his ideas.

Millet preferred to have on hand a dozen or more pictures at the same time. Sometimes he allowed a canvas to remain untouched for years. He worked mostly from memory or from very slender notes, and cared only to paint on a picture when he felt absolutely in sympathy with his motive: when he felt the longing and the power to add to his canvas something that was not already there. That he had extraordinary facility when necessity compelled him to make a painting we know from Mr. Wyatt Eaton. He told Mr. Eaton that while he was living in Paris a dealer would oftentimes come to his studio for a picture when he had no picture by him, finished or unfinished. He would then give the dealer a book and ask him to wait in an ante-room, saying, that he had but to put a few touches to a canvas; and while the dealer read Millet would paint from beginning to end one of those wonderful little pictures of a nude figure, which more than ten years ago, when they were offered at a public auction, realized some thousands of pounds.

Some of the pictures that the artist occupied himself

JEAN-FRANÇOIS MILLET

By permission of M. Durand-Ruel

THE WASHERWOMEN

with on his return to Barbizon were naturally suggested to him by his Gréville sketches. He made one or two landscapes and a pastel of "A Woman carrying Milk" from the oil-picture that he completed or carried almost to the point of completion at Gréville—in the oil-picture the woman, who bears a copper vessel upon her left shoulder, is a vast menacing figure, in the pastel she is a younger woman, moves with a more elastic step, and, if a less impressive, is a far more graceful creature. Other pictures that engaged him were suggested by the recent introduction of grandchildren into his home circle. Three of his daughters were now married: one had become Madame Feuardent, a second Madame Saignier, while a third had married a M. Haymam. It was from Madame Haymam that he painted the mother in "La Maternité," one of the few of the larger enterprises that he began about this time and finished before his death. Although we are told that Millet in this picture worked from his young daughter, what he has presented to us is a peasant of peasants, coarse-limbed, coarse-featured, and clumsy in gesture. Yet about this picture there is a marvellous pathos. The young mother holds her child between her knees, the babe stretches out its arms, making with its partly bound-up little body a distinct form of a cross. On the mother's face is the stigma of toil, of child-bearing, and of outdoor labour; it bears, too, a look of infinite pity for the infant that already seems to be possessed by some foreshadowing of its destiny. In the background, in the dim mystery of a darkened room, nailed up against a wall, is a small image of the Madonna.

The woman and child in this picture are life size, and are both painted with considerable breadth.

In 1872 illness had already laid a firm grip upon Millet. In August he writes to Sensier: " I have not yet finished my church of Gréville. I have done little. I have groaned more than I have worked." On December 31st he writes in even greater trouble about himself: " My eyes have been very painful. They are better; my left eye, however, is still inflamed. But I am oppressed with all sorts of pains. And I work very little, which distresses me greatly."

In February he writes to M. Hartmann mainly about the pictures that he had begun for that collector—about the "Spring"; which already for many years had had an occasional place upon his easel. "You may reckon upon taking your picture of 'Spring' back with you. I promise positively that you shall have it in May. By that time I shall have made some progress with the 'wheat-ricks,' and have worked at the others."

In April the approach of a sale at the Hôtel Drouot brought Millet some temporary anxiety. The collection of M. Laurent-Richard, who had bought a few of Millet's pictures was to be dispersed. But when the sale occurred it was found that Millet had troubled himself about the matter unnecessarily. His "Woman sewing by Lamplight" realized thirty-eight thousand francs, and when a little later "The Angelus" was bought by Mr. J. W. Wilson for fifty thousand francs, even Millet himself must have recognized that the message he had tried to deliver to the world, for so many years, with such un-

failing care, and with such unfailing courage, was at last accepted.

Yet the signs that the Master was approaching his end became more and more insistent. Millet himself recognized them. In September, 1873, he wrote to Sensier: "Since I saw you I have suffered greatly. My cough kills me. Only these last few days am I any better. I am breaking down completely, I assure you." Yet for all his weariness Millet continued to receive solace from the practice of his art, from the knowledge that it was bringing a new light into the lives of many of his fellow-creatures, and from the companionship of his innumerable friends and his beloved family. It was in 1873 that Mr. Wyatt Eaton, who had been studying art in Paris under Gérome, first came to Barbizon, and from him we obtain some very reliable impressions of these last few years of Millet's life. Mr. Wyatt Eaton had seen Millet's picture of "The Woman sewing by Lamplight," and for a while there was for him no other painter in the world but Millet. He approached the great Master full of veneration, and the more he saw and talked with the artist the more this reverence for him increased. Millet conversed with the young student freely about nature, and himself, and his art. Of landscape painting he said that "he wished a landscape to give the feeling that you are looking at a piece of nature—that the mind shall be carried on and outside its limits to that which is lying to the right and the left of the picture beyond the horizon." Mr. Eaton asked Millet on another occasion if anything in nature was not beautiful. To this the great painter

replied with some energy: "The man who finds any phase or effect in nature not beautiful, the lack is in his own heart." That Millet's own sympathies were particularly aroused by very simple motives for pictures we also learn from Mr. Eaton. He tells us that when Millet lay on his death-bed, "he would look out from his bedroom window into his garden and at his closed studio door, and long for more opportunities of painting many of the things that had particularly appealed to him; and he would describe to his son any motives that haunted him; not grandiose subjects for colossal canvases but some quiet nook, perhaps, in his native Normandy, the side of a hill, a road, and a few trees. Could he but live he had so much that he would still say; he would show what could be done with such simple material."

From Mr. Wyatt Eaton, who also made an excellent drawing of Millet, and therefore had observed him closely, we have as well a very convincing word picture of the Master. He writes: "I have often been told of the magnificent appearance of Millet as a young man—tall, proud, square, and muscular, and of enormous strength. As I knew him he was broad and deep-chested, large and rather portly, always quite erect, his chest well out. His face always impressed me as long, but it was large in every way. All the features were large except the eyes, which at the same time were not small; they must have been very blue when young. The nose was finely cut, with large dilating nostrils; the mouth firm; the forehead remarkable for its strength—not massive, but in the three quarter's view of the head, where usually

JEAN-FRANÇOIS MILLET 113

the line commences to recede near the middle of the forehead, with him it continued straight to an unusual height. The hair and beard were originally a dark brown, the beard strong and heavy; in his last years they were of an iron-gray. His voice was clear and firm, rather low in pitch, and not of that deep bass or sonorous quality one might have expected from so massive a physique."

By the side of this description it is interesting to place another, also by an American artist, Mr. Wheelwright, written from notes made by him as early as 1855, nearly twenty years before Mr. Eaton went to Barbizon. "I had," writes Mr. Wheelwright, "been told that he was a rough peasant; but peasant or no peasant, Millet is one of nature's noblemen. He is a large, strong, deep-chested man, with a full black beard, a gray eye that looks through and through you, and, so far as I could judge, during the moment when he took off a broad-brimmed, steeple-crowned hat, a high rather than a broad forehead. He made me think at once of Michael Angelo and of Richard Coeur de Lion."

Mr. Eaton does his best to do away with an impression, which he says exists in England, but which I think has held its ground everywhere, that Millet at all times and in all places wore only the garb of a peasant. When he first went to Barbizon, and during his occasional visits to Gruchy, one can imagine that he did dress as a peasant; very much out of gaiety of heart. But later in his life—is there not the well-known photograph, mentioned by Sensier, of Millet standing up against a wall to inform us?—it seems that Millet's dress was very much what a

man living in the country would wear, who had no desire to spend money on clothes, and who, anyhow, preferred comfortable clothes to fine ones. At all times, while he was in the country, he wore sabots. But this was not an affectation on his part nor a special sign of rusticity. What landscape painter who has to tread through muddy lanes and sodden fields, and dew-drenched grass would not wear sabots, if custom had enabled him to wear them with any comfort? When Millet went to Paris he cast his country garments on one side, and entered the capital dressed as an ordinary citizen in leather shoes, a black coat and silk hat. Naturally he was not comfortable in these clothes; who has not after a long stay in the country rebelled against the tyranny of a town outfit? But he preferred this bodily discomfort to the mental disquietude that a sensitive man feels, who goes among his fellow-creatures in any sort of conspicuous costume. Indeed Millet's rusticity has been a little too much insisted on. He suffered if anything from an over-cultivated mind. Half his troubles with his critics arose from his ability to penetrate the shallowness of their contentions; had he been less before his age he would have had a longer period of prosperity; he could scarcely have had more friends under any circumstances; but there was no doubt that the people of Barbizon felt that there was a gulf between them and him, and that Millet felt the same thing; we know that upon his wife fell the burden of interviewing any men and women whom he required to pose for him.

By 1874 the public had honoured Millet; so had the

JEAN-FRANÇOIS MILLET

critics; and in that year the State paid tribute to him also. Of Millet's art the Emperor who had seen no work by the painter before 1868 said: "Enough! the noise about this painter of sabots is a vulgar one." But the Republic was better informed. On the 12th of May, 1874, the Minister of the Fine Arts signed an order commissioning Millet to decorate the walls of one of the chapels of the Pantheon; for this work he was to receive the sum of fifty thousand francs. The Pantheon being dedicated to Sainte Geneviève, Millet was required to illustrate the story of the patron saint: to picture the "Miracle des Ardents" and the procession of the shrine of Sainte Geneviève—eight subjects in all—on four large and four small panels. Millet was delighted with the commission; the painting of the panels for the house in the Boulevard Haussmann had developed his taste for doing large decorative work, and he was pleased with the recognition of his genius that the order implied. Immediately he went up to Paris to see the chapel for which the paintings were ordered, and found that it was so dimly lit that he would have to accentuate very much the silhouettes of his figures, relieving always his dark forms against light backgrounds, and setting his light figures only in front of masses strongly shadowed. His intention was to so tell his story in these pictures that their meaning should be perfectly evident even to those who were entirely unfamiliar with the legends of Sainte Geneviève. He held that an absence of book knowledge should not interfere with a spectator's enjoyment of a picture.

But alas! This order had come too late to Millet. It gave him pleasure; it engaged his thoughts during his last months of suffering, it caused him to make a few slight charcoal sketches, but that is all. In the summer of 1874 Millet's health was fast failing him. He complained to Mr. Eaton, about then, that often he had not sufficient energy to rise from his seat to fetch fresh paint; that he would instead dig with his brush at the dry colour which was already on his palette. He would spend hours pondering over his designs for the story of Sainte Geneviève. Although the power of performing elaborate handiwork was gradually departing from him, his capacity for using his brain still remained unimpaired; the outer works had been captured by approaching death, but the citadel still remained intact. Mr. Wyatt Eaton tells us that he would sit alone after dinner at the table staring at the cloth, making movements with his hands as if he were completing a design, now moving his hand over the cloth as if he were obliterating some portion of his scheme, now moving his hand hither and thither as if he had been inspired suddenly by some new idea.

Although it is probable that Millet himself knew that his days were numbered, he continued to work at intervals, and he never ceased to make plans for the future. He finished his "Priory," one of the landscapes that he began soon after his return from Gréville; this was sent to America, to Mr. Quincy Shaw, who had already acquired many of Millet's famous works. He finished also his "Spring" for M. Hartmann, and made a sketch for "A Sewing Lesson," another of his peculiarly tender

renderings of maternal solicitude—a series of subjects that Millet treated so simply, so directly, so entirely without sentimentality, and yet with the full consciousness of the delicate understanding that usually exists between a mother and her young child.

In December of 1874 Millet became at times delirious. During his days of calm he talked a great deal to his children. Like the dying father in the fable, he placed before his sons and daughters the blessings that arise from family concord; and to them he deplored that he was dying, just when he was beginning to master his art, and when nature was beginning to tell him some of her more hidden secrets. He lingered over Christmas and the coming of the New Year, a time that always before with Millet and his children had been a period of merrymaking.

Towards the end of January there happened an incident which might well have hurried the death of the great painter. A stag, hard pressed by hunters and hounds, took refuge in the garden of one of Millet's neighbours. The artist, who had fallen asleep, was aroused by the shouting of men, the firing of guns, and the barking of dogs. He, who had been named after St. Francis, was no friend of sportsmen, of the men who find their pleasure in the killing of God's creatures, either great or small, and the sounds of the butchering of the poor maddened stag filled him with horror. "It is an omen," he said. "This poor beast which comes here to die, comes also to warn me that I am about to die."

Within a few days the mighty brain which had given

birth to "The Sower," "The Gleaners," "The Angelus," and many another masterpiece was at rest. Millet died at six o'clock in the morning on the 20th of January, 1875. At his own request he was buried at Chailly, and after the manner of a Barbizon peasant. The day after he died a neighbour went the round of the village announcing the death and the time of the funeral, and when the burial did take place, all the inhabitants of Barbizon collected together and followed the dead painter to his grave. Many friends, artists, and critics were also in the procession. The Minister of the Fine Arts was represented; and had the weather been less inclement, had the death taken place at another time of the year, there is no doubt that the gathering in Chailly churchyard would have been far greater. During the funeral and before the ceremony the rain fell unceasingly, and no speeches were made at the grave-side, but those who bore Millet to his last resting-place, had at least the satisfaction of knowing that, dismal though their office had been made by weather and other circumstances, they had at any rate buried their friend where he wished to lie, by the side of Théodore Rousseau, his well-tried comrade.

Millet's death was followed by a lament which was echoed all over France. To the few critics who at the time of his death still remained hostile to him, there came a great light, and they hurried with the rest to heap laurels upon his grave.

M. Gavet held an exhibition of drawings by the Master, for the benefit of the widow, in the Hôtel Drouot,

By permission of M. Durand-Ruel]

THE CHURCH OF CHAILLY

and to this the people flocked, but neither the money raised in this way, nor the pension of £48 granted to her by the State, were in the end to Madame Millet of more account than a gratifying recognition of her dead husband's greatness; for the sale of the pictures and sketches found in Millet's studio realized at the Hôtel Drouot the substantial sum of 321,034 francs.

And so Millet lived his own life. He did what he liked; what he did he knew was noble. He lived where he liked, he lived a life simple, wholesome, inspiring, and free from any influence that might draw him from his splendid quest. He had the friends that he required, and a family to love him; and for fully five years before his death he knew that his search had been successful, and that all intelligent men bowed down before his discovery. Truly Robert Louis Stevenson did well when he wrote: "To pity Millet is a piece of arrogance."

JULES DUPRÉ

THE POOL.

By permission of M. Durand-Ruel.

JULES DUPRÉ

ALTHOUGH Jules Dupré has departed from amongst us within a comparatively short time, less probably, that is definite, is known of him than about any of the masters of the 1830 school. Stout fighter though he was, he was also a man of reticence. None helped more bravely than he to maintain the position of the Romantic School when its right to exist was contested. When he could, however, when the occasion permitted him to do so with dignity, he appears always to have retired into the background; and when their fight was over, and won, and the men of 1830, with but one exception, dead, Dupré stepped altogether from the front, and allowed the wordy wars that forever rage around art to proceed upon their course without him. Even before he died Jules Dupré became almost like unto a myth. Who amongst us, among the legion of painters who swarmed into France during "the eighties," to study or to paint the country, actually realized that there lived at that time, living a life of almost monastic peace, an artist who had seen Constable's triumph in Paris; had watched and had taken part in the birth of the French Romantic School of landscape painting; had been the intimate friend of Rousseau, of Millet, and of Diaz? Who amongst us would not have felt almost as much surprised at find-

ing himself sketching within sight of Dupré and his easel, as if, somewhere among the shadowy ways in the valley of the Somme, he had encountered the robust person of Père Corot? And yet we—at any rate most of us—really knew that Dupré was then alive, living his life out far away from the scene of his triumphs, painting, and painting large canvases too, but with no thought of exhibitions or of critics, but painting for himself, and for those to whom the increase of beautiful things in this world remained still a matter of importance.

Where Dupré was born, exactly, there seems to be some doubt. Writers have found two birthplaces for him, but the majority are, I believe, of opinion that he first saw light at Nantes. 1811 was the year of Dupré's birth: that is, he was born one year after Diaz, one year before Rousseau, and three years before Millet.

His father was a porcelain manufacturer, in whose factory it is believed that Jules Dupré at one time worked; it is also known that Dupré was later to be found at Sèvres in the factory of his uncle, M. Gillet, where he had the inspiring companionship of Cabat and of Diaz.

After leaving M. Gillet's factory he did not immediately commit himself to the uncertainties of an artist's life. Instead, he took lessons from a M. Diébold, who had formerly aspired to be a painter of importance, but who taught Dupré to be, what he himself was at the time, a painter of clock faces—not of the faces of drawing-room clocks, of clocks framed in dainty china-ware, or in resplendent ormolu; but of the faces of clocks of ample proportions—clock faces perhaps a foot or more square,

JULES DUPRÉ

on which a would-be painter of landscapes, who had just been released from the tyranny of china decorating, could spread his brush with some degree of pleasure and importance.

M. Diébold lived at Ile-Adam, which, if it was not Jules Dupré's birthplace, as some assert, was at any rate very near to it. From Ile-Adam, and from the painting of clock faces, an occupation with limitations that must very soon have occurred to a man of an artistic temperament, Dupré was in the habit of straying Pariswards, for the main purpose, so M. Ménard tells us, of visiting the Louvre, and studying the Old Masters. During one of these visits he encountered Cabat, his old fellow-apprentice in the factory of M. Gillet. Cabat was still under M. Gillet's direction, but was allowed by his master to spend some time in studying and copying in the Louvre. The result of this meeting can easily be imagined. Cabat became immediately Dupré's guide and friend. At the time of the meeting Cabat was copying a landscape by Isaak Ostade, and this fact alone must have given him some ascendency over his former companion. Dupré, anyhow, listened eagerly to Cabat's discourses on art; and soon we find Dupré not an occasional visitor to Paris, but a dweller in Paris, the occupant of a garret, and a landscape painter; at first very much more for his own gratification than for the gratification of other people. We find him wandering around Paris, painting whatever attracts him, painting with enthusiasm, but at the same time having an uncommonly hard battle with poverty.

But at last there came to Dupré, as there comes to

most people who have the strength to work and to wait, encouragement and brighter days. Dupré's fairy did not turn out to be a picture-dealer, with a well-filled face and a white waistcoat, but a more romantic individual altogether—a nobleman—a marquis—a man of taste, and a kind man withal; a man who was very eccentric, but whose eccentricity was by no means to be despised. He bought his first picture by Dupré in—this tells how Dupré was, at that time, accustomed to dispose of his works of art—in an old-clothes shop. After the purchase he asked for and was given the address of the artist.

Of the information that he had obtained about Dupré, the noble marquis made use at the very time when the artist—if he was awake—was least expecting good fortune to come to his door. At five o'clock in the morning a struggling man, if he is not asleep, is more likely to be concerned with his present ill-luck than with his possible future good fortune. At that hour the marquis climbed to a sixth floor, at the address given to him, to the room occupied by Jules Dupré.

It is not to be wondered that Dupré, having admitted the stranger, for a while imagined that he was entertaining a lunatic; for his visitor at first addressed him in nothing but words of censure, which he accompanied by violent thrusts with his umbrella. While, however, Dupré was dressing hurriedly, in his desire to escape from his room and his unwelcome companion, the marquis threw a new light upon the object of his visit. He began to walk around the room, and instead of blaming Dupré for his laziness in being still in bed at five o'clock

in the morning, he began to praise the sketches which were nailed up on the walls.

"For how much will you sell those studies, young man?" asked the marquis, suddenly turning towards the artist.

"Twenty francs each," answered Dupré, "and you can take any of them that you like."

"I will take them all," replied the marquis; and he began at once to pick out the little nails which fastened the studies to the wall.

The marquis collected his pictures, and paid for them, placing the pieces of gold carefully, one after the other, upon Dupré's only table. But the marquis's visit was not to end here; his mission was not to cease with the buying of a dozen or so of Dupré's studies; it was his part to do far more for the young painters, who were already at desperate conflict with the maintainers of classical traditions. Having referred in a sententious voice to the special advantages that arise from the study of nature, the marquis told Dupré that he must also know how to preserve his impressions, and make them into pictures. He then proceeded to commission Dupré to paint for him a picture. The subject of this picture, he said, was to be a landscape, the design of it he left, to a certain extent, to the artist, but he insisted that it must contain a road. On this road he wished there to be a *bonhomme* or *une bonne femme*, whichever the artist wished, but gods or goddesses, or any of the creations of ancient myths, he would not have in his picture.

"It must," he added, "be a *bonhomme* and not a

personnage, such as artists usually introduce into their designs, for my picture must bring back to me the country. I am a sportsman, and when I am on a road I often meet *bonhommes*, but never *personnages*. That is why in a landscape I wish to see a *bonhomme*, and do not like to see a *personnage*. You understand, do you not, young man?"

Jules Dupré painted the landscape, and it contained a *bonhomme*, and the landscape was just such a landscape as would contain a *bonhomme*; and from that time the direction in which he should employ his talents was insured. The marquis brought other clients to his door, and his success was also insured. M. Ménard does not give to us the name of the marquis, which is a pity, for it should be written in any book that has to do with struggles of the Romantic School.

In 1831 Dupré, although but a young man of nineteen, exhibited for the first time in the Salon. And not only did he exhibit there, but his work immediately created a favourable impression, among the critics at any rate.

Notwithstanding that he was a revolutionist, the departure of Dupré from the accepted way never appears to have created any rancour. Dupré was by temperament a mild man, and what emotions he had at his disposal, he preferred to exhaust over the development of his pictures, rather than by participating in quarrels which might in the end prove but futile. This evenness of mind gleams through his work, and must have touched the hearts of countless juries, to whom his pictures cannot always have appealed in a pleasing light, and

JULES DUPRÉ

By permission of M. Durand-Ruel]

SUNSET

to whom he was personally unknown. Dupré's pictures were not always to be found in the national exhibition, but that was because he himself often desisted from sending work to the Salon; in his youth, because of his allegiance to his party; in his old age because his interest in exhibitions had entirely ceased. His pictures were not always well hung, but that was very likely because they did not always deserve to be well hung. He received only a second-class medal: this was bestowed upon him twice; but on the other hand in 1848 he was decorated with the cross of the Legion of Honour.

In his choice of subjects Dupré began very much as he was to go on. It was the quiet pastoral beauty of his landscapes which attracted the critics in 1831, and we who live now like most of the other work that Dupré left behind him for very much the same reason. He also, of course, painted many remarkable sea-pieces; but these, with all their vigour, are ever palpably the work of a man with a sane, and serene mind. Yet notwithstanding his sanity and serenity, Dupré was possessed of emotions which became very poignant when the artist allowed them full play. In one picture that we reproduce in this book—the composition of a single tree standing on the edge of some water, and a sinking sun seen beyond a level marshland—we have drama enough, but it is drama which does not excite: it is a drama dignified and momentous, which stills the mind into a state of placid contemplation. The same sentiment which characterizes so many of Dupré's canvases we notice in his two upright pictures—"Morning" and "Evening"—in the

Louvre. We notice it, too, in so many of his sea-pictures. I can remember one sea-picture, in particular; it was shown but a little while ago in London, in a public gallery. Here the sea was seen through the envelopment of a blue moonlit night, and the feeling the picture left upon the mind was one of immensity, and of a marvellous quiet, which was broken only by the splash, splash of the waves upon the rocky shore. I remember standing before the picture, waiting for the sound, in very much the same mood that I have stood in a large, empty, unlit room listening to the slow, slow ticking of a clock.

We learn from M. Besnus that before any particularly romantic aspect of nature Jules Dupré could be intensely moved. He remembered leaning with the artist against a bridge in the Ile-Adam watching some strangely vivid effects in the sky, during a night of storm. Dupré was all the while in a state of nervous excitement, fearful lest he or his friend should miss any of the splendid or moving sights that the troubled sky was revealing. Once the storm-clouds passed momentarily from the sky, and above them there was one vast sheet of silver. "Just then," says M. Besnus, " I looked at Dupré, his beautiful face was convulsed, he wept."

In 1834, when he was but twenty-two years of age, Dupré was awarded, for the first time, a second-class medal. This honour must have been very unexpected by him, for only the year before he had in a somewhat pronounced manner taken his place among the ranks of the revolutionary painters, and had sent to the Salon

JULES DUPRÉ

[Collection of Sir John Day]

THE APPROACHING STORM

JULES DUPRÉ

a composition which although brilliantly painted set all the precepts of MM. Bertin and Michallon, the last of the really classical landscape painters, at nought.

After this success he came to England, and painted mostly about the flat country which lies to the east and west of Southampton, and he also made some studies of the wonderful Plymouth Sound.

I have seen several of the pictures made near Southampton, and it seemed to me that no man has ever more nearly obtained the sentiment of that desolate open country. I remember one, a long canvas it was, and it gave a large acreage of meadow land, split up by a waterway. In the distance there were some low hills and in the foreground a group of horses, one was a white horse. In the sky was a big dominating cloud coming up from the horizon. Before this picture, as before the blue marine of which mention has been made, I held my breath waiting, waiting: there was something about its noble, but simple composition that was extraordinarily portentous. If this be the picture exhibited by Dupré in 1836, under the title of "Vue d'Angleterre" I cannot agree with the critic of the "Revue de Paris" that its greens are as crude as malachite. But age after all may have tempered them. Or there may be another reason for the difference of opinion. What may have appeared as a crude green to an art critic of 1836 would seem but a sombre and decorous hue to a poor writer on art of 1903, whose eyes have become accustomed to all sorts of viridian horrors.

But that Dupré's pictures were far gayer in colour at the outset of his career than towards the end of it we

have ample evidence always at hand in the one example of his work included in the Wallace Collection. In "Crossing the Bridge"—this painting—we are almost reminded that Dupré was once a painter of china-ware, so very rosy are the roseate clouds, so very positive is the green of the well-designed trees. This picture, too, gives us ample opportunity of studying Dupré's brushwork before he loaded his tools with paint, and approached his subject with a perhaps too preconceived idea of how he was going to deal with it. One can note, as in his English studies, how tentative his handling was then; now anxious the artist then was to give expression to the different forms and surfaces that occurred in his subject.

Quite early in their careers Dupré and Rousseau appear to have met, and without any great preliminaries, to have become fast friends. Dupré, perhaps, more immediately appealed to Rousseau than did the excitable Diaz.

As early as 1833 the two artists had become sufficiently intimate to make long expeditions together in the Dauphiné. In the following year, on the very eve of a trip to Switzerland, where he would have been in the neighbourhood that he longed to be, "near to the clouds, to contemplate the region of the tempests," Rousseau hesitated, being loath to part with his friend Dupré— Dupré being also on the eve of a departure to the land of his heart's desire: to the land of luxurious meadows, and gently flowing rivers. Rousseau at length started on his journey, but not until he had arranged to spend

JULES DUPRÉ

THE MEADOW

By permission of M. Durand-Ruel

part of the season with his friend among the pastures of Les Manches.

In 1841 we find that the friendship between the two men has become still more advanced: no longer are they satisfied with frequent meetings, and occasional journeyings into the country together in search of material for their pictures. In 1841 they decided to live together, and to have studios side by side. In this joint establishment they succeeded in obtaining the interest of Madame Dupré, the mother of Jules, who eventually came to live with them, and by attending to their household affairs, added very much to their comfort. Still closer had grown, according to Sensier, their intimacy in 1844, when neither artist was in the habit of accepting an invitation unless that invitation had been extended to both of them. During this year they painted together at Landes, on the Bay of Biscay. During the following year they went to the Ile-Adam, and about this time Dupré gained over his friend such a control as has been given scarcely to any other artist to exercise over another.

Among Rousseau's unfortunate propensities was that of working upon a picture long after it had passed its highest state of development. This Dupré noted, and when his friendship with Rousseau became close enough to warrant so summary a proceeding, he contrived to save many a canvas from partial ruin by forcibly removing it from Rousseau's easel. During the winter of 1845, while they were at Ile-Adam, Rousseau painted his picture of a landscape covered with hoar-frost, "Le Givre," and he did this—most probably under the influence of

Dupré—in so short a time as eight days. On their return to Paris, Dupré, fearful of allowing "Le Givre" to remain in his friend's possession, took the picture one morning under his arm and walked about the Paris streets until he had delivered it into the hands of a purchaser. This purchaser was M. Baroilhet, the famous baritone and a friend of Dupré's, who gave Dupré twenty pounds for the picture, and who sold it, twenty years after, for £680; so Dupré's kind and timely action did not benefit Rousseau alone.

In 1847, Dupré who had always felt keenly the refusal of his friend's pictures by the Salon jury abstained altogether from taking any part in the exhibition himself, and he and Rousseau together with Decamps, Delacroix, Barye, Ary Scheffer, C. Jacque and Daumier, who all had an antipathy to the Salon jury as it was then constituted, founded a society called the Nouvelle Société. The reason, however, for the existence of this society did not long remain; for in the following year, shortly after the proclamation of the Republic, a new order was issued by the Director of the National Museum of the Louvre. By this decree the entire body of artists was invited to elect a Salon jury, which was not only intrusted with the selection of the pictures for the exhibition, but was also to have the distribution of the medals, and was to arrange as well what pictures should be purchased by the State. This jury, when elected, included Rousseau, Dupré, Corot, Eugène Delacroix and Couture. Indeed, it seemed as if the Romanticists were about to enjoy their rights. Rousseau, however, did not make the most

JULES DUPRÉ

of the opportunity that this exhibition offered to him. Although he must have had many unexhibited pictures at his command, he exhibited nothing. Yet both he and Dupré were fortunate enough to receive commissions from the State: from both painters a picture was ordered, for which in both cases a sum as large as 4,000 francs was paid.

But alas! The year that followed, 1849, with all its promise, ended very sadly for Dupré. It has been surmised that for long Rousseau—who had suffered much for his art, and for whom therefore every excuse can be made—had regarded with no little envy Dupré's easy disposal of his pictures. He had not taken into consideration, possibly, the difference that existed between his own pictures and Dupré's—the difference that arose from the different temperaments of himself and Dupré—the difference that made Dupré's work easily saleable and his own unsaleable. Few of Rousseau's pictures but give evidence of his restless, strenuous and highly poetic nature—a nature which makes a man not always pleasant to live with, but which enables him often to produce great works of art. These works of art, like their makers, are not always comfortable companions, and he who possesses such pictures must sometimes make such sacrifices as few people are willing to make. Dupré had a placid, contemplative mind, his pleasant waterways, his flat or undulating pastures, his delightful pieces inspired by nature, always arranged with care, elegantly often, but never fantastically, or with any marked degree of originality, are just the pictures that

calm the beholder and lead him into the land of peace. Certainly some of Dupré's pictures are dramatic, but none are tragic; none arouse the mind to any uncomfortable extent; and as to their technique, the brush-work of his early pictures is by reason of its suavity in itself peace-giving.

But whether Rousseau was really hurt by his friend's financial success is only a surmise; about what happened after the exhibition of 1849 there is no doubt whatever. At this exhibition both artists were well represented: Rousseau sent three canvases, the first that had been shown by him in any public gallery for many years. So far all went well, but with the distribution of the medals and honours, discord made its entry. To Rousseau was allotted a first-class medal; but Dupré—Dupré, whom Rousseau before had always regarded as a friend, but never as a rival—Dupré was decorated with the ribbon of the Legion of Honour. This preference of Dupré's work to his own, Rousseau ascribed, for some reason or another, not to the wrong-headedness of the authorities, but to the machinations of Dupré; and no counsel was equal to driving this idea out of his head. In the end the two men quarrelled and separated, and the more sensitive of the two, and the really injured one, proved to be as usual the greater sufferer. For three years after this event Dupré exhibited no more, and so distressed was he by Rousseau's suspicions, that for a year or so after 1849, we are told, he did not even paint.

When Dupré did take up his brush again, and when he again exhibited, it was noticed that a great change

JULES DUPRÉ

had come over his work; what that change was students of Dupré's pictures are fully aware. While he had abstained from painting he had been brooding over his art; and his new work showed a very positive intention to arrive at a more personal and expressive technique, and a more poetic intonation. Dupré we know was always a thinker, he was fond of little sayings, definitions and axioms, which his friends treasured up, and which are interesting, because they prove that the artist created for himself a complete theory of his art. Certain words of his, quoted by M. Clarétie, may here be aptly used, for they prove undoubtedly what was in Dupré's mind when he laid aside his earlier, elegant, and somewhat conventional technique, and started on the road towards his later, more robust, more individual method of painting. "Nature," Dupré said—according to M. Clarétie—"is only a pretext, art, passing through the individual, is the goal. Why does one speak of a Vandyck, a Rembrandt, without saying what the picture represents? It is because the subject should disappear, so that the individual only, the creator, may exist. Another example; one says, 'stupid as a cabbage.' But who dares to say 'stupid as a cabbage painted by Chardin?' It is that the human being has passed into it."

It was not until 1867 that the style at which Dupré intended, or at any rate was destined, to arrive, was clearly evident. When he first of all parted from his old course, he retained some of his former varied and brilliant colouring, but his painting was a little rigid. In 1867 the early brilliant colour had departed altogether, and

so had the precise handling. The new brushwork was large and forcible, the paint being often laid on in thick impasto. A larger harmony of colour had been also striven for, and, in some cases, arrived at; but some critics averred then, as some critics aver now, that these simpler harmonies of Dupré were not obtained without some considerable sacrifice of truth and of local colour. M. Paul Mantz in noticing "The Bridge at Berry," "The Forest of Compiègne," "Morning," and other pictures which Dupré sent to the Exhibition of 1867, wrote: "The trees freely affect tints of red and yellow, which seem to be systematic; M. Dupré can no longer find on his palette those bold greens and powerful blues, which have been the delight of our youth." That Dupré was then, and remained afterwards, somewhat mannered in his colouring, no one will deny; but there are not a few to whom this sacrifice of local colour in his later pictures is not unwelcome. His brown trees often play a valuable part in the decorative scheme of his pictures, and to a certain impressive tonality, which Dupré at one time almost habitually aimed at, they are, indeed, wellnigh indispensable. To the objection that they have but little reference to the tones of nature, one can but quote again the words of the great painter himself: "Nature is only a pretext: art passing through the individual is the goal." One criticism, however, of those brown tones used so freely by Dupré may be made without fear of any reproach of narrow-mindedness—the brown was not always of that cool and lovely quality, which brings peace to the eyes and mind.

By permission of M. Durand-Ruel]

JULES DUPRÉ

That by his thicker and heavier method of painting, Dupré lost much of that transparency of colour which in the skies and in the water of his earlier pictures was so noticeable, is also true; but then, on the other hand, the sentiment which his more impulsive handling enabled him to bring into his pictures, places the spectator in a mood in which transparency of colour is of no very great consequence.

The pictures, however, exhibited by Dupré in 1867, found little favour in the eyes of his fellow artists. He received an award, certainly—an award which was uncommonly like a reproach. He was given a medal of the second class for the second time; this being exactly the same honour which had been paid to him more than thirty years before, when he was but twenty-two years of age, and this second medal was offered to Dupré notwithstanding that Rousseau, his former friend and ally, worked unremittingly to secure for him a higher honour.

After 1867 Dupré again withdrew from the vexations and disappointments of picture showing, for which the country he cared so to wander about, the very subjects that he loved best to paint, must have always given him a distaste. What could exhibitions and the acquiring of medals have been to a man who loved the poetry of lonely places, the absorbing splendour of the sunset, and the play of fleeting sunlight over marsh, moorland and mountain? For a man who could discover sufficient food for contemplation, and material for pictures, by the side of a reedy river, or in a world in which the moving objects were the sky, the wind-blown trees, a few brows-

ing cows, and an occasionally passing peasant, could find all the companionship that his soul craved for; all of variety of spectacle and emotion that was necessary for his existence?

When the war of 1870 broke out, Dupré went to Picardy, to Cayeux, which is on the coast, not far from Abbéville, and all among the sand dunes. There he remained for some time, painting both pastoral subjects—the flat country at the back of Cayeux is a paradise for a painter of harvest fields—and coast scenes, and pictures of the open sea. The desolation of the sea-shore it became his to convey, and the unrest of the sea, and the movement and menace of turbulent skies. Nothing that he touched was trivial; nothing indeed that he painted was wanting in that dignity which to a thoughtful and peaceful man is ever the most striking characteristic of nature. And many things that he painted were remarkable for their large and often majestic brushwork, their firm but unobtrusive drawing, their strong rendering of atmospheric effects, and their unity of tone. From Cayeux he went to the Oise, where he painted more pictures of groups of trees by the waterside, and with flat country between the river and the distant hills; more pictures of country buildings and scenes of country life—Dupré at all times varied his subjects but little, too little so many of his critics say. From the Oise he moved to Barbizon, where he died in 1889, long after his friends and comrades, an artist who had forgotten the world, and who was himself, except by a few, forgotten.

During those long years of retirement: of painting

By permission of M. Durand-Ruel]

A MARINE VIEW

JULES DUPRÉ

without thought of exhibitions or of honours, the aged artist found, it is well to know, the peace that he sought for. One, who found him in his house on the banks of the Oise, saw Dupré surrounded by his family, his wife, his daughters and his sons, who were all devoted to him, and were ministering to him, bringing in their different ways some little added happiness into his life. He saw the old man painting with all the eagerness of youth, still as much absorbed in the observation of nature, still as absorbed in translating the result of his observations into the terms of art. He found Dupré working continually, painting large canvases with some return to his more coloured methods of rendering nature, happy in the kingdom of his studio—the fire of his room he would light so that it might more entirely remain his kingdom. He found him absolutely contented with this life all among his pictures—a life enlivened by reading and talking with his friends and his family, and listening to his daughter's music; he found him looking back with no regret to the time, when he, Dupré, stood in the foremost rank of the revolutionary painters, a modest, but a stubborn fighter.

.

NARCISSE-VIRGILIO DIAZ

NARCISSE-VIRGILIO DIAZ

By permission of M. Durand-Ruel]

A YOUNG GIRL PLAYING WITH A DOG

NARCISSE-VIRGILIO DIAZ

TO none of the lives of the artists of the Romantic School belongs quite such a flavour of romance as that which distinguishes the career of Narcisse-Virgilio Diaz; or to give him his entire name, which is itself full of almost florid suggestions, of Narcisse-Virgilio Diaz de la Peña. Even the circumstances that attended his birth were not devoid of drama. He came into the world to please the eyes of no ecstatic father, for Diaz *père* had at the time of his son's birth other more pressing matters to concern himself with; no female relations were at hand to sing the praises of his baby form; and soon after his birth his mother became a lonely woman, and an exile in a foreign land.

As to how it happened that Narcisse-Virgilio was robbed of some of the rights of babyhood there seems to be a slight mystery; but what we are told appeals not a little to the imagination, however distressing the circumstances may have been to his young mother.

Diaz the elder, so the story goes, was a native of Salamanca; there, in 1809, like many another Spaniard, he became involved in a conspiracy against King Joseph Buonaparte, and, in consequence of the discovery of the plot by the authorities, he was compelled to flee from his native land. Why he should have fled into France,

into the very heart of his enemies' country, is a little hard to understand, but we do know that in the year mentioned he and his wife left Salamanca secretly, and after long and arduous journeying—a journeying that must have been a terrible ordeal to Madame Diaz—they reached Bordeaux, where their child was born.

Here, at Bordeaux, the father soon felt himself, not unnaturally, less secure than before from the vengeance of the Buonapartes, so he fled to England. How he managed to get to England is another mystery; and why he did not take his wife with him is also a little inexplicable. Madame Diaz was, however, certainly left at Bordeaux alone to cope with the difficulties of her situation, which must have been immense, in any way that she was able; and with his departure from Bordeaux the father of Narcisse-Virgilio drops almost entirely out of our story. What tidings we have of him show that for three years, until his death, he made efforts, unsuccessful efforts, to make a home for his wife and child. We hear of him teaching Spanish in London and in Norway, and Mr. Mollet writes of a book which fell into his hands, a Spanish translation of Madame Cottin's "Exiles of Siberia," published by Gall and Child, of Paternoster Row, by D. T. Diaz de la Peña, Professor de la lingua Castellana.

Madame Diaz, left alone at Bordeaux, grappled with the difficulties that beset her like a true woman. From her the artist must have inherited the indomitable nature that from almost the outset of his career made him the master of his fate. Left alone in a foreign country, with

NARCISSE-VIRGILIO DIAZ

herself and her child to support, her courage seems to have never failed Madame Diaz. Speedily she adopted the only means at her disposal of obtaining a livelihood; that of teaching Spanish. She taught it at Bordeaux, and then at Montpelier, and then at Lyons; but some instinct was drawing her to Paris, to Paris where she was to find friends for herself and a protector for her son, and to Paris she eventually went. There Madame Diaz died, when her boy was just ten years old. Her part in his life had been a splendid one. Notwithstanding her toilsome life Narcisse-Virgilio was blessed with the memory of a happy childhood. His mother left him with his body trained in all sorts of athletic exercises, and his mind attuned to such a degree of receptivity, that the influences which came to it in after life with such prodigal and magnificent results were like seed falling upon well-prepared ground. After her death the guardianship of the boy was undertaken by a Monsieur Paira, one of the good friends that Madame Diaz had made in Sèvres, the suburb of Paris in which she had finally lived. M. Paira was a Protestant clergyman; of the kindness of his heart there is evidence enough, of his excessive kindness there is also some indication, for we are told that under his care the boy did very much as he liked, the good pastor doing but very little to restrain the turbulent spirit which young Diaz began rapidly to develop.

Whether from M. Paira's leniency came good or bad results it is hard to say. If Diaz had been trained on severer lines we should have had undoubtedly a less

wayward man, and a less wayward artist. But the waywardness of Diaz helped him more than once to success; compelled him more than once to noble actions; as an artist it started him on his career before he was well equipped, before indeed he was equipped at all; but out of his struggles to supply the want of academic training, came forth good fruit: came forth the art of Diaz, than which no art could be less replete with the skill that can be acquired in the schools; and no art could blind one more to the necessity of formal scholarship.

To learning, during his youth at any rate, except in his own manner, Diaz had a rooted objection; and at an early stage of his career Nemesis overtook him in a way that reminds one somewhat of a Sunday-school tale. From the lessons of M. Paira, Diaz not infrequently succeeded in escaping; and instead of spending the day in the companionship of the pastor he would loiter among the solitudes and silences of the woods and byways of Meudon, or of St. Cloud. Poor Narcisse-Virgilio! He was but obeying really a good impulse; he was taking the classical knowledge, imparted to him by his tutor, into the woods, to mould it there according to his heart's desire, to lay, among the leafy glades, the basis of that peculiar understanding of ancient myths, which in after years was to bring about the production of so many a beautiful painted dream. But he was disobeying the rules set aside for the conduct of boys, and it was perhaps right that he should have been punished. Anyhow he was punished; and for a while the enjoyment of expansive branches, of sunlight, and of the shadow of

trees and of the romance of tree-trunks was denied him.

One day young Diaz, after a particularly long ramble, threw himself upon the shadowed grass and went to sleep, and while he slept there came to him the avenger in the form of a poisonous viper. Diaz awoke to find his right foot swelling rapidly. From the viper he suffered, but from those who came to his assistance he suffered more. One, whom M. Silvestre describes as "a good woman," was his first nurse; when he was removed from her care he was a victim to gangrene. At the Hospice of the Child Jesus, to which he was carried, the gangrene was quickly dealt with by an amputation; but Diaz was again unlucky, for the amputation was performed by unskilful hands, so that it had to be followed by a second amputation, and when Diaz rose from his bed after months of suffering he had lost almost the whole of his right leg.

But Diaz must have been born under a good star; from all his apparent misfortunes he seems to have gained some profit. While he lay in his bed during those long hours in the Hospice of the Child Jesus, there came to him a fine development of the dreams that he had dreamed in the woods and byways of Meudon, and Saint Cloud, and in his bed, too, the object of his life was partly unfolded to him. Not even the wooden leg, which he was now to carry through life, was destined to be to him always a source of vexation. "Mon pilon" he called it, and whenever he was in a good temper, which was often, for only the troubles of his friends made Diaz really

angry, he made with this wooden leg a source of infinite amusement to himself, and the gay folk that he had habitually about him.

When he left the hospital, and was well enough to learn some occupation he was apprenticed to a printer, but his stay with the printer was not a long one. Fortunately for Diaz, the wife of M. Paira had a great taste for porcelain, and she, understanding thereby better what was in the boy's mind, caused him to be sent to one of the manufactories for which Sèvres is so well celebrated. He was attached to the atelier of M. Arsène Gillet and among his companions were certain young men who were also destined to become great painters, Raffet, Cabat, and Jules Dupré, who was a nephew of M. Arsène Gillet's.

But notwithstanding his congenial companions and the amusement that a young man of Diaz's tastes was likely to derive from painting all sorts of porcelain dainties, it is not surprising that in the factory of M. Gillet, Diaz did not long possess his soul in peace. For a while he satisfied his appetite for fine spectacles, and romance, and pageantry by constant visits to the theatre, but the theatre in the end only increased the longing that he was trying to assuage. Soon the theatre laid him at the feet of Delacroix, and not only Delacroix's drama, but Delacroix's rich designs and brilliant technique took full possession of the young man's brain. This enthusiasm quickly showed itself in his treatment of M. Gillet's ornaments. M. Gillet, however, had the public to satisfy, and was no friend of Diaz's innovations. He expostu-

lated: but in vain; then the connection between master and pupil was severed, and Diaz was thrown upon his own resources. For a while Diaz had poverty as his constant companion. There were fine ideals in his head, but no public at present to understand them; he painted, but he could find no buyers. Yet Diaz at this period of his life, as at every other crisis, bore himself gallantly; he clung to his ideals and he picked up his money in any way that he could. He lived alone, for one can well understand that he no longer cared to look for support to his once amiable protector, M. Paira. So desperate, indeed, became his position that at one time he was obliged to seek for bread, not by the use of his brush, but by the performance of humiliating tasks in the streets. At evening-time he would steal forth and earn a coin here, and a coin there, by holding open the carriage doors of rich people while they alighted. It is an unpleasant spectacle to look back upon. Diaz suffering silently in his studio, a victim to a want of understanding, and hunger, a sort of youthful Don Quixote, a victim of his own dreams, is one vision; but Diaz standing on the curb-stone, his hand stretched forth, a supplicant for small coins, is another vision altogether. But after all the man had to live; and it is well that Diaz had the courage to seek and find his bread in the only way that was then possible to him.

And it is well to know that in spite of these furtive and dreadful raids into the streets in search of the means of existence, Diaz had at all times a more than glimmering knowledge of his own worth. The dawn of day would find

him at his easel again, his faith in his beautiful visions unshaken, his belief steadfast that one day there would come to him a believing people, their hands laden with bags of gold like the oriental merchants that he loved to paint. "Some day," he would say, "I shall have horses and carriages, and as a coat of arms a golden 'pilon'"—the wooden leg was never very far from his thoughts—"and it will be my paint-brush, my paint-brush which will give me all these."

In the dreams of most young painters bags of gold form no very important part; but with Diaz it was otherwise. About Diaz there was nothing of the ascetic. His mind dwelt upon the fascinations of costly stuffs, of gold that glittered, of pearls that shimmered, and of sapphires and precious stones that brought peace to the eye. All the romantic folk that he loved so to paint, the nymphs, the gods and goddesses, the heroes and heroines of vague fairy tales, the splendid Orientals, majestic in mien, and lords of women coloured as freshly and delicately as a half-opened rose in the early morning—all these people lived in a land where sordid wants were unknown; and Diaz yearned too to place himself beyond the grasp of poverty, aye more, he fought to surround himself with coloured silks and costly embroideries, such as they wore, with chains of chased gold all set with gems and carved ivories, such as the creatures of his brain bedecked themselves with. For gold he fought, not as a miser fights to obtain a hoard, but that the dreams which came to him in his bare rooms might have their birth between walls more worthy of their existence; might be nurtured

among surroundings which would quicken and fortify their development, even as a hothouse brings into existence, and to full beauty, some exotic flower.

For the little instruction that he received, Diaz turned to M. Souchon, who became afterwards the Director of the Ecole des Beaux-Arts at Lille.

M. Souchon was a clever painter, and an able instructor, yet he had Diaz but a little while as his pupil. Many images were in the young man's brain, calling out impatiently for expression, and all calm and reasonable study became to him intolerable. But if Diaz did not pick up much learning in M. Souchon's studio he picked up a friend—a friend who reminds us not a little of Marolle, the companion discovered by Millet in the studio of Delaroche. This friend, Sigalon, did for Diaz very much what Millet's friend did for him. Sigalon not only made a hero of Diaz—"Diaz," he said, "makes pictures as an apple-tree makes apples,"—but he carried Diaz's pictures from dealer to dealer, from connoisseur to connoisseur. The amount of money that Sigalon obtained for his friend's pictures was not often magnificent —twenty-four francs being the outcome of an exceptionally fortunate sale—but he enabled Diaz to live; he brought bread to the artist's lips, while Diaz was forcing his way into the enchanted world, of which he has left us so many enthralling visions.

Victor Hugo's "Orientales" is possibly responsible for Diaz's pictures of Eastern subjects; but the book must have fired the train, not laid it. With all that is Eastern Diaz must have had a strange affinity. To the

like of that mysterious connection between Diaz and the East there is no equal in the history of art. From his imagination Diaz realized what most painters from a lifelong study of the country have failed to do. He gave us the East, all its seductive poetry, all that is voluptuous about its women and gorgeous about their dress, all its luxuriance of form and colour, all that is bizarre about it, and all that is suggestive of romance. Diaz's oriental women were made for a harem; could have had no possible existence except in a harem; and his oriental landscapes! Look at that little picture by him in the Wallace Collection! What might not happen in that shaded grove? The spirit of life in the East with all its possibilities of good or evil fortune is in that small landscape; and yet Diaz never went to the East, was never many miles from Paris; at least so they tell us. The Diaz that we know about certainly was not. But how about the Diaz of some earlier incarnation! A knowledge so mysterious as he possessed cannot but suggest strange possibilities.

If Diaz owed but little to any master of his time except Rousseau, he was very considerably indebted to one of a bygone age. As Millet worshipped Correggio, so did Diaz; but while a study of Correggio's masterpieces left its mark upon Millet's work for only a short time, it influenced the painting of Diaz until the very end of his career.

In this manner M. Ballu tells us Diaz spoke of his beloved master: "I go to him," he said, "as a moth to a flame; he may be accused very possibly of effeminacy

NARCISSE-VIRGILIO DIAZ

By permission of M. Durand-Ruel]

TURKISH CHILDREN

and slackness of form, but I only see his colour which radiates. Let him who will hold forth on his drawing and his composition, it matters not to me; he pleases me, that is enough. I find after all that he expresses himself quite as completely as his illustrious rivals, and that his painting is endowed with a particular charm which has been approached by none."

By this elaborate and somewhat unnecessary defence of Correggio, it may not unnaturally be inferred that Diaz had in his mind certain criticisms which had been passed upon his own work. These criticisms may have been well deserved; but, after all, what work of art done by mortal hands is beyond criticism; the canvas possessing every quality that can be contained in a picture is yet to be painted. To Diaz it was given to be a superb colourist; but that, in his search for lovely colour, he treated lightly certain matters which have been much insisted on by other great painters, who were not great colourists, cannot be denied.

The enchanting and poetic colouring which characterizes the painter's masterpieces was not however arrived at until Diaz had practised painting for a long while. We find that singular clarity of colour which can only have been brought about by innumerable experiments, that resourcefulness in the use of paint in his later work, far more than in the pictures which he produced earlier in his life. Of his pictures painted soon after leaving the factory it is said that they were very low in tone, were wanting in transparency, and were painted with none of the gusto of his later works. These faults were particu-

larly noticeable in his early landscapes, and until indeed he became virtually the pupil of Théodore Rousseau, he found no really satisfactory method of landscape-painting, and even after Rousseau taught him all he knew, he painted many a forest scene which was markedly wanting in brightness and limpidity in its shadows. I have seen landscapes by Diaz in which the sunlit foliage and trunks have emerged from shadows that have been far more reminiscent of an unlit coal-hole than of forest depths.

The friendship between Diaz and Rousseau, which was forced into existence in a truly characteristic manner by Diaz, did not begin until 1836, by which time Diaz had made some name for himself, and had aroused some antagonistic comments by the few pictures he had shown in the Salon. He exhibited first of all, in 1831, a picture which did not bring about his advancement in any marked degree; he was then twenty-two, an age at which most artists who have afterwards won repute, have made very substantial strides towards fame.

In 1835 he exhibited "The Battle of Medina," which was described by one critic as "a formless sketch"; by another with more humour, as "The Battle of the Broken Gallipots."

Hardly any more encouraging was the verdict of the press on a work, completed and exhibited by Diaz in 1836 —a picture called by him "The Nymphs of Calypso." This time not the form, but the colour of the work was objected to. Diaz's bright and perhaps then too obviously varied colouring startled the critics, as they viewed

IN A WOOD

(Victoria and Albert Museum (Constantine Ionides Collection)

the picture among its more sombre surroundings. Its tints, they said, reminded them of the contents of a confectioner's shop, and they went away disgusted with the young artist. Not so out of temper was the public at this early sign of Diaz's genius. In the minds of many onlookers the gay colouring of the Spanish painter found an answering echo. Studies from the nude—nymphs, Dianas, and Cupids—began to flow from his brush to find homes in the houses of the wealthy, for Diaz quickly became a fashionable painter, and even at this early period of his life it required much gold to obtain possession of one of his richly coloured and voluptuous dreams.

But this monetary success, with all that it promised Diaz of a life of luxury and the possession of beautiful things, did not keep him away long from his desire to become a great landscape painter. In the summer of 1836 we find Diaz at Barbizon, an acquaintance, but not yet a friend of Rousseau's; yet determined not only to became a friend of " Le Grand Refusé," but to find out, by hook or crook, by what means Rousseau wrought his wondrous forest scenes. But Rousseau was not easily to be approached. He was a quiet, reserved man, a bit suspicious perhaps of new acquaintances, and certainly not one that any but a friend would very lightly ask a favour of, and such a favour as Diaz had in his mind. It was in a somewhat singular manner that Diaz finally overcame the obstacles which stood between him and the desire of his heart, but the sight of the canvases brought back by Rousseau every evening to the inn at

Barbizon—the inn of Père Ganne—stung him into some definite action. One morning when Rousseau started forth to work, laden with his canvases and a supply of food, and anything else that he might require for probably the next twelve hours or so, Diaz stole after him and they entered the forest, one man but little in advance of the other. With such cunning did Diaz take advantage of the tree-trunks, and whatever other cover the forest offered him, that Rousseau found his subject, sat down, and began to paint, utterly unconscious that he had been followed and was being watched. But there is little to be gained by watching a painter from afar off; his jugglery is as delicate as the jugglery of the mountebank, and just as difficult are his methods to comprehend from a distance. Diaz soon discovered that his scheme was a failure, although he repeatedly made use of it; but he had not yet come to the end of his resources. He adopted then the course which a less fantastic man, if he had been as wilful as Diaz, would have taken at first; he went boldly to Rousseau, told him first of all in full of his immense admiration for his art, and then asked him by what magic he produced his pictures. Whether Rousseau's sense of humour overcame his reticence, or his love of admiration, or whether he fell under the influence, as did many others, of Diaz's gallant and somewhat imperious manner we are not told; but to Diaz, Rousseau gave all that he wished for. He revealed to Diaz all the secrets of his technique: by what means he was able to give life and depth to his forest scenes, solidity to his trunks, light and air to his masses of foliage,

NARCISSE-VIRGILIO DIAZ

THE OUTSKIRTS OF THE FOREST

[*Victoria and Albert Museum (Constantine Ionides Collection)*]

and mystery to his skies. More than this did he give to Diaz, for he gave him his friendship, which he never afterwards withdrew.

As to Diaz, this friendship, which he had so remarkably gained, remained for ever, according to Sensier "the conviction and religion of his life." Even when Rousseau was dead, Diaz's love for the great landscape painter never diminished; the memory of the "chief who led him on to victory" was the most inspiring of the thoughts which haunted him until wellnigh the hour of his death. That Diaz profited by Rousseau's teaching there is no doubt, although such close adherence as was adopted by Diaz to the principles of another artist does not often produce very admirable results. When he took advantage of Rousseau's method in the treatment of subjects similar to his master's, he seldom, if ever, produced a work that could be quite mistaken for a Rousseau; but, on the other hand, when he made use of the same teaching in the creation of backgrounds to his figures, great or small, to his hunting scenes, or to any of his innumerable fantasies, he produced a picture, the like of which it has been given to no other artist to bring forth.

But even in pure landscape Diaz painted many a work which obliges us to make no comparison between the two artists. I know of one canvas by Diaz in Mr. Forbes's comprehensive collection which might in some respects be the work of some latter-day impressionist; so absolutely and scientifically true is it as a rendering of a certain expression of nature. In this picture the artist has been influenced by no search for a fine composition,

no search for any particular intonation; he has given himself wholly up to nature, and with a few simple tones of green and gray has given all that is impressive about a somewhat melancholy afternoon in early summer. "The Storm," one of the artist's most famous works, a picture of a rough landscape seen under a tumult of clouds, is another example of what Diaz could do when he allowed his own personality to dominate what he had gained by the teaching of Rousseau. In this work there is an expression of drama that could have been realized only by Diaz. It could be the work only of a man of tempestuous nature, of a man with some Southern blood running in his veins, in whose heart a scene of chaos and anger finds a response that to a man of more even mind would be impossible. Indeed, although Diaz is best known by his painted fantasies, his fairy-tale lovers, his nymphs, his studies of the Orient, and his woodland scenes, it would be difficult to overrate his versatility. From subject to subject he flitted with often an uncertain, but always an inspired, hand. Not the least among his extraordinary accomplishments was his gift for painting flowers. Diaz's flower pictures have no rivals; there are no flower pictures that can be compared with them. Flowers themselves often make such beautiful decorations in a room, that they destroy the value of any counterfeit presentment of their kind which may be hanging on the walls that surround them. But the owner of one of Diaz's flower pictures may fear nothing by comparing his treasure with nature. It would indeed often puzzle an experienced horticulturist to determine

[Collection of Sir John Day

from what sort of flowers some of Diaz's blossoms have been painted, yet neither have the old Dutch painters of stately flower compositions, nor the more recent students of realism produced pictures that appeal so to those who number flowers among their more constant companions.

To certain minds Diaz's flower studies bring mostly visions of rainbow-coloured jewels and precious stones, and many other things that are splendid to the eye. His little canvases fascinate such folk as if they were the work of a wizard, and occupy their minds by a delicious unrest. But to him who has lived much in gardens, these flower pictures tell a different tale. He sees before him pictures of his flowers as they have appealed to him, when he has surprised his beloved blossoms in some supreme moment: when the spiritual beauty of the flowers has bewitched him into an ecstasy, and into a temporary disregard of their actual form.

In 1844 Diaz, who had been a persistent exhibitor in the Salon, received a third class medal. The picture which gained him this honour was "Les Bohémiens," a work of which a replica has now become the property of the French nation. In this picture Diaz declared for the first time all that he was capable of as colourist. There was no more talk of "broken gallipots" and of "confectionery," the critics this time recognized to the full the beauty of the painter's work, and vied with each other in their search for epithets which could describe the depth and brilliancy of the artist's radiant tones. Not only is "Les Bohémiens" of extraordinary charm as an eloquent and decorative arrangement of lovely colour, but there is

about it a poetry, a romance, that belonged peculiarly to Diaz. It reminds one a little of a poem by De Musset, or rather of a poem that De Musset might have written if there had been Spanish blood in his veins, and if he had had the bodily vigour of Diaz. From De Musset's fantastic world might have come forth this procession of gipsies, who in Diaz's picture are streaming down a dark ravine with steps uncertain and tentative; some with arms outstretched as if they were groping for a light, which in their hearts they never hoped to find.

In 1845 Diaz exhibited three portraits; these not being works that he was temperamentally qualified to produce, created but little notice. In 1846, however, Diaz scored another success. This year he showed not only figure subjects, but landscapes as well. Among the titles of the figure pictures we find "Leda," "L'Abandon," "L'Orientale," and "The Gardens of Love." One of the landscapes, a forest scene of trees with their tops bathed in glittering light, was bought by Meissonier. Thoré, in writing of this picture and its purchaser, says, "It is impossible not to worship Nature expressed with so much poetry. In effect, Meissonier has set out at once for some forest, after the purchase of the Diaz. It is very likely that he will come back to us a landscape painter." Thoré's idea is amusing, and it is a pity that there is no record of what Meissonier did while he was intoxicated by the painting of the magician Diaz. For the pictures that he exhibited this year, 1846, Diaz received a second-class medal.

In 1847 Diaz showed more pictures of nude, or half

By permission of M. Durand-Ruel]

THE BOHEMIANS

nude women, and more landscapes—more of his studies of opalescent flesh, of glittering jewelry and of splendid draperies; more of his researches into the mysteries of the forest glades. We read, however, of one critic, who this year does not join the chorus of Diaz's admirers. After the manner of critics, he cannot content himself with the beauties of the artist's work; he must ask for more, for what exists in plenty in many a work by many a mediocre artist. This critic, M. Planché, writes: " Diaz makes no progress. In figure painting, or landscape, it is always the same story; he finds on his palette charming tones, with which he makes very clever sketches, but he gets no further. His trees want leaves, his avenues want air and space. He dazzles with a brilliant variety of haphazard tones, and is content." M. Planché stated his case with a deal of exaggeration, but it must be acknowledged that in the structure of his figures, in the structure of his landscapes, Diaz was not always altogether infallible. Yet who among the lovers of Diaz's work, who among those who can feel to the full the magic of their colouring, and their fantasy, is ever troubled by the artist's sometimes impetuous descriptions of both human beings and landscapes. Does one question the proportions of all the forms and figures that come to one in a dream? Fortunately not. Every bit as absorbing are Diaz's painted dreams. Under their charm we are no more vexed by the absence of commonplace facts than we are in our own dreams; at least those whose temperament permits them to enter Diaz's magical world are not, for those who can only look at it from outside there are

painters enough; painters who will give them facts t[o] their hearts' content.

In 1848 Diaz obtained a medal of the first class. H[is] principal exhibit this year was a fine landscape, entitle[d] "Mare à la Vallée de la Sole." With this M. Planch[e] could have found no fault of construction. Trunk an[d] stem, foliage, and the forms of the ground, are state[d] with almost severity; nor is there any vagueness abo[ut] the light and shade of the composition—of a marshlan[d] set in the middle of some tall trees—which is gracefull[y] if somewhat conventionally arranged.

In the same year, in 1848, Diaz made another bid f[or] fame; this time he was not successful. He took part, [as] did Millet also, in the competition inaugurated by th[e] Government, who were desirous of obtaining a desig[n] representing the Republic. Diaz drew a dark-haire[d] woman—a Venus she might have been—supported b[y] two children, representing Science and Literature, an[d] the Fine and Industrial Arts. One can well imagi[ne] that the composition, of which nothing I believe [is] now known, was lacking in the necessary monument[al] qualities. It was, anyhow, rejected, as was Millet's draw[ing], although most probably for a totally different reaso[n]. There could have been little in common between t[he] gay, voluptuous and undoubtedly unsubstantial realiz[a]tion of Diaz, and the *triste* and too restrictedly seve[re] design of the peasant-painter; but what was wanted [by] a people rejoicing in their newly-recovered power was [a] conception vigorous and commonplace, and expresse[d] with less art than was contained in either of these tw[o]

drawings; something in fact a little more indicative of their own feelings.

To the Salon of 1850, the second Salon held under the Republic, both Diaz and Rousseau sent many pictures. Rousseau's interest in the national exhibition had been revived by the change of government, and to both men it seemed that for them, as for other people, a golden age was at hand. But alas! when the distribution of medals and honours came about, poor Rousseau found out that governments may change, but not human nature. His name alone, of all the principal exhibitors, was missing among those of the decorated ones. Rousseau felt the slight, but there was one who suffered more because of it, and that was Diaz. How Diaz's anger culminated is worth narrating, for the story shows, anyhow, that Diaz, with all his love for his art, with all his love of worldly success, could be dominated by a stronger passion—one that might very much endanger his own interests—when an injustice, or what he considered an injustice, had been meted out to a man to whom he had given his friendship. At the dinner given to the new officers of the Legion of Honour, he delivered a toast amidst a silence which told, perhaps, more effectively than words, with what feelings it was received by his companions. This toast which he had prepared well beforehand, was given with point, and in a stentorian voice so that none present should miss either its words or meaning. "A Théodore Rousseau," he cried," à Théodore Rousseau, notre maître oublié!"

Uninterrupted good fortune did not follow Diaz to the

end of his days. But although there were times when his friends, and they were many, were bereft of the sound of his gay voice and gay laughter, and the vigorous stamp, stamp of his wooden leg, Diaz himself never seems for long to have remained a victim to his disasters. Thus, in 1855, he sent to the International Exhibition about half a dozen pictures; the majority of these—we have their names: "Les Nymphes," "La Rivale," "La Fin d'un beau Jour," "Nymphe tourmentée par l'Amour," "Nymphe endormie," "Présents d'Amour," "Larmes de Veuvage," but it would be difficult to identify the pictures by these titles in the present day—met with admiration enough to quiet even the heart of Diaz himself; yet upon the success of "Les Larmes de Veuvage" the painter appears to have set particular store, and "Les Larmes de Veuvage" proved a failure. The picture had unfortunately little of that alluring colour which makes us for the most part oblivious to any faults that Diaz's canvases may possess. The critics therefore, finding themselves no longer under the glamour of the artist's magical tints, turned their attention to the drawing and composition of the picture, and dwelt, perhaps, more unpleasantly upon their defects, because the picture had been painted by a man whom they had surprised for once without, as it were, his magician's rod. Not only the critics, but the artist's friends took part in the chorus of condemnation of the unlucky "Les Larmes;" and the showing of the picture, on so great an occasion, turned out for Diaz to be a most unfortunate venture. But Diaz acted during this crisis in a characteristic manner. He

Victoria and Albert Museum (Constantine Ionides Collection)

NARCISSE-VIRGILIO DIAZ

turned his back on Paris, and on the painting of nymphs, and set out for Fontainebleau. At Barbizon he found nature waiting to restore again to him his peace of mind; and for a while he gave himself up exclusively to landscape painting. For the better development of his work from nature he built near the scene of his principal subjects a large studio, and in time he produced one of the most important, at any rate one of the most elaborated, if not one of the most inspired of his landscapes, "La Mare aux Vipères."

More lasting in its effects upon Diaz was the loss of his eldest son, Emile. This young man's place in his father's heart was doubly insured, for not only was he also a painter, but he was as well a pupil of, and beloved by Rousseau, his father's dearest friend. Although Emile Diaz, who died in 1860, was twenty-five years old at the time of his death, he does not appear to have left behind a work of art of any importance. That he divided his time between painting and the making of verses may be some explanation of this, but that he was a painter of some promise we can feel assured by the interest he excited in Rousseau.

Eugène, the second of the great artist's sons, was a musician of sufficient standing to have his compositions performed in the Paris Opera House. It was after the first production of one of these works—on a cold winter's night—that Diaz caught the chill which in the end brought about his decease. The funeral music which accompanied his father's obsequies was composed by Eugène Diaz.

In 1857 we find Diaz again in Paris, the owner of a fine studio in the Boulevard de Clichy, and once more the painter of delightful fantasies. In 1857 he exhibited one of the works which now represent him in the Louvre, "La Fée aux Perles," a picture painted in his most Correggioesque mood. The principal figure in this radiantly coloured work—the woman who holds the pearls beyond the reach of the laughing amoretti—is about as large as it was given to Diaz to paint with any surety. In his youth when he, possibly, should have been making academical studies, he was painting pictures; he occupied himself then with throwing feverishly upon his canvas, with little concern for form, some of the more insistent ideas which teemed in his youthful and terribly active brain. While he should have been studying anatomy he was mastering that strangely original technique, so like often unto an Oriental lacquer-maker's, which in his smaller pictures is so delightful; discovering those secret ways of producing colours which enabled him later in life to bring, in spite of themselves, so many captious critics to his feet. Certainly Diaz's method of conducting his studies was unusual, and one that few young men can follow without failure. But who can say that Diaz did not know what was best for himself, and was best for us to whom his pictures are a legacy? Is it not often better that an artist should hasten to develop what is good in his repertoire of accomplishments than spend years in attempting to rectify what is not good? If he struggle to hide his faults he may in the end find himself as well equipped as any other intelligent student,

but that meanwhile his own particular gifts have flown from him; and upon his adherence to good copy-book principles the world will turn only a cold eye, and be entirely thankless. Yet undoubtedly Diaz's inability to model figures on a large scale must have at times worried him; he must at times have pined for that knowledge which Paris studios give every year to hundreds of young men, who are destined to remain for ever artists uncared for and absolutely unknown. One knows that Diaz sometimes pined for a firmer hand and a wider knowledge, for his larger figure pictures give us evidence of a hopeless struggle with the impossible. In the painting of them you can see that the brush has passed beyond the artist's control; their technique is flimsy and exhausted; and so occupied has the artist been in trying to place the limbs and features in their right places and right proportions, that the poetry of his motives has escaped him, and instead of the brilliant colouring that characterizes his smaller canvases, we are given the colouring of flowers that have prematurely lost their beauty by contact with too hot an atmosphere. But yet although Diaz must have suffered for his want of knowledge—he must have, or he would never have tried to paint those large pictures—we are glad that he obeyed his own impulses when he was young. Diaz's best pictures are just the pure offspring of an impulse, and had his impulses been at one time checked, the world might have been the poorer by the loss of works of art which can be best compared to bits of either perpetual sunshine or moonlight. But with whatever difficulties Diaz con-

tended in the painting of his pictures, he never seems to have had any difficulty in selling them. From 1860 onward, he became ever more financially successful. According to Silvestre he kept "success attached to the leg of his easel with a pink ribbon." Although he never painted to please the public, but to please himself, what he painted did please the public. For once, anyhow, in the history of art a painter of poetical imagination, a painter of dreams, a painter with an individual technique, and a contempt for all conventionalities, was not entirely at variance with the commonplace buyers of pictures. They may not have seen all that the imaginative man sees in a canvas by Diaz, but they saw enough to satisfy some longing in their natures, and they bought from the artist unstintingly.

In 1870, at the outbreak of the war, Diaz, who was useless to his adopted nation by reason of his wooden leg, and his sixty-three years, fled from France to Brussels. Here, while the guns of the Germans were operating around Paris, he remained peacefully, painting from his ever restless imagination, and from the studies which he brought with him from Fontainebleau.

After the war, or rather as soon as Paris was at peace with itself, Diaz returned to his adopted city, and when an interest in the fine arts began again to assert itself in the capital, he also began again to sell his pictures, and for larger sums than he ever had received for them before. He added enormously to his already splendid collection of bric-à-brac and pictures; every sort of *bijouterie* he bought, and furniture, always of a slightly flamboyant

[By permission of M. Durand-Ruel]

BAS-BRÉAU

period, and tapestries, and costumes, and all kinds of Oriental works of art, especially Japanese, for which a taste existed in Paris long before it came to London. He bought for himself, too, a villa at Etretat, a house overlooking the sea, from which he could paint marine studies whenever the desire to do so possessed him. Truly he had realized the dream of his youth. With perfect satisfaction he could think of the buoyant and boastful young man who once exclaimed: " Some day I shall have horses and carriages, and a golden 'pilon' as a coat-of-arms, and it will be my paint-brush which will give me these." It is not, I believe, recorded that he ever did use a golden "pilon" as a coat-of-arms; although he was entitled to, morally, at any rate, for he made his wooden leg a constant source of amusement to himself and to his friends, and no wooden leg was ever worn more bravely than Diaz's, or put to a better purpose.

At the very height of his prosperity, it was destined that Diaz should die. During January of 1873, on the night of the first performance of his son's opera, he caught the chill which developed into an attack of pleurisy. Of course he partly recovered from this malady, it was not likely that a man of Diaz's temperament would die without a struggle. Yet for the next two winters it was considered necessary that he should winter among the Pyrenees. In November, on " The Day of the Dead," 1876, he went forth again to honour a son, this time a dead son, to lay a wreath upon the grave of the dead Emile. The following two or three days he spent in bed a victim to bronchitis, and within less than

a fortnight, he, in company with his wife, was hurrying towards Mentone to save his life. Unfortunately the journey took place in the coldest of weather, and when they arrived at Mentone they found it in the grip of a severe frost. Diaz's bronchitis became worse than ever, and finally, on the seventh day after their arrival in the South, he died of exhaustion in his wife's arms.

Madame Diaz brought her husband's remains back to Paris, and they were interred in the Montmartre cemetery with full military honours, which were Diaz's due as an officer of the Legion of Honour. Among the pall-bearers were Meissonier and Dupré, while a host of artists and literary men followed the dead Diaz to the grave, for he was worshipped as an artist and beloved as a friend.

And so lived and died one of the most fascinating figures in the group of painters known as the School of 1830. Stronger men were among them, but none with a more poetical mind, or whose work had about it a more exquisite charm; certainly there was none with so generous a mind, or one who conducted himself through life so entirely valiantly.

There are many portraits of Diaz, and all present to us a man of dark Southern aspect, bearded, with eyes that tell of the dreamer and very much of the man of action. They tell us, too, that he was a very good friend and a very generous one, that as an enemy he was fearless; that he was easily made angry and just as easily conciliated. Although an artist to his finger-tips he was a keen business man; notwithstanding, he does not seem

[Collection of Sir John Day

to have made much use of any sort of banks. As an amateur seller of other men's pictures, he was unequalled. Millet, and Rousseau, and others owed a lot to him for his continual upholding of their work, and for his actual efforts on their behalf in the picture market itself. And not only did he charm people into a good temper with his friends' pictures, but he had many a time to reconcile his friends in their moments of despondency to their own works. Often, indeed, did he prove a veritable staff to his less buoyant and less courageous friends at Barbizon.

Unlike many artists he took gladly of everything that life had to offer him. Painting was not his sole entertainment. He loved to be with his fellow-creatures; divers forms of literature appealed to his imagination; he gained stimulus, and repose as well, from music; and to those who are familiar with his pictures, it is hardly necessary to say that he owed not a little to the theatre. All beautiful things and sights he loved—he loved beautiful men, beautiful women, beautiful children, beautiful landscapes, beautiful pictures, and indeed every sort of beautiful thing made by God or man. In spite of his wooden leg he was intensely active. He was a keen sportsman—his pictures of running dogs could have been done only by a man who was intimate with animals engaged in the chase—he was fond of riding, swimming, at these exercises he was an adept; and he could dance too with considerable effect.

Surely to contemplate the personality of Narcisse-Virgilio Diaz de la Peña is a most engaging occupation.

THÉODORE ROUSSEAU

THÉODORE ROUSSEAU

[Collection of Sir John Day

SUNSET

THÉODORE ROUSSEAU

OVER Théodore Rousseau, who never sought disfavour by the enunciation of violently revolutionary principles, there hung a cloud which now and again lifted itself, and let a little sunshine into his life, but which in the end overwhelmed him and sent him to his grave an honoured, yet a heart-broken man.

Rousseau was born in Paris on the 15th of April, 1812. Although he was the son of bourgeois parents—his father was a tailor—he was by no means the first of his family to follow the profession of the fine arts.

Even by his father's calling Théodore Rousseau may have profited, for it is recorded that the clothes sold by Rousseau *père* were well-shaped, indeed, among his customers he numbered Prince Talleyrand; but Théodore had even more than this to be thankful for.

His great grandfather was a gilder of the "King's equipages," an occupation that to many minds may seem but very remote from that of the painting of pictures, yet has not a well-known academician given us his opinion, that two years' apprenticeship to a carriage varnisher would be an excellent beginning for any man who desired afterwards to paint either carriage doors or pictures. From this grandfather may not Théodore Rousseau have inherited that precision of handling to which

he himself attached so much importance, and which is noticeable in even the least successful of his landscapes?

To an Uncle Colombet, a grandson of the carriage gilder, Rousseau was able to refer for evidence that his unwelcome gift of extraordinary sensitiveness was also inherited. Of Colombet, who was a portrait painter, it is told by a humorous biographer of Rousseau's, that so grieved was he on seeing a signboard which had been painted by one of his fellow-students, that he fled from his native country, and lived and died where a better order among artists prevailed—in India. Another relation, whose connection with the fine arts was intimate, was a cousin of Rousseau's mother, and from him we know Théodore did obtain some direct assistance. He, Uncle Pau, as Rousseau called him, painted landscapes, which were occasionally exhibited in the Salon. He, as well as Théodore Rousseau, seems to have had an inclination for introducing into his pictures, instead of personages, objects far more familiar. Uncle Pau, we are told, seldom painted a landscape without including in his design a donkey, or donkeys, according to the necessities of his composition.

His leisure time young Rousseau spent with this Uncle Pau, and with fragments of colour, obtained from the artist, he learnt in time to make copies from his relation's pictures. He copied also from engravings, and from copying proceeded to making observations on his own account, which he soon began to set down in paint. His first study made from nature which excited any great interest, was of the Place de la Concorde. Of this it

THÉODORE ROUSSEAU

was said that although the study was deficient in many respects, it showed that young Rousseau was already alive to the subtleties of atmosphere, and that even at that age—he could not have been more than eleven at the time—he had begun to regard his subject not as a collection of different detached objects, but as an ensemble.

When he was but twelve years of age Rousseau was subjected to another influence. He was handed over to the care of a relative, a M. Maire, who was by profession a sculptor, but who at that time was occupied in establishing a series of saw-pits in the forests of Franche-Comté. To M. Maire, Théodore acted as a secretary, and the post seems to have been well to young Rousseau's taste. In the not uncongenial society of his relation, he learnt something besides writing in a fine hand. He learnt something of the life in a forest; of the lives of the woodcutters and sawyers, of the gamekeepers and foresters and charcoal-burners. He learnt, too, something about the nature of the trees themselves, of the great oaks and beeches and hollies that he saw for the first time. Occasionally he was obliged to make long expeditions into the very depth of the forest; and there, among the vast masses of tree-stems and foliage, an understanding came to him of the poetry of his surroundings—an understanding which was destined to develop, until it found its right expression in the splendid and romantic scenes painted by the artist during his later life in the forest of Fontainebleau.

M. Maire's mission to Franche-Comté failed, and Rousseau returned to his own home to find that during

his absence he had so far impressed his father with his business capabilities that his parent desired earnestly to make of him a civil engineer.

Young Rousseau, however, had returned to Paris with his plans already made; his future had been decided for him by the forest trees of Franche-Comté, and, instead of pondering over the possibilities of an engineer's life, he purchased some brushes and a box of colours, and went forth to sketch the picturesque neighbourhood of Montmartre.

The Montmartre cemetery he painted with so much realism and with so fine a comprehension of the medium he was using, that his father was immediately conquered. He set aside his plans for making an engineer of the boy, but, being of a prudent mind, he did not give his son full permission to make of painting a profession until Théodore had worked for a while under the superintendence of his Uncle Pau. What work he did with Uncle Pau we are not told, but we know that to young Rousseau the uncle proved a worthy ally. Whatever doubts still existed in Rousseau *père's* mind, with regard to his son's future, were quickly swept away by the old artist; and Théodore was sent to the studio of one Rémond, a landscape painter of the classical school, to make his first serious studies.

It would be, perhaps, difficult to say what effect these serious studies under Rémond's guidance had upon Rousseau. Rousseau himself denounced his master in pretty round terms: he was years, according to his own account, before he finally escaped from the results of

THÉODORE ROUSSEAU

Rémond's evil teaching. Rousseau's compositions, however, show very few signs of a struggle with a vitiated mind; whenever any formality is evident in his designs it appears to have arrived there as a welcome, not as an importunate guest.

At any rate, while Rousseau was with Rémond he seems to have done very much what he liked. With Rémond's teaching, he mixed a great deal of learning that he obtained directly from nature. He would often absent himself from the studio and sketch at Bas Meudon, Compiègne and other places around Paris; and on favourable occasions he would go even as far as Fontainebleau; so Rousseau was not long in discovering the scenes which he was to make so famous, and from which he himself was to derive so much fame.

Although Rousseau had but a very poor opinion of Rémond, Rémond must have thought very highly of Rousseau, for he tried to persuade his pupil to compete for the Prix de Rome; for the landscape scholarship, which, until his death, had been held by Michallon, the friend of Corot. Rousseau did, indeed, begin a picture with the view of taking part in this competition, but the subject that he had to contend with did not appeal very much to his taste, and it did appeal very much to his sense of the ridiculous. "Zenobia picked up by Fishermen on the Banks of the Araxes" was the subject given to the competitors, and when Rousseau realized that any landscape he was likely to paint would profit little by the introduction of Zenobia, he turned his canvas to the wall, and went forth again into the woods to study; and at

the same time he appears to have left the studio of Rémond for good and all.

What further instruction was picked up by Rousseau in Paris came apparently from the studio of Guillon Lethière, a figure painter and a classicist, but a milder one than Rémond: he also worked in the Louvre, copying from the pictures of Karil Jardin, Van Goyen and Claude. Of the masters of landscape painting the Dutchmen must have appealed with greater force to Rousseau, notwithstanding all the beauty of Claude's sunsets and sunrises, for between the suave silhouettes of Claude's compositions and the broken outlines of Rousseau's designs, there existed a difference which arose from the vastly dissimilar temperaments of the two painters.

In June, 1830, Rousseau, who had become weary of politics, and therefore weary of Paris—he was then but eighteen, but he was ever something of a prodigy—resolved to depart for a country where he would find absolute solitude and nature untouched by civilization; where he could wrestle with the artistic problems that beset him, and where everything that was individual in his temperament would have ample opportunity of expression.

To the Cantal Mountains he went, in the district of the Auvergnat, and there among the ravines and torrents and dark woods of that volcanic region he made innumerable studies and pictures. It is easy to understand the impulse which sent Rousseau to such a place. The message which had come to him in Franche-Comté, in Fontainebleau, and the environments of Paris, had brought

MOUNTAIN SCENERY

[Collection of Sir John Day

about his revolt against the school of Rémond; but he wished to have that revolt still further justified, so he approached this rocky and desolate land, this land in which the earth and sky appeared to be involved in an endless contest: this land he approached in very much the same spirit in which a priest approaches an altar, so that the voice which before had come to him faintly but very audibly might now be heard by him in its full volume.

At Auvergnat the message of nature came to him in its full volume; and Rousseau received a glorious inspiration. The studies that he took back to Paris filled the minds of those who saw them with all sorts of suggestions of primeval things. It appeared to them not that Rousseau had painted France or Switzerland, or any other country in particular, but the world before the flood. Rousseau—boy though he was—was acclaimed one of the leaders of the School of Romanticism, and while most artists and connoisseurs wondered at his new work, there were many who condemned it emphatically. Chief among the voices which condemned was that of Rousseau's former master, Rémond. "His landscapes," Rémond said, "were the work of delirium."

But if Rousseau lost one champion by this splendid venture, it also brought him a new one, one far more influential than Rémond, even Ary Scheffer, about whose own work there could at no time have been anything volcanic.

That Rousseau should have found a champion in Ary Scheffer seems now strange enough. To modern eyes

the work of this popular painter—in whose veins ran Dutch as well as German blood, but more German than Dutch one is inclined to think—appears to be no less academical than that of the very men against whom he himself rebelled; for Ary Scheffer considered himself, and was considered, a Romanticist, and a very ardent Romanticist too, notwithstanding that we of to-day regard his mighty canvases with scarcely any emotions whatever.

But if Ary Scheffer left behind him nothing that appeals to our imagination, he was evidently not slow in finding out when a vein of genuine imagination ran through the work of a fellow-painter, and being a generous man withal, he does not appear to have been slow —in Rousseau's case he was not at all events—in holding out to him a helping hand. Not only did he prove to Rousseau his understanding of the spirit which animated the landscape painter's studies; which indeed so dominated all that Rousseau then painted, that the artist in his effort to express all that within was calling out for expression, often expressed himself not a little uncouthly: not only did Ary Scheffer give to Rousseau this aid, almost the most valuable aid that one artist can give to another, but he carried Rousseau's pictures to his own home, and hung them upon the walls of his studio; and whenever the opportunity offered itself, preached the gospel of Rousseau's new virulent, and what at the time must have appeared almost grotesque, art with vehemence.

In 1830, when the School of Romanticism was yet young, and a need was felt among its apostles for close

THÉODORE ROUSSEAU

and constant commune, there existed many little clubs and societies, which met either in private houses or in restaurants, and at whose meetings there was a great deal of talk, some mutual admiration, a vast amount of denunciation, and what was even more healthful, for the foregatherers were for the most part very young men, a fine display very often of animal spirits.

Of one of these little societies Rousseau brought into prominence as he had been by his famous champion, became an honoured member. Although a quiet man, one who cared little for expressing his own views, except through the medium of his work, he at all times appears to have liked the companionship of those who talked volubly. The little society to which Rousseau attached himself met at the house of one Lorentz, a disciple of De Musset, who lived in the Rue Notre Dame des Victoires: here Rousseau spent most of his evenings watching the acting of charades, listening to the praises of Victor Hugo and Dumas, and to the perpetual denunciations of every individual or society still labouring in the darkness of academical principles. When they became mentally exhausted by their talk, these young men, we are told, would sometimes set forth and walk through the night and the following day, not returning home until they had traversed far into the country: sometimes they would cover a distance as great as forty or fifty miles.

Rousseau was known among this group of friends as "Père Tranquille." Poor Rousseau! it is pleasant to know that at one time there were for him tranquil hours;

that during his youth at any rate he was able to wear a serene countenance. Its serenity indeed must have been a very marked characteristic of Rousseau's disposition, before continuous ill-luck and injustice broke his faith in himself and in human nature, and set his reason tottering until he came well-nigh into the shadow of the mad-house.

Even to a man of mature years such recognition as Rousseau received at the age of eighteen would be somewhat unhinging. But Rousseau, with his pictures hanging in the well-frequented studio of one of the most popular artists of the day, with his name on the lips of all the men whose opinion he then most valued, pursued an even course, with thoughts only for the further development of his art. He continued to work from the figure in the studio of Guillon Lethière; and from Gros he learnt the principles of perspective; and when he had leisure from these studies he would paint from nature in the suburbs of Paris; or in his little studio, under the roof of No. 9 Rue Taitbout, he would search for means of translating his outdoor observations into shapely and pictorial forms.

It was not until 1833 that Rousseau scored a veritable success in the Salon, although his first picture was exhibited there as early as 1831. Until 1833, notwithstanding his visit to the Auvergnes and all that he did there, he does not seem entirely to have escaped from the influence of Rémond; but in 1833 he showed distinctly what he was going to do with his art, and "Les Côtes de Granville," his exhibit of this year, was hailed by the

critics as one of the finest landscapes of the period. Of this picture—"Les Côtes de Granville" has been for many years in Russia, and has therefore been beyond the reach of most picture-lovers—of this picture M. Lenormat wrote: "It is one of the truest and strongest landscapes, and one of the most refined in tone that the French school has yet produced." The critic also added that he would be unwilling to exchange Rousseau's future for the whole career of "our most famous landscape painters." However promising it appeared at its beginning, and few young painters have made a better start, or have been better favoured by opportunities, it is not unlikely that M. Lenormat would very soon have bitterly repented of his bargain, if by any means he had been able to obtain for himself the future of Théodore Rousseau.

About this time Rousseau made the acquaintance of Théophile Thoré, a man who was a journalist, an art critic, but above everything else a revolutionist. To what extent his appreciation of the new school of young painters was genuine no man may say: but we know that he praised their work in season and out of season. Their pictures may have appealed to his heart; but it is just as likely that he was attracted far more by their attitude towards an existing institution, than by their art. Yet what he wrote about the men of 1830, and especially about Millet, is vastly interesting, for if he did not understand the work of these young artists, he saw a great deal of the young men themselves, and he had therefore every opportunity of finding out what they wished to

have written about their work, and that we may be sure he wrote. Thoré and Rousseau for some time actually lived together, and it was not until the Revolution of 1848 that the alliance was broken up. It is not improbable that to this friendship, as well as to his intimacy with the young men of the Rue Notre Dame des Victoires, who possessed a journal called "La Liberté," a journal very objectionable to the "authorities," that Rousseau owed some of the persecution which followed him almost to his grave. He was a man of few words, and at all times of temperate speech, and no words that fell from his lips could have been responsible for the enemies who did so much to spoil his life.

In 1833 Rousseau made his first long stay at Chailly, on the borders of the Forest of Fontainebleau. There, after painting a number of studies, for the trees of the forest were beginning to hold him really in thrall, and he found it difficult to settle down before any one subject, he completed with much labour a view of the "Forest of Compiègne." This picture obtained for him a third medal, and was moreover bought by the Duke of Orleans, just before M. Cailleux, the director, entered into treaty for the work with the view of adding it to the Luxembourg Gallery.

So far success indeed seemed to be following hard upon Rousseau's heels, and he set forth in the summer of 1834 for the Alps with his friend Lorentz in the very best of spirits. They travelled to La Faucille, one of the Jura range of mountains, and within sight of Mont Blanc, in a village named Salines, where Rousseau's

THÉODORE ROUSSEAU

[Collection of Sir John Day

A WATERFALL IN THE AUVERGNE

grandmother, an old lady of over eighty, lived, they remained for four months. With a life of prosperity apparently before him and scenery that appealed enormously to his imagination, Rousseau must have been now happy enough, and we know in fact from the sketches and studies that he brought back with him of mountain roadways, with all the rocky structures of the steep mountain sides so appealingly and so sensitively defined— of waterfalls that might be waterfalls on which no mortal eye has looked—how entirely he found a sketching ground that was in accordance with his desires. He had, too, in Lorentz a companion as gay as Fantasio, that delightful creation of De Musset's, and one about as fantastic. No wonder that he prolonged his stay at Salines until the summer was well passed.

Before they left the village an incident occurred which was not without its results. Whether the unusual length of their sojourn in the village, or their unconventional behaviour, excited the suspicion of the authorities, is not known. At any rate, a M. de Montrond, an official of Gex, was sent to Salines to inquire into their characters. He was received by the airy Lorentz and conducted into the presence of Rousseau: Lorentz, who was as resourceful as Fantasio in his manner of covering the ground, led the way with a series of somersaults. M. de Montrond did not take long in grasping the true character of the suspects; and became without any further preliminaries their friend and adviser. At his suggestion they set off for the Hospice of St. Bernard, and while they were staying at the hospice Rousseau witnessed the spectacle,

which suggested to him the "Descente des Vaches"—the picture that was to bring him a large increase of admirers, but was yet to bring into his life its first real unhappiness.

The sketch of the "Descente des Vaches" was painted and completed within a few days of the travellers' return to Paris; and Rousseau then began to set out his composition afresh upon a canvas in size more worthy of his motive. But he soon found himself in an unexpected dilemma. Both the size and the lighting of his room made painting on the long canvas which he had selected almost impossible. Ary Scheffer, however, again came to his aid. The elder painter recognized immediately the beauty of the conception and design of Rousseau's new work, and without any hesitation he removed both the young artist and the big canvas to a studio in his own house where the "Descente" was painted, and as it happened was exhibited also; for the Salon jury rejected this picture, just as they rejected everything that Rousseau set before them, until the body was reconstituted after the Revolution of 1848.

The big "Descente des Vaches" as well as the sketch of the picture are both in the collection of Heer Mesdag, the well-known marine painter and picture collector, who lives at the Hague. From the sketch the original illumination of the large picture can be better understood than from the large picture itself. Rousseau unfortunately in the large "Descente des Vaches" used a large amount of bitumen, a medium which never really dries, and is, moreover, sensitive to nearly every change in the

THÉODORE ROUSSEAU

A VALLEY

[Collection of Sir John Day

weather. But of the evils of using bitumen, enough perhaps has been already written. It is sufficient to say that it is one of the most dangerous and alluring of colours. In the "Descente des Vaches" it has behaved unusually badly. All the shadow sides of the cows and the trees which at one time must have been so rich and transparent in colour, and so opulent in surface, are now dull, opaque, and corrugated, and look not unlike burnt leather. But the composition remains, and for that reason alone Heer Mesdag is to be envied because of his possession. The spectacle which so moved Rousseau is simply suggested to us even by the ruined canvas. We see near the top of the frame the distant view of the mountains, and a little lower, half screening the mountains, a mass of fir trees. A little lower still is an illuminated rocky peak, which rises up beyond the hill-side that occupies all the rest of the picture. Down this hillside, which is interspersed with riven rocks and spare fir trees, proceed the cattle and their drivers. They are confined in a narrow sunken road, and the sunlight of late afternoon strikes the backs of the moving beasts, and the sides of the trees, and rocks above them. Over all there is a sentiment of autumn, and of a change in the order of things. It is in the crisp late autumn sunlit air; it is in that long string of lowing beasts descending from their mountain plateau to their winter feeding places in the lower plains—that procession of which we see no beginning and no ending, that is pouring down the hillside like a mountain torrent. With so much art has Rousseau told us that the beasts we see are but a por-

tion of one vast, long, continuous string of moving animals, that it seems to us, even as we look upon Heer Mesdag's picture, ruined though it may be, that we can hear the distant lowing of innumerable cows and oxen, that are yet to reach the top of the hill, as well as the voices of those that have already passed from our vision into the valley below.

It is not unnatural that Rousseau was bitterly disappointed by the rejection of his beautiful picture; but if his work of art was excluded from the Salon, the artist was at least left in no doubt that what he had done was well appreciated by his friends, and by those who had learnt to understand his art. Crowds of men and women visited Ary Scheffer's studio, where the picture was for awhile exhibited, and critics, who had never taken notice of the painter before, championed his cause. And—this may also have been some sort of consolation to him— Delacroix and other distinguished artists were among those excluded from the Salon of 1836.

During the summer of this year Rousseau went to Barbizon: this is, I believe, his first recorded visit to the village in which he afterwards lived for so many years, and died. Of what he painted there during this stay there is no mention, but we know that his work greatly excited Diaz, who was also sketching in the forest at the time, and that when they returned to Paris, Rousseau and Diaz had become fast friends; and that Diaz had acquired from Rousseau nearly all the instruction in his art that the latter was able to impart to him.

Two kinds of trouble visited the unfortunate Rousseau

in 1837. During April of that year his mother died. To her the artist was much attached. He owed to her an excellent bringing up, and to a great extent his distinguished personality. Later in the year came another Salon rejection; more anger on the part of Rousseau, and more agitation on the part of his friends. The picture which caused the trouble this time was the "Avenue de Châtaigniers," a work on which the artist had bestowed an enormous amount of labour. It was painted at the end of the year, in 1836, after Rousseau had returned from Barbizon, and while he was on a very limited tour, for his monetary resources were low, with his friend Leroux.

The "Avenue de Châtaigniers" is a study of an avenue of chestnut trees, and very little more. Most admirably drawn are these trees. Their structure, from their gnarled trunks to the tips of their spreading branches, has been followed with scientific care: the play of light on the leaves, and through the leaves, and the perspective of the trees, has been carefully observed; but notwithstanding all this, it is a picture which many artists would prefer to keep within the four walls of their studios, and would regard, not as a work for exhibition, but as a sort of dictionary of facts; something to refer to for information and suggestions, and even consolation, during the time of inventing and developing more elaborate and ambitious compositions. Claude, it is said, had a picture of trees, which must have been in some respects not unlike the "Avenue de Châtaigniers." This hung always upon his studio walls; and although he was many times offered much gold for it, he would not part with this

study; it was the source from which he drew most of the forms contained in his graceful tree groups.

But undoubtedly the "Avenue de Châtaigniers" was worthy, and much more than merely worthy, of being placed in the exhibition of the Salon; and that Rousseau thought, and so did his friends. Thoré and Diaz were loud in their protestations. Dupré and Madame Sand offered the disappointed painter their sympathy: while Delacroix showed his feeling for Rousseau in a very practical way indeed. He induced M. Cavé, the Director of the Department of Fine Arts, to offer Rousseau two thousand francs for the rejected work, but the artist, who was beginning to grow suspicious of all officials, contrived to find a purchaser more after his heart in M. Casimir Périer, who bought the picture for the same amount offered by M. Cavé.

Again, in 1838, Rousseau sent a picture—view of Château du Broglie—before the Salon jury, and again he had his picture rejected. From these repeated rejections of course poor Rousseau suffered. Every year it became more difficult for his friends to find purchasers for his pictures: visits to the Alps, or to any far-off country, became impossible for him, and he had, indeed, to look to his father for pecuniary assistance in order to live at all. Fortunately for him cheap living was to be found at Barbizon, which is not far from Paris, and near to it is all that is most beautiful in the Forest of Fontainbleau: and there Rousseau, until 1840, spent most of his time. There he was able to escape from the worries of poverty, and artistic rivalries, there he was able to

[Victoria and Albert Museum (Constantine Ionides Collection)]

THÉODORE ROUSSEAU

live mentally if not physically almost perpetually in the forest.

It was his habit at Barbizon, we are told, to set out alone from his inn quite early in the morning, taking with him canvases and painting materials, and food enough to supply his wants for the whole day, and not until night had well set in would his friends see him again. And even then, it would seem as if his mind still wandered in the forest glades; he would set up his canvases against a meal-tub or chair, or any object that was handy, and whether he was seated in a lighted room, or a half dark one, he would proceed with the work that had engaged him during the daytime; arranging and rearranging it, trying to imbue it with some new sentiment, some fresh knowledge of the inner life of the forest, which had come to him, and in the interpretation of which he had been baffled while sitting before the trees themselves.

Who has studied even a drawing of trees by Rousseau without recognizing that to the great artist trees were something more than mere masses of stems and foliage; that to him they were sentient beings capable of transmitting thought and ideas; and that with them Rousseau held commune. We know why he loved to be alone among the trees although we may not be able to comprehend the mysterious converse that happened between them and him: we know by the many beautiful studies and pictures that he has left of the Forest of Fontainebleau. How do one of these majestic presentments strike a new and sympathetic student of Rousseau? First of all as beautiful and decorative arrangements of warm and

glowing colour; then he admires the unity of tone in the picture and then its unity of composition. Later it occurs to him that he is indeed before a picture by a painter who knew all about trees; who knew all about their formation and growth, about the shapes of their leaves, and how the foliage of different sorts of trees is massed; and he notices, too, that the artist not only knew these facts but that practice and sympathy gave him a perfectly artistic and absolutely masterly method of rendering them. Having noticed all this, a new revelation comes to the student; he is not in the presence of such paintings of trees as have proceeded from the brush of any other landscape painter before or after Rousseau. The student looks around him for some explanation of this difference, and he finds it in a group of men and women, painted by an artist who understood something of the character and life of his sitters; of their dreams and their ambitions, their happinesses and their woes—this picture gives to the student the clue that he is in search of, and he understands the subtle, mysterious, and fascinating charm of Rousseau's forest scenes. In the same spirit in which the portrait painter painted his men and women, Rousseau painted his trees. Just as the portrait-painter knew about his sitters, so Rousseau knew about his trees; we cannot understand all that Rousseau was able to comprehend, but before one of his pictures we know that we are in the presence of representations of things that were understood, and that between the painter and the thing painted there was some strange and mysterious affinity.

Whether Rousseau has presented to us his forest scenes

THÉODORE ROUSSEAU

in autumn or winter, summer or spring, whether they are immersed in the light of midday or radiant with the glow of the setting sun or steeped in the gloom of twilight, whether his trees are set in the foregroud or mid-distance, with the principal groups on this side or that side of his canvas, be there pools in the foreground or no pools—there was, of necessity perhaps, a sameness about Rousseau's forest compositions—we see before us refined brushwork and splendid colour, and always the same mysterious record of an intercourse between a man and what to most of us, at any rate, is silent nature.

In 1841, Rousseau's friendship with Dupré, which had been growing for a long time, culminated in the retirement of both artists to the village of Monsoult on the borders of the forest of the Ile Adam, where the two friends occupied the same house, over which Madame Dupré, the mother of Jules, came in time to preside. Jules Dupré brought a great deal of happiness, and bitterness as well, into Rousseau's life, although it was his desire to bring only happiness. Here at Monsoult, among its orchards and wooded valleys, Rousseau was for a while happy enough. Here he was not beset by poverty, for Dupré, anyhow, had always money enough at his disposal; and here Rousseau had always worthy companionship, for he had Dupré with him, and there came occasionally to visit the two artists Barye, Decamps, and Delacroix.

But Rousseau was by temperament not made to live at peace. In 1842 we find him again wandering about in the valley of the Creuse by himself; again the spirit

of unrest had come upon him, and the necessity of being in a land where man is but an outlaw, and nature reigns supreme. This valley of the Creuse was a primitive land, a land of old superstitions, which even pilgrims were said to approach shudderingly. The titles of some of the pictures painted there by Rousseau are given, but so often have the titles of Rousseau's pictures been changed that it is often impossible now to identify his works by any of their former descriptions; yet there are certain pictures of Rousseau's with foregrounds set with heavy foliage, with foliage much overpainted, as if the artist had been possessed with the idea of giving to each leaf some weird personality—landscapes with low, hot, miasmatic backgrounds, which may well have been painted by or suggested to Rousseau during his lonely quest to satisfy those emotions, which his friend Dupré was unable to share.

In the following year, in 1844, Rousseau and Dupré went forth again to work together; this time on a long expedition to the Landes, for good fortune had awaited Rousseau on his return from the valley of the Creuse, and he had sold several of the pictures which he painted there. It is noteworthy that Rousseau invariably did his most successful work when he was alone; it would seem that in his more morbid moods his artistic faculties quickened.

During his long sojourn in the south, Rousseau made studies for, and began many pictures. Of these, "Marais dans les Landes," now in the Louvre, was the most successful, while "La Ferme," another conception which came to him in Les Landes, possibly gave him more trou-

By permission of M. Durand-Ruel]

LANDSCAPE: SUMMER SUN

THÉODORE ROUSSEAU

ble than any picture that he ever attempted. Rousseau undoubtedly was little in sympathy with the brilliant colouring of the southern landscape, although he tried often to paint it; nature in a low key, or wrapt in the glories of sunset, called forth from him always his highest powers of delineation—and as to the blue, cloudless, southern skies, they baffled him altogether. "La Ferme," a group of farm buildings seen under some tall trees, remains as evidence of the agony that these skies brought to him. The whole of the upper part of that picture is opaque and lifeless; so often have the spaces between the branches been painted and repainted, that the trees might be things of paper cut out with a penknife and pasted upon the canvas.

Rousseau had indeed a rare, and sometimes unfortunate tenacity of purpose. Whether the motive of his picture was a worthy one, or not, having begun a subject he seldom stopped in his efforts to develop it, unless the canvas were taken from him by Dupré, or he himself considered that he had entirely realized his original intention. So many of Rousseau's works were spoilt by over elaboration, and much time was wasted by him in futile attempts to obtain effects which temperamentally he was unfit to paint.

Thoré in an open letter to Rousseau, which was printed in L'Artiste, while Dupré and Rousseau were absent in Les Landes, refers pathetically to the struggles that he had witnessed when, in their youth, he and Rousseau lived in an attic together. "At night," he wrote, "you arose, feverish and despairing. By the light of a lamp,

you tried new effects on your canvas already covered many times, and when the morning came I found you tired, sad, as in the evening, but always ardent and inexhaustible."

When the two friends returned to Paris from Les Landes in the autumn of 1845, the city seemed to them in many ways so uncongenial that they started off again, going to the Ile Adam, where Rousseau painted "Le Givre," his celebrated study of a white hoar-frost. This picture, a majestic conception showing the white land under a dark and menacing sky, and painted with admirable taste and directness, occupied Rousseau but eight days in the doing. That he would have spent more time in working on "Le Givre" is not improbable had not the painting been forcibly removed from his easel by Dupré, who remained in possession of the picture until a purchaser was found for it in Paris.

For an artist who had a strong natural inclination to labour long over a work, Rousseau had the power of painting with extraordinary facility. So great became his knowledge, from long observation of various effects of the earth and the sky, that before he had hardly touched his canvas he evolved a picture. Mr. Forbes's splendid river scene, the Italian landscape belonging to Sir John Day, and the picture now in the South Kensington Museum, are evidences of Rousseau's rapid brushwork and power of gripping the innermost meaning of a motive. One of these pictures is on a large canvas and the others are but small pictures, yet they all show equally his gift of concentration and facile handling, by the help of which

[Victoria and Albert Museum (Constantine Ionides Collection)]

THÉODORE ROUSSEAU

the artist has added not one stroke of the brush that does not contribute either to the design or to the sentiment of his composition. But unfortunately so great was his knowledge that he often wanted to add something more to a fact that he had already stated with sufficient distinctness, and so his pictures were frequently not shown to the public until long after they had passed their best state of development.

During the years 1846 and 1847 Rousseau passed through one of the darkest periods of his life. He was beset by money troubles, and for a while it seemed as if his continued struggle with the injustice of the Salon jury must end in a real victory for the stronger side. About this time he appears to have had an unfortunate love affair. He became engaged to a young girl who was in every way qualified to make him a suitable wife, but the engagement was broken off, and, it is said, by Rousseau himself. Rousseau must have been at this period, notwithstanding his misfortunes, a singularly attractive young man. M. Burty tells us: "Rousseau was a young man of rare beauty. Long brown hair and a curly beard framed his fresh-coloured face. The brightness and intelligence of his large black eyes will be remembered by those who were near him even during his last days. He was graceful and of middle height. He blushed like a young girl, and until his marriage he preserved the chastity of a young priest. He lived for his art alone. His hands were beautifully shaped, excessively mobile and eloquent. His manner of speech, at least when I knew him, was wanting in brilliancy until he

became animated, which he did after some minutes of conversation, then he spoke with great fluency and I have never heard a master who could expound with such precision his doctrine and his views." Well can we understand that it probably was Rousseau who put an end to his engagement, although his motives for doing so are not told us definitely. Rousseau was an extraordinarily sensitive man and very prone to suspect a slight, and some misunderstanding may have ended this promising love affair. But it is more probable that Rousseau, immersed as he then was in gloom, feared to link his fate with one for whom he had a great attachment. That his freedom brought him only unhappiness we learn from Thoré, who soon after this crisis joined Rousseau at Barbizon. There Thoré found the artist visiting no one, seeing no one, but working determinedly, and finding in his art and in his mysterious converse with his beloved trees his sole consolation for his loss.

But in 1847—if Rousseau had only known it!—his dawn—although it was to be but the dawn of a stormy day—his dawn was almost at hand. In 1848 came the Revolution, when a change took place, not only in the politics of France, but even in the direction of the Salon jury itself, and in 1848 Rousseau—how he must have wondered!—found himself on the jury intrusted with the hanging of the pictures for the exhibition. Rousseau did not take advantage of his position by exhibiting himself; notwithstanding he received from the State a commission for a landscape of the price of four thousand francs. This order Rousseau filled with the "Coucher de Soleil,"

THÉODORE ROUSSEAU

[Collection of Sir John Day

ENTRANCE TO THE VILLAGE

THÉODORE ROUSSEAU

which was exhibited in the Salon of 1850-51, and is now in the Louvre.

Sensier tells us of a solemn conclave of artists that took place in 1851. Their object was to consider the election of a representative in the Assembly. But who with any knowledge of artists will not be able to guess the result of this meeting? There was no sort of agreement among the assembled bodies. The engravers wished the member to proceed from their body, the landscape-painters from theirs, the portrait-painters from theirs, and so on. Rousseau, who had a liberal mind, retired from the conclave in disgust, and was not heard of until a little later, when he and Dupré were called upon to shoulder muskets and assist in preserving the peace of the city.

After Rousseau had returned again to Barbizon, to the little house which he occupied there, his friends discovered that he was no longer living alone. He had taken to himself a female companion. Madame Rousseau, for so she seems always to have been called by courtesy, was a native of Franche-Comté, and was a peasant's daughter. There was nothing very romantic in the alliance between the two people. The girl came to Rousseau when she was ill, and in difficulties, and Rousseau attended to her wants, and in time made her mistress of his little home. While she was with him she never had good health—Rousseau always spoke of her as his "malade"—and there came a time when she must have been to the painter a serious embarrassment. Yet Rousseau must have derived some

pleasure from her companionship, for even when there was a strong reason for their separation, when she became positively insane, he refused to be parted from her.

Three important pictures were shown by Rousseau in 1849. One of them, a "Lisière de Forêt," is now called "A Glade in the Forest of Fontainebleau," and is to be found in the famous Wallace Collection. Not one of these canvases was well hung, and when the medals and decorations were distributed, Rousseau found, to his immense chagrin, that while Dupré and Raffet were given the ribbon of the Legion of Honour, to him was offered only a first-class medal. Unfortunately Rousseau's disappointment led him into making a strange error. He attributed the slight that had been passed upon him entirely to the machinations of Dupré, and before his friends could intervene he had parted from a fellow-artist who had always treated him with generosity and affection. This rupture between the two friends was mended some years later, but not until both Dupré and Rousseau, and especially Dupré, had suffered from Rousseau's unfounded suspicions.

The second, "Lisière de Forêt," the picture now in the Louvre, was exhibited in 1850, and again the exhibition of his work brought sorrow to Rousseau. His picture was at first well hung, and then, after Rousseau had seen it in its good position, it was shifted, just before the opening of the Exhibition, to an inferior place. Again, when the distribution of medals and honours took place, Rousseau's name was not to be found among

THÉODORE ROUSSEAU

the decorated, although one of the new recipients of the Ribbon was Diaz, who was, and loved to call himself, the pupil of Rousseau. Fortunately Rousseau did not act towards Diaz as he had acted towards Dupré. Diaz certainly left his master very little room in his mind for untimely doubts. His famous toast at the dinner of the new officers of the Legion: "A Théodore Rousseau, notre maître oublié," must have removed even from Rousseau's mind any suspicions of foul play on the part of his outspoken pupil.

The "Lisières de Fôret" are certainly among the very finest of Rousseau's pictures. They differ in composition and illumination, but both are splendid harmonies of colour, both show a great knowledge of nature, both are full of bold and supple brushwork. Of the two compositions possibly that of the Louvre picture is the more elegant, while the larger mass of shadowed trees in the London work produces an impressive effect, which compensates one for its slight deficiency in grace. In both pictures the flat sunlit country which lies beyond the limits of the forest is described with infinite poetry and understanding. If it were possible to compare a painting with a musical composition, one would have to search among the sonatas of Beethoven to find any melody of sounds akin to these two glowing and splendid landscapes. Of our own Constable we can always think with satisfaction: he raised the trumpet-call to which the French landscape painters of 1830, with Rousseau at their head, responded. He called and pointed out the way, and they took that way, and found the goal of

which Constable had never more than a distant and interrupted view.

During the five or six years which followed the delivery of Diaz's memorable toast Rousseau concerned himself very little with exhibitions and honours. He lived during that time principally at Barbizon, where he completed a number of now very celebrated works. True, he did not abstain altogether from exhibiting, but the works which represented him in 1852 were not sent to the Salon at his own initiative, but at the urgent request of the official Director of the Museum.

Rousseau had now reached a stage when poverty ceased to knock continually at his door. Pictures by the artist had arrived at a certain market value, and we read of Rousseau being not only able to provide himself and Madame Rousseau with all the necessities of life, but that he could even satisfy his longing for a few little luxuries as well. He bought etchings, Sensier tells us, by Rembrandt, Ostade, and Claude; he bought old Japanese prints; and in 1855 he had sufficient ready money at hand to buy Millet's "Peasant Grafting a Tree." This purchase—Rousseau gave £160 for the picture—was more than anything else a graceful attempt on Rousseau's part to relieve Millet's wants, and to give him encouragement as well. He bought the picture under the pretence that he was dealing for an American, and when Millet discovered his secret, he generously gave Millet the opportunity of selling the work again.

Among the pictures that engaged Rousseau during these years of comparative peace at Barbizon were

By permission of M. Durand-Ruel]

CROSSING THE FORD

弱き者

THÉODORE ROUSSEAU

"Marais dans les Landes," "Le Soir," "La Ferme," "Le Four Communal," "La Reine Blanche," and "Gorge d'Apremont." Of these pictures four at least were resolute efforts to realize an effect of hot noonday sunlight. In "Marais dans les Landes," with its flat country, its pools of water, its groups of cows, its flowers, its distant range of snow-capped mountains, the effect is expressed with real grace. In the "Gorge d'Apremont," with its great oak-trees and almost overwhelming flood of light, the effect is expressed with drama, and in "La Ferme" we are given all the tiring monotony of the noonday sun.

To nearly all the work done by him at this time Rousseau gave an enormous amount of labour. He touched and retouched his pictures; he tried this and that method to solve the problems which interested him, by which he was in fact obsessed, so that it was seldom that any of these pictures passed from his hand in a condition which entitles them to be regarded as masterpieces.

Rousseau remained at Barbizon until 1860, when the health of Madame Rousseau compelled him to take her to Franche-Comté, her native county. Already she suffered from attacks of insanity—attacks which towards the end of Rousseau's life became of frequent occurrence, if she at that time could ever have been called sane. At Franche-Comté Rousseau left Madame Rousseau with her relations, and he, with Millet, proceeded to Neufchâtel, where Rousseau made many sketches which he afterwards developed into pictures. That Millet worked

with him at Neufchâtel there is no record. Indeed, Millet in a letter assures us with emphasis that the scenery of Switzerland gave him no impressions which he felt at all inclined to render pictorially.

On their return from Switzerland Rousseau for the second time gathered together what pictures remained at his disposal and sent them to the Hotel Drouot, where they were sold by public auction. This sale was but a qualified success; for when Rousseau had paid all the expenses connected with the auction, he received for twenty-five canvases only £600; not quite £25 a piece. The sale was undoubtedly necessitated by the expenses arising from Madame Rousseau's illness, and by the fact that since the Salon of 1857 there had been a growing tendency on the part of the critics, and on the part even of the artist's own friends, to disparage his more recent pictures. Rousseau's conscientious efforts to work out problems of illumination, and his more elaborate efforts to complete his pictures, found more enemies than his early work, and not so many champions as his freer, more poetical, and more spontaneous method of painting.

So threatening seemed Rousseau's outlook at this period, that he appears to have seriously entertained the idea of leaving his native land. Amsterdam, London, and the United States were all in turn thought of as possible refuges for him. At Amsterdam the artists had made him a member of their academy. In every other country Rousseau's art was more appreciated, it appeared, than in France. Nothing, however, came of

THÉODORE ROUSSEAU

these plans, and Rousseau remained, fortunately perhaps, to die among his friends, and in the land where he had fought out the battle of his life.

While Rousseau was considering the advisability of leaving France, Madame Rousseau became again seriously ill, and again Rousseau sent her to Franche-Comté. After she had been there for some time, and her reason had been somewhat restored, Rousseau set forth to Franche-Comté himself to fetch her home, leaving behind alone in his house a young man of the name of Vallardi. This young fellow, a painter, came also from Franche-Comté, and he came to Rousseau, to the not too fortunate Rousseau, as Madame Rousseau had come, in a state of distress, and as unhesitatingly as Rousseau had offered shelter to the young woman, so he offered a home also to the young man. For neither act of kindness was Rousseau very amply rewarded. While the great artist was absent in Franche-Comté, young Vallardi committed suicide, killing himself with a pair of scissors, and nearly setting fire to Rousseau's house in his death agonies. Millet, who was fetched by a neighbour to see the body and the bloodstained room, wrote graphically of what he witnessed to Sensier. The danger to which Vallardi had exposed Rousseau's house and belongings, impressed Millet scarcely less than did the horrible death of the young man. "It is a perfect miracle," he wrote, "that the house was not burnt down. The candle had fallen first against the sheets, and then had rolled under the curtains, which it had touched. And what an accident for Rousseau! for it

would have been impossible, if the fire had broken out, that the studio, which is just above, should not have been burnt too. Think of Rousseau's canvases, sketches, drawings, all on fire—all he had finished and begun, destroyed on his return—a heap of ashes! I am bewildered." This addition to the already gloomy atmosphere which hung around his house affected Rousseau seriously. He blamed himself, most unnecessarily of course, for leaving Vallardi at the very time when the young man required his companionship.

Soon after this tragical occurrence Rousseau went to the neighbourhood of Mont Blanc to make some sketches for a picture commissioned by M. Hartmann, but here again ill-luck befell him. From working out of doors too late in the season he contracted inflammation of the lungs, and when he returned to Barbizon he was physically, at any rate, a wreck. He lost his power of sleeping and to some degree his capacity for working, which was lamentable, for he was then passing through a difficult period in the development of the three important canvases, which became afterwards the property of M. Hartmann, his new patron,—I refer to "La Ferme," "Le Four Communal," and the "Village of Becquigny." Led astray by his study and love of Japanese pictures Rousseau attempted what it has been given only to a Japanese artist to accomplish, and to give to a landscape painted in the West the splendour of a scene that has been copied in the East. There were times during these strange and mistaken travails, there were times—for Rousseau was everlastingly trying new experiments with these pictures

during his unnatural quest—when the sky over the Picardian "Village of Becquigny"—Picardy that land of tempered sunlight!—was like unto "a firmament in which Buddha would have chosen his throne of light." That this picture ever reached its present sober state is a marvel. As we know it, it is a work that may well be considered at the same time as Hobbema's "Avenue, Middelharnis." In the design of both pictures there is the same sober sentiment, in both pictures are fairly commonplace forms treated with simplicity and with restraint, and with an enormous amount of art and imagination.

His wife's illness, as much as his work kept Rousseau occupied until 1865, when the artist received an important commission from Prince Demidoff. The Prince required of him two large pictures to decorate a room in which there were to be also canvases of similar size by Corot, Dupré—two pictures by each of them—and Fromentin. For the work Rousseau was to receive four hundred pounds. He painted two upright panels representing "Spring" and the "Setting Sun"—two upright compositions in which there are trees and water and a great deal of foreground foliage; in the evening subject is a very lurid sky. Both pictures, if they may be judged at all from reproductions, appear to be a little scenic, in touch as well as in sentiment, but one must remember in judging these big panels that Rousseau did not paint them under advantageous circumstances—was he not constantly in the companionship of an insane woman?—and that the scale on which he was working was far larger than that to which he was accustomed. To every artist

is appointed a limit to the dimensions of the picture that he can complete with any facility. Rousseau touched his limit in pictures very much smaller than the Demidoff panels. That Rousseau's art, however, was at this time again winning popularity we know from the fact that in 1865, Messrs. Durand Ruel and Brame offered him £4,000, "for all the old studies that he had made in his youth," and £1,400 more for some pictures that he then had in hand. This offer after some hesitation was accepted by the artist.

In 1866 Rousseau was again elected on the Salon jury, and so conscientious and wise a juryman did he make, that in the following year, in 1867, the artists made him President of the Jury of the Exposition Universelle. Rousseau had nearly now run his course. He was to know to the full what popularity meant; what it was to possess riches; he was to taste a little further of ill-treatment and injustice, and then—death.

His duties as President he performed with great care and success, making his goodness of heart known to all those who had dealings with him. By the pictures exhibited by him, he made clear to the Parisians that they possessed the greatest landscape-painter in the world; he sold at the time of the exhibition two hundred thousand francs' worth of pictures, and he received the grand medal. But when the distribution of honours came about every man who had served on the jury but Rousseau received some promotion, while he remained as he had been for fifteen years, a Chevalier merely of the Legion of Honour.

From this blow Rousseau never recovered. Sensier

[Collection of Sir John Day]

THÉODORE ROUSSEAU

says: "He returned [from the distribution] with a purple face and bloodshot eyes ... I saw by the twitching of his features that a dreadful battle was raging within him, and I feared at first that he would break a blood-vessel." Within a month after the distribution he had a stroke of paralysis.

On the 12th of August, Alfred Stevens and Puvis de Chavannes came to Barbizon to tell the sick painter that the honour he so much desired had been at last bestowed upon him—that he had been elected an Officer of the Legion of Honour. But justice was done to Rousseau when such justice mattered to him little.

From the first stroke Rousseau partially recovered, and Millet and his wife took him to Paris, but the change did him no good and almost immediately after their return to Barbizon he was again attacked by his malady. These strokes followed each other with ever increased rapidity until the 22nd of December, when he died in the arms of Millet, his old, and perhaps, his best friend.

As he approached his end it is said that he moved his hands in the air as an artist often will who is searching in his brain for a beautiful composition. May we not therefore hope that as he passed into eternity his thoughts were not entirely thoughts of bitterness: that the presence of his dear friend brought some peace to him during his last moments, although it must have required not the sight and touch of Jean-François Millet, not visions of pictures that could come only to a dying brain, but death alone to still poor Rousseau's ears to the awful cries of his insane mistress.

THE INFLUENCE OF THE ROMANTIC SCHOOL

OF all the group of artists which arose in opposition to the classical school of painting in France and has for convenience sake been termed the Romantic School, Rousseau and Diaz alone bore to each other the relationship of master and pupil. And even of Diaz it can be said that he owed to Rousseau but a small portion of his learning. That which endears the figure pictures of Diaz to us could have been taught to the artist by no man; and there are landscapes by Diaz in which even the influence of Rousseau is not at all evident.

The very essence indeed of the sentiment which brought about the revolt against the classical school—the school of David—made any very distinct relationship between members of the younger group an impossibility. The Romanticists fought not against the antique spirit which controlled the classical school, but against the restrictions which were imposed upon its members. They—the Romanticists—maintained that in painting, as in all fine arts, there should be a force dominating all formula, and that dominating force should consist of the personality of the artist.

A painter, they said, having chosen his subject should express it just as his temperament most particularly prompts him, but without being entirely heedless of what

has been painted before. He should set aside the chosen tints, the chosen attitudes which the classicist held could be used only in a picture with any decorum. For attitudes he should go to nature, for colouring he should consult the requirements of his subject, but in regulating the arrangement of either, he should consult first of all that which lies within himself. They maintained that from the brush of one painter colour might be made to give something more than mere pleasure to the eye, while the line of another artist might give all the satisfaction that may be derived from divers tints. Hence we find Delacroix expressing passion and movement not only by the energetic attitudes of his figures, but by his colour as well; and we find Millet showing us the sentiment of a melancholy November afternoon, not only by a gray sky, by bare brown listless branches, by flocks of black home-going rooks, but by the amount of expression that he has put into the outline of a shepherd's cloak. Diaz we find expressing orientalism in his pictures not by costume alone, nor alone by the peculiar cast of the features of his personages, or by his radiant colour, but even by the very manner in which he has applied the paint to his canvases.

Such sensitive use of the brush and the colour-box no man could transmit to another, even if he wished to; and although Rousseau taught Diaz a few technical secrets which enabled Diaz to paint forest scenes as he had never painted them before, there is no instance of a Romanticist passing on to a pupil information that enabled his disciple to produce a work which is ever likely to be confounded

THE ROMANTIC PAINTERS

with that of his master. Such a miracle would have been impossible. An artist who follows his own emotions in the directions of his brush can have no real pupil, cannot form a school. As well might he attempt to transmit to another or others his own soul.

But although it may have been forbidden to those who have painted according to their impulses to transfer what has been their heritage to those who have come after them, there is no doubt that many of the most individual of the painters have profited by the victories of former masters, and that they in turn have left to those who follow them something which is very much like to a sign-post upon a road; it indicates the way to the haven at which a persevering artist may arrive be he only sufficiently equipped—with genius.

The first French artist who proved that besides the kingdom of the classicist there were other kingdoms worth conquering was Baron Gros. But he, after all, proved an unwilling guide. Having by his pictures, "Les Pestiférés de Jaffa," and "Bataille d'Eylau," undermined the dominion of the great David, and having started by his example such artists as Géricault, Delaroche and Delacroix upon their conquering way, he became saddened by the unlooked-for fruits of his success and after one pathetic effort to return to his earlier style —which was of the school of David—he committed suicide by drowning himself in the Seine at Meudon in 1835.

Delacroix, in his turn, took a part in the influences which favoured both Millet and Diaz, at all events at the beginning of their careers. To Diaz he explained to what

extent emotion may be aroused by colour, and to Millet he suggested the amount of force and sentiment that may be lent to a canvas by lively brushwork.

In landscape painting the classical traditions were first of all interfered with by Paul Huet, but before he entered into revolt it seems that even in the older school there had been some unrest. The landscapes of Valenciennes, who painted pictures after the patterns of Poussin and Claude, proved that good models may be followed closely for too long a while, and Michallon, Rémond and Watelet turned their backs on temples and nymphs and made pictures out of such picturesque ingredients as broken bridges, Alpine torrents, châlets and waterfalls.

But to Huet it was revealed that from the more intimate scenes in his own country material could be derived for pictures, and his revelation was brought further home to him by the arrival of the landscapes of John Constable and the presence of Bonington in Paris. Huet was of a poetical temperament but somewhat lacking in observation, and his execution was not always equal to his conceptions, yet he did some good work, and when he died in 1869 many of his pictures had been already added to the national museums. But notwithstanding his good though somewhat accentless painting, it was more by his upholding and explanation of the art of Constable that he benefited his art and his nation. With Huet worked in a somewhat similar spirit Cabat and Camille Flers and Roqueplan. To Jules Dupré, however, it was given to go forth into the fields and show definitely that in the rendering of light and actual

facts there was a charm against which all worn-out formula could hold no longer sway. This triumph he shared to some extent with Rousseau—to some extent only, at first, for it was owing to the example of Dupré that Rousseau finally delivered himself from the influence of Rémond, his master.

Of the painters who profited by their intercourse at Barbizon with Millet and Rousseau, none rose to higher eminence than Charles Jacque. Before Jacque studied the pictorial arts he had served as a lawyer's clerk, as an assistant to a map-maker, and as a soldier in the line. His education as an artist was not very systematic, yet he appears fairly early in his artistic career to have gained some reputation as an illustrator of books. Later he made himself known as an etcher, and he is said to have produced as many as four hundred plates; all these, some of them containing very picturesque designs, were done before he began to paint.

After he had been using colours for about four years —during that time he had been an intimate friend of Millet and Diaz—he started with Millet, in 1849, on the memorable first visit to Barbizon, where Jacque afterwards spent also a greater portion of his life. He was a persistent worker out of doors, and many artists now living were familiar with the picturesque figure of Jacque on his way to his subject, laden with innumerable canvases, and accompanied by four or five very tame sheep, who acted as his companions and his models. Jacque for the most part painted two sorts of pictures—farmyard interiors, in which there were animals and birds,

and forest scenes, or pictures of the plain of Barbizon, in which there is almost invariably a flock of sheep. A vivacity of touch and richness of colour characterize his farmyard pictures, while his landscapes are usually of dignified composition: the trees in them are well drawn, the masses of foliage largely conceived and decorative in their arrangement, and, like Millet, Jacque was uncommonly alive to the beauty of a well-imagined and a well-drawn foreground. His sheep, when he introduced them, were as a rule important features in his landscape. About a sheep he knew nearly all that an artist need know. He drew them admirably. And not only did he draw them well, but he was able to envelop them in atmosphere, and give them just their right importance to their surrounding landscape and sky. Jacque received the Ribbon of the Legion of Honour in 1867.

It would be not unfair to say that Jules Breton, who was born thirteen years after the great peasant-painter, had his attention drawn by Millet to the pictorial beauty of rural life. Between, however, the pictures of the two artists there is a vast difference. Full of sentiment though his "L'Alouette" may be and "La Glaneuse," and statuesque though his figures certainly are in both canvases, they have about them a poetry that is essentially modern, while the poetry of Millet's pictures belongs to all ages. Jules Breton received five medals between 1855 and 1867: the Medal of Honour was bestowed upon him in 1872, the Ribbon of the Legion in 1861, and the Cross in 1867. He received, therefore, for his agreement with the spirit of modernity a rich reward.

MONTICELLI

Monticelli certainly more than any other artist profited from a study of Diaz's eloquent use of colour. He was born in Marseilles in 1814, was the son of a gauger, and became the pupil of a local artist who had learnt from Ingres. It was not until he went to Paris and saw the work of Delacroix and Diaz that he understood in what manner he was himself best equipped to express himself in painting. From the time of this revelation form played an ever less obviously important part in the composition of his pictures; and in his latter days Monticelli produced work which to an eye unaccustomed to the pictures of Monticelli, appears to be devoid of design, drawing and meaning. Yet in these apparently chaotic arrangements of glowing and deeply harmonious colour, design and drawing are always to be found; and many of them are as full of incident, anyhow of suggestion and of poetry, as an early Italian romance. Indeed, some of Monticelli's figures, which at first sight appear not unlike butterflies, or birds, or merely fragments of deliciously coloured paint, in the end turn out to have been fashioned by a hand as keenly alive to the allurement of feminine beauty as was the hand of Watteau, or to the impressiveness of a statuesque form as was the hand of Ingres himself.

During Monticelli's life his pictures were of little value. Strange stories are related in the inns of Provence about his methods of working and of living. If we are to believe what we are told rather than our senses and our intelligence, his tempestuous technique was the result more of chance than of set purpose. Many of his

canvases are said to have been executed while Monticelli was under the influence of drink. We are certain, however, that both in Provence and in Paris he must have been often at his wits' end to obtain the necessities of life; for no pictures could have appealed less than Monticelli's to a bourgeois taste. In Paris poor Monticelli is said to have actually hawked his pictures about in the streets.

During the war he returned to Marseilles, his native city, and there he remained until he died, in 1886, of drink. During his last years in Marseilles he received sufficient money, paid to him daily, for his requirements, although at that time neither in Paris nor in London was his work well known. The first people to discover that in Monticelli's gorgeously-painted dreams there was food for contemplation and delight, and that they had a marvellous decorative value, were the Americans, who also were the first to realize that Millet was a great master. It is hardly necessary to add that Monticelli received neither orders nor medals.

Not only has the study of the peasant in the open air and at his toil been perpetuated by Jules Breton, but one or two other painters besides have carried on the work in a more or less notable manner.

Bastien-Lepage, who was born in 1848 at Damvillers, and who was also the son of a farmer, recognized the dignity of the peasant's life, and he set down in full the result of his observations. Lepage was by no means an imitator of Millet or of Breton. Realism was his particular study; and to the study of light and of character

he made many great sacrifices. With transitory effects of light and shade he had nothing to do; nor did he pose his models in attitudes which they were unable for long to maintain. Hence his pictures are a little monotonous: we have in them mostly the same effect of quiet gray light; and in his figures there are the same uninspired gestures. But that effect of gray light which he so favoured—by necessity—he rendered excellently, and his peasants are well drawn and well modelled; and no one will deny that he followed their character closely. It was Lepage's ambition to make a painted scene resemble a slice of nature seen through a window, and so nearly did he attain to his heart's desire, that from his pictures it is impossible to say what manner of man Lepage was. He died in 1884.

For a while Mr. George Clausen followed the example of Lepage, and during that time he made us as intimate with the features of the English peasantry as we had become, because of Lepage, with the characteristics of the countrymen of France. Finding, however, that his manner of study was incapable of development, Mr. Clausen has of late years adopted a freer and more artistic technique, has studied many beautiful effects of illumination that were unapproached by Lepage. He has studied, too, the poetry of movement, and when his work reminds us of Jean-François Millet, as it does very often, we can still enjoy it, for in addition to that which he owes to the master, Mr. Clausen presents us with the result of his own observation, and that which is the outcome of his own poetical temperament.

M. Lhermitte has also drawn and painted the French peasant at all manner of toil with some of the careful observation that was characteristic of Jean-François Millet. His work is remarkable for its great ability and still more for its extraordinary frankness.

One of the most unlucky painters who fell under the sway of Rousseau and Diaz and other great landscape artists of their period was Adolphe Hervier. He was born in 1827 and died in 1879. During his life he was refused twenty-three times by the Salon jury. But for all that he was a capable artist. However, he was wanting in individuality, and he followed too many signposts, and never quite reached the kingdom of his desire. Whether he followed the inspirations of Rousseau, Corot, or his master, Eugène Isabey, his technique was always marred by too heavy a touch. In his etchings he is more interesting, and in his lithographs he is more interesting than in his etchings. They show that he had a fine sense of composition—a capacity for arranging massive forms, and for setting out his picture in good proportions of light and shade.

Far more successful has been Harpignies, who seldom composed a picture that was not replete with elegance and style. At a ripe age, as late as 1897, he covered himself with glory by his splendidly-conceived and painted "Solitude," a picture of a river bank flanked with trees, in which one of the most transient and beautiful effects of evening was set forth poetically and with that truth which can be the outcome of only very long study.

HARPIGNIES

Here in England, in our midst, we have Mr. Peppercorn and Mr. Muhrmann among others painting landscape and searching for broad effects of light and shade and of tone, such as Millet and Rousseau loved. But they are obeying their own emotions, as did Millet and Rousseau and the other artists whose names are mentioned in this book. The bond which binds all these painters together is that they have sought or are seeking in their own ways not for what is trivial in nature, but for what in some way or other conveys to us a sense of the beauty of infinity.

INDEX

Titles of pictures are printed in Italics, and where no painter's name is given they are by Millet.

Angelus, The, 77, 80, 81, 91, 96, 110.
Attente, L', 69.
Avenue de Châtaigniers (Rousseau), 193, 194.

Baratteuse, La, 102.
Barbizon, Millet at, 62, 72.
Baroilhet, M., 134.
Bastien-Lepage, 222, 223.
Battle of Medina, The (Diaz), 156.
Becquée, La, 87.
Becquigny, Village of (Rousseau), 210, 211.
Berger au Parc, Le, 77.
Blanc, M., Contract between Millet, Stevens and, 85, 86, 88.
Bohémiens, Les (Diaz), 161.
Boucher *pastiches*, the, 15.
Breton, Jules, 220.
Bridge at Berry, The (Dupré), 138.
Burns, Robert, 90.
Burty, M., description of the Millet family at dinner, 24, 25, 85; description of Rousseau, 201.

Cabat, Dupré and, 125.
Chassaing, M., 90, 96, 97.
Clausen, Mr. George, 223.
Correggio, influence of, on Diaz, 154, 155.

Côtes de Granville, Les (Rousseau), 186, 187.
Coucher de Soleil (Rousseau), 202.
Couseuses, Les, 67, 68.
Crossing the Bridge (Dupré), 132.

Daphnis and Chloe, 56.
Day, Sir John, 200.
Death and the Woodcutter, 81, 96.
Decamps, Millet's description of, 84.
Delacroix, 216, 217.
Delaroche, Paul, Millet in the studio of, 49; anecdote of, 68.
Demidoff, Prince, 211.
Descente des Vaches (Rousseau), 190, 191.
Diaz, Eugène, 167.
Diaz, Emile, death of, 167.
Diaz, Narcisse-Virgilio, recognizes Millet's greatness, 53; welcomes Millet to Barbizon, 61; romantic story of his birth, 145, 146; death of his mother, 147; his childhood, 147, 148; loses his leg from a snake bite, 149; in M. Gillet's atelier at Sèvres, 150; his poverty, 151; his visions, 152; studies under Souchon, 153; his love of the East, 153, 154; influence of Correggio on, 154, 155; his success, 157; at Barbizon, 157; story of

his friendship with Rousseau, 158, 159; his flower pictures, 160; story of his toast to Rousseau, 165; loss of his son, 167; his limitations, 168, 169; his increasing success, 170; goes to Brussels, 170; his death, 171, 172; his appearance and character, 172; his debt to Rousseau, 215, 216.
Diébold, M., 124, 125.
Dupré, Jules, birth of, 124; goes to Paris, 125; story of the marquis and, 126-128; his temperament, 128; early success, 130; visit to England, 131; his friendship with Rousseau, 132, 133, 197; commission from the state, 135; Rousseau's quarrel with, 136; change in his work, 137; his colouring, 139; goes to Picardy, 140; death of, 140.
Durand-Ruel, M., 105, 107.

Eaton, Mr. Wyatt, quoted, 4, 63, 72, 84, 85, 93, 108, 111, 112, 113, 116.
Evening (Dupré), 129.

Fée aux Perles, La (Diaz), 168.
Ferme, La (Rousseau) 198, 199, 207, 210.
Feuardent, M., 105; portrait of the daughter of, 55.
First Steps, The, 21.
Flute Lesson, The, 56.
Forbes, Mr. J. S., 53, 54, 78, 96, 159, 200.
Forest of Compiègne, The (Dupré), 138.
Forest of Compiègne, The (Rousseau), 188.
Fountain of Montmartre, The, 59.

Four Communal, Le (Rousseau), 207, 210.

Gardeuse d'Oies, La, 87.
Gavet, M., 93, 101, 118.
Georges, M., 45, 46.
Gillet, M., 124, 125, 150.
Giorgione, his "Concert Champêtre" copied by Millet, 47.
Givre, Le (Rousseau), 133, 134, 200.
Gleaners, The, 78, 80, 96.
Going to Work, 66.
Gorge d'Apremont (Rousseau), 207.
Grafter, The, 73, 74.
Gros, Baron, 217.

Hagar and Ishmael, destruction of the canvas, 59.
Harpignies, 224.
Hartmann, M. Frédéric, 98, 101, 107, 110, 116, 210.
Haymakers resting, 59, 60.
Hervier, Adolphe, 224.
Horses Drinking, 58.
Huet, Paul, 218.

Immaculate Conception, the, painted for the Pope, and lost, 82.

Jacque, Charles, 62, 219.
Japanese Art, Millet and Rousseau's love of, 100.
Javain, M., Mayor of Cherbourg, portrait of, 52, 55.
Jumelin, Louise, Millet's grandmother, 5, 33, 34, 40, 42; death of, 67.

Knitting Lesson, The, 101.

Langlois, Millet's master, 40, 41.
Larmes de Veuvage, Les (Diaz), 166.

Latrone, M., befriends Millet, 70.
Lebrisseux, Abbé Jean, 71, 72.
Lemaire, Catherine, Millet's second wife. *See* Millet, Madame.
Lemerre, M., 99.
Lhermitte, M., 224.
Lisière de Forêt (Rousseau), 204.
Lorentz, 185, 188, 189.
Love the Conqueror, 54.

Maire, M., 179.
Man leaning on a Hoe, 88.
Man spreading Manure, 67.
Mantz, M. Paul, 93, 138.
Marais dans les Landes (Rousseau), 198, 207.
Mare à la Vallée de la Sole (Diaz), 164.
Mare aux Vipères, La (Diaz), 167.
Marolle, 15, 50, 51.
Maternité, La, 109.
Meissonier, a picture by Diaz bought by, 162.
Michael Angelo, influence of, on Millet, 8, 12, 47, 48.
Milkmaid, The, 53.
Moissonneurs, Les, 64, 68.
Monticelli, 221, 222.
Millet, Abbé Charles, 6, 33.
Millet, J. F., the tragical side of his life exaggerated, 1; inspired by St. Francis, 3; his love of children, 4, 5; influence of his grandmother on, 5; his early teachers, 6; his wide reading, 7, 8; his self-confidence, 9, 10; cannot be called a martyr, 11, 12; his first and second marriages, 13; the Boucher *pastiches*, 15; his ideal life at Barbizon, 17; his power of description, 19, 20; his love of the country, 21; his love of gardening, 23, 24, 25; his life consistent, 25, 26; his friendships, 27; appreciation of his work in England and America, 27, 28; his connection with Sensier, 28-30; his birth and parentage, 32; his early drawings, 36, 37; goes to Cherbourg with his father, 37; placed under Mouchel, 39; death of his father, 40; return to Cherbourg, 40; studies under Langlois, 41; granted a yearly allowance, 42; goes to Paris, 42; life in Paris, 44; studies the old masters in the Louvre, 46-48; enters Delaroche's studio, 49; returns to Cherbourg, 51; his first marriage, 53; returns to Paris, 53; nude studies by, 54; his second marriage, 55; visit to Havre, 56; again in Paris, 57; serious illness of, 58; his *Winnower* bought by the Government, 58; in the Revolution of 1848, 59; goes to Barbizon, 60; life at Barbizon, 62-64; *The Sower*, 64-66; death of his grandmother, 67; visit to Gruchy, 71; description of his studio, 72, 73; pictures of shepherds by, 76-78; story of his picture painted for the Pope, 82; his frequent headaches, 83; his home-life, 85; his contract with Stevens and Blanc, 85, 86; his drawings, 88, 93, 94; visits to Vichy, 95, 97; death of Rousseau, 97; growing infirmities, 98; made Chevalier of the Legion of Honour, 98; visit to Switzerland, 98; etching for Lemerre, 99; his children, 101, 109; goes to Cherbourg, 105; visit to Gréville,

106; peacefulness of his last years, 107; his personal appearance, 112, 113; commission to paint a chapel in the Pantheon, 115; last days, 117; his death, 118.
Millet, Jean-Louis, father of the painter, his musical talent, 2, 5, 35; takes his son to Cherbourg, 37; illness of, 39; death of, 40.
Millet, Madame, Millet's first wife, 13, 53.
Millet, Madame, Millet's second wife, 13, 14, 55, 56, 95.
Millet, Madame, mother of the painter, 34, 35.
Morning (Dupré), 129, 138.
Mouchel, Millet's first teacher, 38, 39.
Muhrmann, Mr., 225.

New-Born Calf, The, 91.
Nouvelle Société, The, 134.
November, 101, 102.
Nymphs of Calypso, The (Diaz), 156.

Œdipus being taken from a tree, 57, 58.
Offering to Pan, An, 56, 57.
Ono, Mlle. Pauline-Virginie, Millet's first wife, 13, 53; portrait of, 53.

Paira, M., 147, 148, 151.
Parc aux Moutons Series, The, 77.
Pastel, Millet's drawings in, 89, 103.
Peppercorn, Mr., 225.
Périer, M. Casimir, 194.
Piédagnel, M., 24, 84, 85.
Pig-killers, The, 104.
Poussin, Nicholas, his influence on Millet, 47, 48.
Priory, The, 116.

Rémond, M., 180, 181, 183.
Rollin, M. Ledru, 58.
Romantic School, The, 215.
Romieu, M., 67.
Rousseau, Madame, 99, 207.
Rousseau, Théodore, 61; his friendship for Millet, 70, 75; tragedy of his life, 83; late honours accorded to, 97; his friendship with Dupré, 132, 133, 197; quarrels with Dupré, 136, 204; story of his friendship with Diaz, 158, 159; toasted by Diaz, 165, 205; birth and parentage of, 177; early sketches, 178; secretary to M. Maire, 179; studies under Rémond, 180, 181; goes to Auvergnat, 182, 183; helped by Ary Scheffer, 183, 184; acquaintance with Thoré, 187, 188; tour in the Alps, 188; his *Descente des Vaches* rejected by the Salon, 190; first visit to Barbizon, 192; death of his mother, 193; life at Barbizon, 195; his painting of trees, 195, 196; visit to the valley of the Creuse, 198, 199; expedition to the Landes, 198; spoilt his pictures by over-elaboration, 199; his extraordinary facility, 200; his engagement broken off, 201, 202; his personal appearance, 201; his position after the Revolution of 1848, 202; return to Barbizon with Madame Rousseau, 203; insanity of Madame Rousseau, 207; visit to Switzerland with Millet, 207, 208; sale of his pictures, 208; suicide of Vallardi, 209; seized with inflammation of the lungs, 210; commission from Prince Demidoff, 211;

made President of the Jury of the Exposition Universelle, 1867, 212; overlooked at the distribution of honours, 212; elected an officer of the Legion of Honour, 97, 213; seized with paralytic strokes, 213; death of, 213.

Sacrifice to Priapus, A, 56.
Scheffer, Ary, 183, 184, 190.
Sensier, Alfred, his friendship with Millet discussed, 28-30; quoted, 1, 4, 8, 13, 17, 18, 19, 24, 25, 68, 75, 81, 85, 90, 97, 100, 106, 110, 133, 203.
Setting Sun (Rousseau), 211.
Sewing Lesson, A, 116.
Shaw, Mr. Quincy, 116.
Sheepfold by Moonlight, 86.
Shepherdess, The, 91, 92, 96.
Sigalon, M. 153.
Silvestre, Théophile, 96, 149, 170.
Sleeping Labourers, 58.
Souchon, M., 153.
Sowers, The, 64-66, 80.
Spring (panel painted for M. Thomas), 92; (Louvre), 101, 108, 110-116.
Spring (Rousseau), 211.
Spring Flowers, 22.

Stevens, Alfred, 85, 86.
Stevens, Arthur, contract between Millet, Blanc and, 85, 86, 88.
Storm, The (Diaz), 160.

Tesse, M., 91, 92.
Theocritus, Millet's illustrations to, 90.
Thomas, M., 92.
Thoré, Théophile, 187, 199, 202.
Tobit, 69, 86.
Tondeuse, La, 87.

Vallardi, suicide of, 209.
Vanner, M., portrait of, 56.
Van Praet, M., 91.
Vue d'Angleterre (Dupré), 131.

Wheelwright, Edward, 4, 14, 84, 113.
Wilson, John, 91, 110.
Winnower, The, 58.
Winter, 88, 92.
Woman carrying Milk, 109.
Woman Churning, 101, 102.
Woman feeding Chickens, 70.
Woman leading a Cow, 82.
Woman sewing by Lamplight, 110, 111.
Wool-carders, 88.

CHISWICK PRESS: CHARLES WHITTINGHAM AND CO.
TOOKS COURT, CHANCERY LANE, LONDON.

Milton Keynes UK
Ingram Content Group UK Ltd.
UKHW020637201123
432908UK00011B/1684

9 781016 870